Nancy and Visual Culture

Critical Connections

A series of edited collections forging new connections between contemporary critical theorists and a wide range of research areas, such as critical and cultural theory, gender studies, film, literature, music, philosophy and politics.

Series Editors
Ian Buchanan, University of Wollongong
James Williams, Deakin University

Editorial Advisory Board

Nick Hewlett
Gregg Lambert
Todd May
John Mullarkey
Paul Patton
Marc Rölli
Alison Ross
Kathrin Thiele
Frédéric Worms

Titles available in the series
Badiou and Philosophy, edited by Sean Bowden and Simon Duffy
Agamben and Colonialism, edited by Marcelo Svirsky and Simone Bignall
Laruelle and Non-Philosophy, edited by John Mullarkey and Anthony Paul Smith
Virilio and Visual Culture, edited by John Armitage and Ryan Bishop
Rancière and Film, edited by Paul Bowman
Stiegler and Technics, edited by Christina Howells and Gerald Moore
Badiou and the Political Condition, edited by Marios Constantinou
Nancy and the Political, edited by Sanja Dejanovic
Butler and Ethics, edited by Moya Lloyd
Latour and the Passage of Law, edited by Kyle McGee
Nancy and Visual Culture, edited by Carrie Giunta and Adrienne Janus
Rancière and Literature, edited by Julian Murphet and Grace Hellyer

Forthcoming titles
Agamben and Radical Politics, edited by Daniel McLoughlin
Balibar and the Citizen/Subject, edited by Warren Montag and Hanan Elsayed

Visit the Critical Connections website at
www.euppublishing.com/series/crcs

Nancy and Visual Culture

Edited by Carrie Giunta and Adrienne Janus

EDINBURGH
University Press

Edinburgh University Press is one of the leading university presses in the UK. We publish academic books and journals in our selected subject areas across the humanities and social sciences, combining cutting-edge scholarship with high editorial and production values to produce academic works of lasting importance. For more information visit our website: www.edinburghuniversitypress.com

Edinburgh University Press Ltd The
Tun – Holyrood Road
12(2f) Jackson's Entry
Edinburgh EH8 8PJ

First Published in hardback by Edinburgh University Press 2016

Typeset in 11/13 Adobe Sabon by
Servis Filmsetting Ltd, Stockport, Cheshire,
and printed and bound in Great Britain by
CPI Group (UK) Ltd, Croydon CR0 4YY

A CIP record for this book is available from the British Library

ISBN 978 1 4744 0749 6 (hardback)
ISBN 978 1 4744 2581 0 (paperback)
ISBN 978 1 4744 0750 2 (webready PDF)
ISBN 978 1 4744 0751 9 (epub)

Contents

Illustrations

Acknowledgements

Carrie Giunta and Adrienne Janus would like to thank: Carol MacDonald, our editor at EUP, for encouraging us to frame the volume around Nancy and Visual Culture; James Williams, for prompting the initial discussion; and the whole editorial team at EUP for their support. We are grateful to Jean-Michel Rabaté for giving us permission to retranslate and reproduce the dialogue between Jean-Luc Nancy and Soun-Gui Kim from the Slought edition. We extend our sincere appreciation to Jean-Luc Nancy for his support and generosity in allowing us to translate his essay, 'The Image: Mimesis and Methexis', and to the seven other contributors to the volume, with special thanks to Robert Luzar for the cover image.

Carrie Giunta is especially grateful to: Chris Kul-Want and the Art and Philosophy Research Group at Central Saint Martins; Janet McDonnell and CSM Research; and Robert Luzar for his participation in the pre-stages of this project.

Introduction: Jean-Luc Nancy and the Image of Visual Culture

Adrienne Janus

Whether we are artists, scholars, curators, collectors, casual admirers or a combination of each, our encounter with images is rarely innocent. The proliferation of images in contemporary culture – of 'old' and 'new' media, of pictures, painting, photography, cinema, television, video and internet – has been accompanied by an extraordinary increase in the number of discourses on what images are or do, what we should or should not do with images, what they mean, represent, what they show or tell, what value they have, and how we should or should not look. If these discourses set the general terms of debate in the study of visual culture,[1] it is a debate often framed at its (post)modernist and historicist poles by the question of whether the proliferation of images in contemporary culture marks a new epoch in the West (the oft-proclaimed hegemony of the image over the book, the visual over the textual),[2] or is merely a culminating moment in a history of 'visual turns' as old as the biblical or Byzantine battles between iconoclasts and iconophiles that have emerged throughout Western history at times of competing world views and socio-political uncertainty.[3] In one characteristically provocative response to this question, delivered with a dose of playful self-irony, Jean-Luc Nancy suggests that either way, this doubled proliferation of images in contemporary culture and of contemporary discourses on the image often makes us 'look cross-eyed'. We have one eye on the image, 'the other on discourse [. . .] One eye empirical, the other theoretical. One eye on the exhibition wall, the other on the text of the catalogue.'[4] How then do we resist the strabismus Nancy describes here?

For Nancy, as for this critical appraisal of Nancy's immense contribution to the arts of what we call 'visual culture'[5] (a contentious term in itself, and one that Nancy does not use, preferring

terms such as 'the arts' or 'the image'), the effort to resist this kind of cross-eyed vision would not mean producing a better, more adequate account of what an image is, an ontological theory from which we might derive a practical ethics or politics that would somehow allow us to 'see straight'.[6] Nor would it mean developing new and improved 'practices of looking', if these practices were restricted to the hermeneutics of the image in terms of cultural expression or cultural critique.[7] Rather, for Nancy, to resist looking cross-eyed involves provoking productive interference between discourse and image, between the theoretical and empirical, in order to expose the 'reality of the image'. This reality is neither equal nor inverse to 'the image of reality': it is neither the 'representation of reality', nor the recovery of some invisible 'real' below or beyond 'mere' appearance. To expose the 'reality of the image' is, for Nancy, to expose the multiple ways in which any particular image, and every singular 'work' of art, comes to presence as the intelligible, sensory reality that it is. To ex-pose[8] – one of the operative terms in Nancy's effort to think our relation to images in terms of relations of exteriority as *partes extra partes,* or parts outside of parts[9] – would not then be to set out or posit the image as an object before a subject. This ex-posing would rather be a dynamic, untotalisable taking-place of a distinct actuality (*this* image, *this* work of art, at *this* instant), which resists being absorbed into any 'visions of the world, representations, imaginations'.[10]

Nancy's emphasis on the singularity of each work of art as a distinct modality of bringing to presence or taking place that has multiple possible formations, deformations, and reformations makes him resistant to general categorical formulations (such as the term 'visual culture').[11] Nancy writes:

> Art is never in general: it is always such and such an art. It is called painting or music, sculpture or video, architecture or literature, a garden or cinema, and sometimes one doesn't even know what to call it. One says 'intervention', 'installation', 'action', 'work', and one even says nothing at all, and some take the opportunity to say it's 'whatever'. Whatever, if you will, but not wherever or whenever, nor even however. Somewhere, sometime, it takes place, it performs [. . .].[12]

In a move that is as refreshing as it is disarming (and entirely characteristic of Nancy's writing), Nancy is content to let the dis-

tinct reality of the image, and of art, come to presence even as the inform and in-formulable 'whatever' that it is, in ways that disrupt (or cut into) the continuum of theoretical (academic) discourses to open a space for something new: a space where we can think about, make, and encounter images without having to ask, or answer, questions like 'What is it? What does it mean?' Nancy's thinking then also places the emphasis not on what an image is, but on what an image does: its performativity, its taking-place in the world with us and between us somewhere, sometime, somehow, exposing us in turn to a strange, yet intimate, perceptual experience that impacts our senses and that *makes sense* in ways that are always in excess of fixed meaning or signification. And here, in another move that surely speaks both to the tenor of Nancy's participation in the art world and to the attraction of Nancy's writing for artists, Nancy shifts the terms of debate of visual culture away from performativity as a modality of discursive power relations towards performativity as a modality in relations of pleasure.

These relations of pleasure are announced in the titles of such works as *Le Plaisir au Dessin/The Pleasure in Drawing*.[13] They are also explored in important essays such as Nancy's 'The Image: Mimesis and Methexis' that this volume offers in an authorised new translation appearing for the first time in print. The appearance of Nancy's essay in an edited French volume, *Penser l'Image/ Thinking The Image*, alongside essays by Jacques Rancière, Hans Belting, Georges Didi-Huberman, and W. J. T. Mitchell marked an important point of contact between continental philosophers, art historians and Anglo-American theorists of visual culture. Here, Nancy writes, 'That which we name "image", is that with which we enter into a relation of pleasure. First the image pleases, that is to say draws us into the attraction from which it emerges. (Nothing can foreclose from any aesthetics or from any ethics of the aesthetic this principle of pleasure [. . .].)'[14] This relation of pleasure is of course not hedonistic aestheticism or mere sensual immersion for its own sake (and pleasure for Nancy does not foreclose displeasure). The pleasure of our attraction to, and desire for, the images that art sets before us, a desire that is never realised by possession or mastery, also has for Nancy ethical and existential implications. For, to enter into relation with an image or work of art is to enter into a particular relation with the world as a world. As Nancy writes, 'a work of art "says" or "announces": yes, there is a world, and here it is'.[15] This enunciation is not of

the order of signification, of language, as though the world, or the image, were a sign-system to be 'read', interpreted, or decoded (a common modality in art-history and visual culture in the 1980s).[16] It has more to do with the communication or circulation of what Nancy calls 'sense' [*sens*]: 'sense' not as reducible to 'meaning', as Nancy's term *'sens'* is too often translated in English, but sense 'as the very stuff of worldly being or existence'.[17] As long as we understand 'stuff' or sense not as a graspable materiality, but as the reality 'open to us and the opening from which we address ourselves as existents in the world'.[18] This, in a different articulation of pleasure-relations, is what Nancy calls 'adoration' – not the worship of the world through 'images' or 'idols', but the praise of the infinite sense that *is* the world whose fortuitous taking place happens every moment.

If 'adoration' relates to a particular disposition to the sense of the world, 'regard' relates more closely to a disposition of care for the sense of the image (as in *Le regard du Portrait/The Look of the Portrait*). Here, looking is always a deferred touch that concentrates, intensifies one sensual register of our bodies (the visual) while opening a space of resonance between, and oscillating with and against, the others. In this oscillation, we are singular bodies exposed as pluralities not before the image but in resonance with it, whereby a self is drawn out of itself as an embodied, spatial existence shared out between discontinuous sensual and ideational registers. We are not, then, a kind of disembodied ocular consciousness that may go cross-eyed trying to fix a point of view. We are what Nancy calls a 'corpus sensitivus': a body whose resonant frequencies in any particular visual range or medium, when excited or 'touched', also necessarily produce vibrations at the limits of other sensual and ideational zones, such that the resonant force of the image may 'form the sonority of a vision, and the art of the image a music or dance of sight'.[19]

Multiple-exposures or 'rubbing up against a little wet paint'

In a playful dialogue, 'On Painting (and) Presence', Nancy doubles and deconstructs himself in the roles of both art historian and philosopher of aesthetics. The art historian accuses the philosopher of critical 'clowning' that pours the freshness of paint into endless theorising, 'attracting the eye to your discourse and away from

painting'. The philosopher belittles the art historian's 'tiresome' obstinacy in taking painting as an object of knowledge and taste', and declares, 'what a bore . . . Why don't you rub up against a little wet paint . . .'[20] 'Rubbing up against a little wet paint' might be the exact hyperbole of Nancy's engagement with images, if we keep in mind that the image for Nancy is not limited to painting, but 'occurs also in music, in dance, as well as in the cinema, photography, video, etc. [sculpture, installation, performance . . .]'[21]

In the first case, this is because Nancy's published writings on the image, often emerging from close collaborations with particular artists, usually make their first presentation on scene by appearing together with the works in their particular place of exposition. These include texts pronounced while walking through an exhibit (On Karawa's exhibition, *Whole and Parts*).[22] It also includes small essays written for exhibition catalogues of painting, photography, video installations, and sculptures that are too numerous to list in their entirety. As translated into English, they are: 'On Painting (and) Presence', François Martin, Le Semainier, 1988; 'The Soun-Gui Experience', on the videos of Soun-Gui Kim; 'Lux, Lumen, Splendour' on the photographs of Annabel Guerrero. These writings might be said to actualise, in a praxis of sense that momentarily gives discourse a leave of absence, that which Nancy had previously articulated in his political writings on the community of existence as 'compearance': 'We "compear": we come together (in) to the world [. . .] not as a simultaneously arrival of several distinct units (as when we go to see a film "together"',[23] but as a coming (in)to the world where singularity only takes place as exposure to and with others.

Other writings on the image take Nancy's praxis of sense further to make their co-appearance with exhibitions Nancy himself has curated: *The Pleasure of Drawing* (*Le plaisir au dessin*, the Musée des Beaux-Arts, Lyon, 2007, an exhibition of sketches from the sixteenth century to today); and following on from *Le regard du portrait* (2000), *l'Autre Portrait*[24] appeared with an exhibition Nancy curated on contemporary painting and photographic portraiture at the Mart, Rovereto, 2013–14. Nancy's thinking of dance as a privileged mode of exposition involves close collaboration and correspondence with the choreographer, Mathilde Monnier, with whom he wrote *Dehors la danse*. This collaboration also resulted in the production of *Alliterations,* a series of email exchanges and dialogues between Nancy and Monnier, out

of which emerged a text written by Nancy and performed by him in the eponymous dance-spectacle choreographed by Monnier that toured France in 2003 (a production that also involved collaboration with the film-maker Claire Denis, with whom Nancy has also worked with extensively). Nancy's writing has also appeared in expositions where one of the multiple arts rubs up against the other. *Trop*, at the Galerie de l'UQAM, Montreal, 2005, engaged Nancy's thinking of art as always in excess of any model, structuring plan, or concept, and presented unpublished texts by Nancy, paintings by François Martin, and music by Rodolphe Burger.[25] Finally, arising out of Nancy's long collaboration and correspondence with the painter Simon Hantaï, the two produced a book in collaboration with Derrida entitled *La Connaissance des textes: Lecture d'un manuscrit illisible (Correspondances)*.[26] This 'illegible' book presents images in the form of painting, drawing, calligraphy, and photography, with full-colour plates of Simon Hantaï's works, photographic reproductions of hand-written letters between Nancy and Hantaï, and a final closing letter from Derrida addressed to both Nancy and Hantaï.

As Nancy's writings on images often have their genesis in the space opened up by close collaboration, extensive correspondence and dialogue with individual artists, this volume does not restrict itself to critical commentary on Nancy's writing. Instead, one of the aims of the volume is to expose to critical reflection the ways that Nancy's writing opens up a productive space of encounter between theory and artistic practice: to expose how Nancy's thinking has inspired and animated individual artists and how the practices of individual artists animates and inspires Nancy's own thinking. Following this, this volume offers, in the first case, a new, complete translation of 'Presentation and Disappearance', a dialogue between Nancy and Korean artist Soun-Gui Kim on the occasion of the Gwangjiu International Biennale, Korea. In this dialogue, Nancy and Soun-Gui Kim not only touch upon the multiple arts between which Soun-Gui's practice and Nancy's writing moves: installation, performance, video, photography and drawing. They also think about the locations and dislocations of contemporary artistic practice, when the disappearance of any dominant or common model of formation (of worlds, of the arts) displaces image-making understood as the shaping of form and content and moves towards performance and presentation as the very content and form(ation) of art today.

Secondly, this volume offers contributions by interdisciplinary scholars who engage with Nancy's writing on the differential plurality of the arts of image-making across painting and drawing, photography, film, video and dance. Many of these scholars are also practising artists who have been inspired by or have collaborated with Nancy and bring critical reflection of their own artistic practices into dialogue with Nancy's thinking. To provide an introductory frame for this dialogue between thinkers and artists, and to indicate how, in Nancy's thought, any particular art and practice of image-making organises and presents experience as a particular modality of world-formation, the following provides a (necessarily incomplete) outline that folds threads of Nancy's writing on particular arts and artists into a more general schema.

1. **Painting/Drawing**: In drawing and painting, the image belongs to the regime of surface distinguished from ground, where the surface only becomes distinct as surface with the inaugural gesture of brush, pen or charcoal whose 'light mark comes to imprint its possible presence' upon canvas, parchment, paper, or cloth.[27] Similarly, ground only becomes distinct as 'ground inasmuch as forms draw themselves from and upon it'.[28] In this tension between surface and ground, the world is exposed as having no preconceived design or plan, but as always opening anew to: the 'quiescent shadows of possible worlds'[29] (Chinese still life) or the corpuscular presence of organs that 'press toward and against existence' (François Martin).[30] In the resonant stillness of painting, 'a world turns towards itself to see itself' and 'turns toward us to hold our regard',[31] opening a space where self and world come to light as drawn by the incessant tension of sameness and alterity, exposing the singularity plurality of existence.

In regards to painting, the new translation of Nancy's 'The Image: Mimesis and Methexis' in this volume contains some striking meditations on Cézanne's 'Young man with Skull' set within a more extensive analysis of the image in Western culture as a site of tension between surface and ground, mimetic form and methexical force. If the methexical force of the image is that which presses towards and against existence, it is also aligned with the heaviness, gravity, the perceptible pressure and inclination towards which and against which the artist moves to enact the inaugural gesture of mark-making. It is this inaugural gesture that practising artist and scholar Robert Luzar concentrates on in bringing Nancy's thought

into dialogue with his own practices of drawing and graphic performance art. Taking as his point of departure Nancy's conception of the mutual implication of weight (pesée) and thought (pensée), where 'the heaviness [. . .] the gravity of a "thought" ("idea", "image" [. . .]) affects us with a perceptible pressure or inclination, a palpable curve – and even the impact of a fall',[32] Luzar analyses how in his own works of graphic performance art, this pressure, heaviness and inclination condenses throughout the whole body in the 'complex event' of image-making – the heaviness of arm and hand, the pressure of holding pen or brush between finger and thumb, the downward pressure of gravity upon the gestures out of which drawing arises. Here, 'thought' does not have to do with tracing intellectual actions, figures, or forms but with the corporeal opening to and extension of sense.

2. **Photography**. For Nancy, the photographic image is not the instantaneous mechanical or digital reproduction of the real, but a surface of liquid or digital pulp upon which rising and descending light waves are suspended in their multiple refractions against the surface limits of the real, to expose, with the hesitant force of a 'click': (1) the 'transience, grace, fragility of something, someone, appearing somewhere at a particular moment in time' (on the photo-portraits of 'Georges'); (2) 'the curves, edges and surrounds of a body' that expose the truth of bodies and the world as nothing else but these exteriorities (on the photographic bodies of Annabel Guerrero). These 'thin surfaces detached and removed by film' that 'brush the liquid surface of our eyes',[33] expose us as familiar strangers to ourselves, and the strange familiarity of the world as 'the possibility of a taking place of sense' – sense without determinate place, landmarks, figures, circumstances, or actions.[34]

It is this strange familiarity, these multiple refractions of light against the surface limits of landscapes without determinate place, that photographer Chris Heppell explores in his chapter, 'Uncanny Landscapes: The *partage* of double exposure after Jean-Luc Nancy'. Moving from Nancy's frequent descriptions of the image as the doubling of surface and groundless ground, and in dialogue with Nancy's writing on photography in 'Nous Autres' and 'Uncanny Landscapes', Heppell reflects upon his own photographic practice of using double exposures of multiple, overlaid scenes in his *Time Out of Joint* series of landscapes. Here, the hesitant, and often faulty, 'clicks' produced by the mechanism

of an early 1980s analogue Minolta camera, and the possibilities of rewinding and subjecting analogue film to multiple exposures, produces images where the simultaneous division and sharing out (or *partage*) of multiple landscapes co-appears in the distension of each singular, discrete photographic image.

3. **Film:** For Nancy, unlike Deleuze and Rancière, the cinematic image is not articulated by a schema of passage from movement-image to time-image that can be historicised, or by image-functions that supplement and contradict each other in ways that contest the sensible (and political) configuration of the world. On Nancy's view, the filmic image offers us intimacy with a world that is always withdrawing in the movement of its passage – a passage that exposes the world in its discontinuous continuity, without origin or end as a continuous routing and de-routing of the senses.[35] This passage or route opened with the movement of the filmic image is without ground, but with 'sol' and 'solation': 'sol' as the fluid suspension of a colloidal solid in a liquid as the chemistry of 'film'; 'solation' as the solace and suspense offered by the lightening, softening surface of the little filmic skin (pellicule) stretching over the absence and the blackness of the screen.[36]

Nancy's conception of film is put into play in novel ways by film-maker Phillip Warnell, whose film, *Outlandish*, made in collaboration with Nancy, follows the routing and de-routing of the senses occasioned by the film's exposition of the strange, foreign bodies of film-maker, philosopher, and animal who share a passage by boat on the Mediterranean. Here, the 'Sol' of Nancy's filmic image as fluid suspension of a colloidal solid in a liquid is doubled by the suspension in a raised aquarium constructed on the deck of the boat of 'that most inside-out of creatures', an octopus. Warnell's contribution to this volume, 'Writing in the Place of the Animal', meditates on the place and displacements of the animal body, and the ethics of human-animal co-existence, in relation to *Outlandish* and *Ming of Harlem,* a recent film made in collaboration with Nancy and to which Nancy contributed an original poem (re-printed in this chapter). Warnell explores the shared worlds of human, felid and reptilian animals in relation to *Ming of Harlem's mise en scène* of the co-habitation in the years around 2003 of human, tiger and alligator in a Harlem fifth floor apartment. Throughout his chapter, Warnell returns to 'Strange Foreign Bodies', a text written by Nancy to accompany *Outlandish*,

which highlights the intimate distance between and 'outsidiness' of bodies, whether of our 'own' bodies as human animals, or of the bodies of other existents whose separation and distinction is exposed as skin, scales, fur or feather, yet which briefly share the space of the world in passage, a passage exposed by the little filmic skins of Warnell's cinematic images.

4. Video: With video, 'the image becomes particular or particulate', not suspended or stretching as in photography and film, but emerging and disappearing in the 'dance of points' of 'light converted into punctual signals'.[37] As Nancy reminds us, video means 'I see', and it is with video that the 'I''s absorption in vision opens into the dance of points that exposes the singular plurality of each particular being as the auto-differentiation of particles that never make a unity, but ceaselessly emerge and disappear, as in the video-installations of Soun-Gui Kim, in the 'groundless darkness (a glassy and groundless darkness, the darkness of the video screen)'.[38]

The emergence and disappearance of particular existents, of the finitude of individual lives, and the possibility of art to occasion a shared rebirth to presence without the unity of communal fusion, is explored by installation artist Lorna Collins in relation to Nancy's conception of community as the sharing of finitude, as developed most prominently in *The Inoperative Community*. Collins brings Nancy's work into dialogue with the video installation of Sophie Calle, *Couldn't Capture Death*, and with her own sensory installation *Flashback*, where the audience is absorbed not only in the vision of images of the artist's childhood that appear and dissolve into pixels, but are also immersed in the strangely beguiling yet impossible to grasp olfactory and tactile presences from that past.

5. Dance: Dance presents a *mise en scène* of the birth to presence, the primal opening or 'originary leap' or 'Ursprung'[39] that lifts bodies outside of themselves to expose a new space in 'the traction, contraction, and attraction'[40] of bodies, worlds and world. Dance, then, for Nancy has a certain privilege amongst the other arts in that it 'exposes exposition as such' in the movement of a body that extends and throws itself to open a new space or spacing.[41] The 'spectacle' of dance is not the exhibition of objects (as in the Situationist critique of the society of the spectacle), but a

presentation to our 'regard' as a sensibility, where we participate in the movement by which body and world are shared out in 'the same discontinuous quaking of sensibility'.[42] Dance then, presents an image that is kinaesthetic, haptic, visual, and auditory all at once. It is a kind of 'ur-image' of bodies and worlds in formation, a praxis of sense 'regulating the de-multiplied chorasethesie of all the senses'[43] – in other words, a praxis of sense regulating dance as the spacing or interval of all the senses in the world as sense.

Chris Watkin's chapter, 'Dancing Equality: Image, Imitation and Participation', investigates the particular privilege that Nancy's aesthetics and philosophy accords to dance, drawing extensively from *Alliterations*, Nancy's as yet untranslated dialogues with choreographer Mathilde Monnier, as well as from Nancy's essay, 'The Image: Mimesis and Methexis'. Watkin argues that dance does not merely serve as an exemplary illustration or embodiment of concepts or linguistic figures drawn from Nancy's wider philosophical project, but rather itself stages the gestural energies, the movements and ontological tensions, which also seize us in our relation to images of visual art, to images of thought, and indeed in relation to the circulation of sense in the singular plurality of being-in-the-world.

Taking the long-view or '600 years. That's not a long time'! – Nancy, in dialogue with Soun-Gui Kim

While Nancy has written extensively on particular images produced both by European and non-Western artists today, his effort to address the reality of the image also involves writings where we encounter works from throughout history: from the Cosquer cave hand paintings ('Painting in the Grotto') to Caravaggio ('On the Threshold') and Cézanne ('The Image: Mimesis and Methexis');[44] and from images that mark the Renaissance rediscovery of figures of antiquity, such as Artemesia Genileschi's painting of *Cleopatra* ('The Sovereign Woman in Painting'),[45] to images that mark contemporary re-engagements with the birth to presence of 'Christian' painting, like Simon Hantaï's . . . *del Parto* (1975) and Pierro della Francesco's *Madonna del Parto* (1470) ('Visitation: Of Christian Painting').[46] This second mode of exposition that informs Nancy's writings on the image might be called 'taking the long view', as long as we remember that for Nancy, art is always in a certain way contemporary because it takes place in 'the space of an actuality,

and that in this actuality art makes us sense, see [. . .] a certain formation of the contemporary world, [. . .] a certain perception of self in the world'.[47] Or, in other words which indicate the ways in which Nancy folds temporal extension into spatial presentation (and does away with the historicity of 'art history'): 'An artist's work always makes present a present (of eternity, if one wants to say it that way, or an instant)'.[48]

Nancy's writings on the image frequently turn back to paintings of religious scenes, and this engagement works to distinguish the image from any religious 'logos' or doctrine. In Nancy's afore-mentioned essay, for example, 'Visitation: On Christian Painting', 'Christian painting' does not mean the depiction of biblical scenes that can be read as religious allegory, or as commemoration or 'sign' of the divine, but the exposition of a coming to presence shared out among all existents, an exposition that endlessly repeats the gesture, and the corporeality, but not the signification or content, of the Eucharistic ritual *hoc est corpus meum* or 'this is my body'. In this regard, all Western art bears the vestigial mark of this gesture that emerged with Christianity.[49]

All images presented by the arts, then, are sacred and 'iconic' insofar as they mark a separation from the everyday organisation of socio-political and cultural experience to expose the presence of that which is otherwise invisible, calling thereby for a vision other than that of a sight directed by a subjective viewer towards objects. Religious icons enclose and bind us to a vision of the invis-ible that is regulated by an idea of transcendence, or a divine pres-ence, whose withdrawal from the world into the beyond requires continual debate or contests over how and what we know what that idea (or image in the iconic sense) means. On the other hand, the image continually opens to expose a new, sensible presence whose withdrawal from grasp (from identification, signification, meaning, etc.) requires no consensus or determination of what follows. 'The image', writes Nancy, 'is the *there* of a *beyond*', where the *beyond* is not a transcendent divinity or onto(theo) logical system, but a cut or opening in the immanence of the world that lets presence come to the fore.

It is these two complementary tendencies – that of cutting and letting-be – that Martin Crowley analyses in his chapter as funda-mental to both Nancy's aesthetics and his philosophical ontology. If cutting relates to the tracing of a line as an incisive gesture of cutting off, circumscribing, and also maintaining an opening to the

delineation of forms, letting-be is the affirmation of the coming-to-presence of any form whatsoever that is also an active, incisive stance of care. Crowley sets these operative modalities of Nancean aesthetics in relation to the 'tagli' or cut and slashed canvases of Luciano Fontana and to the sketches of Alighiero Boetti, sketches in blue biro punctured by points that evoke the starry punctuations of the night sky, and, as their title – 'mettere al mondo il mondo' – indicates, the coming into the world of world. In all cases, this coming to presence or opening to forms is the particular specificity of something as nothing that would be the object of, or available to, representation or signification, and also not either the unspeakable, unrepresentable sublime, but a coming to presence that this image, this gesture, puts into play as an opening to the possibility of world.

Another important way that Nancy shifts the terms of debate away from the image conceived as 'representation of' (x, y, z), or mimetic copy, towards the image as a site of presentation, is by resuscitating the classical Greek companion term to *mimesis* that has long been overlooked or occluded: namely, *methexis* as participation, contagion, the mixing of attraction and repulsion, desire and distress – the force that mixes with and overflows the forms of *mimesis* in the image. While it is a term that appears throughout Nancy's writing, Nancy explores this relation more extensively in 'The Image: Mimesis and Methexis'. Here, Nancy writes, there may occur 'no *mimesis* . . . without *methexis* – or else be merely copy, reproduction – that is the principle. Reciprocally, no doubt, no *methexis* without implicating *mimesis*, that is to say precisely production (not reproduction) in a form of the force communicated in participation'. This mixing of the force of participation that draws us to the image, and the forms with which mimesis is associated, is also a mixing or mutual implication of sensual and intellectual pleasure: 'Each *eidos*, here, is an *eros*: each form marries a force that moves it'. Eros, the force of desire, is no longer the property of a (Freudian) psychic interiority, but a property of 'imaginal bodies' conceived as a discontinuous spacing of erogenous zones (zones of the bodies moved by encountering the image, zones of the bodies or forms in the image, zones of the bodies that make the image). Similarly, Eidos, the form of the Platonic idea or the Idea as Platonic form, shifts here to become the movement or presentation of spatial form as such, both material and intelligible.

In a contributing chapter that is as challenging as it is titillating,

Peter Banki's 'Pornosophy: Jean-Luc Nancy and the Pornographic Image' teases out the multiple implications of Nancy's conception of the force of Eros particular to each image, moving through Nancy's writing on sexuality in *Corpus II*, as well as Nancy and Ferrari's collaborative work, *Being Nude: The Skin of Images*. In relation to the erotics of pornographic images, as well as to the ethics and politics of sex-work, Banki examines what 'a regard juste', a just regard, in relation to pornography might be and asks how art and philosophy might, against the virility of the drive of reason that always demands accountability, give greater hospitality to the force of sexual desire as that which is without account or reasonable explanation.

Carrie Giunta's chapter, 'A Question of Listening: Nancean Resonance, Return and Relation', follows Nancy's gesture of pulling images from a past era into the present in her analysis of 'silent' images: from Han dynasty shadow-puppet play to da Vinci's *Mona Lisa* to the silent films of Charlie Chaplin. Moving from the resonance of the image that Nancy examines in 'The Image: Mimesis and Methexis', through Nancy's articulation of a philosophy of listening, *À l'Écoute/Listening*, Giunta explores how the images of visual culture ask us not only to look, but also to listen.

Nancy's articulation of the mutual implication of *mimesis* and *methexis*, of the form and force of the image, raises interesting questions regarding the relation of the image to force conceived not only as Eros, but as violence. It is a relation, as Nancy acknowledges, that has long been the topic of cultural and political debates surrounding the image ('Image and Violence')[50] and is also addressed in the specific modalities of painting and pornography by Crowley's and Banki's contributions to this volume. In a more general sense, for Nancy, every image has a relation to violence, in that the force of bringing forms to presence, as a spatialised presencing, occupies space and therefore 'competes for presence', pressing towards and against the presence of things in the world. But the violence of the image, and of art (or of love or thought), is a force that does not exhaust itself (or other existents) in the action of its taking place, but opens up with the force of its formation a new spacing 'to expose a sense that has no other goal than to be and to circulate among us'.[51]

Provoking 'soft' collisions

This brings us to the third and final strategy that characterises Nancy's writing on the image, and our strategy for this volume, one which might be called, 'Provoking "soft" collisions': the strategy of dipping into, moving through and provoking collisions between multiple discourses, or, as Nancy recites it from his mentor, Gerard Granel, the move to 'suddenly dip into the flux of language's possibilities, modify the current, provoke a collision, [. . .] and give birth to waves of thought'.[52]

How Nancy's own thought provokes collisions between the arts and sciences of images, between visual culture and visual nature, is taken up by Adrienne Janus' contribution, 'On the Threshold: Visual Culture, Visual Nature'. Drawing together a philosophical image from one of Nancy's early unpublished texts that appeared in the exposition *Trop*[53] and a complementary image from contemporary video performance artists Harrison and Wood, Janus explores how these images can be made sense of not only in terms of philosophy but in terms of contemporary scientific research in visual perception and the physics of complex systems.

This effort to provoke soft collisions between diverse discourses is in part why we include in this volume chapters from contributors who work across a variety of fields, not only those whose primary disciplinary identification is 'film and visual culture'. By doing so, we also hope to gesture towards the divergent interdisciplinary practices of artists and scholars that have made 'visual culture' such a productive site of disciplinary turbulence, and that both testify to and reinforce the image as a site of such powerful gravitational force. This in itself may also testify to how the arts of the image today retain the possibility of a 'being-in-common' that Nancy's work as a political and ethical philosopher articulates. If the arts expose and animate the sense of being-in-common as being-with that for Nancy, is the sense of being itself, this sphere must nevertheless always be separated and distanced from politics, which is a sphere in charge of the maintenance of relations, of groups and associations, but not of the sense or forms of being itself. For Nancy, then, unlike Rancière, there is no politics *of* drawing, *of* painting, *of* the arts, but only a politics that maintains an opening or spacing for the forms and senses in the existential effectivity or ethos of the arts.[54]

Finally, to conclude this introduction to *Nancy and Visual*

Culture, we would like to acknowledge, and reprise on behalf of the collection as a whole, the *mea culpa* Nancy offers in his meditation on the incapacities of writing to account for art, and on the great attraction, and the risk, of writing on the image: 'writing is not obliged to account for its incapacity [to write on art], but it is obliged to take into account the fact that it will never account for it'.[55] This volume then does not attempt to account for or provide extensive commentary introducing readers to the entirety of Nancy's writing on art. Nor does it intend to serve as a synoptic introduction to Nancy's conception of the image and image-making in relation to the field of visual culture/visual culture studies, a relation that we address quite extensively in this introduction. Recalling Nancy's awareness that 'the artist himself does not much like to speak about art, nor call what he does "art". On the contrary, he quite likes to say "what I do"', this volume attempts to open a new space of encounter between Nancy's writings on the image, practices of image-making today across the arts, and our contributing artists' own reflections on what they do.

Notes

1. In regards to the genealogy of 'visual culture' as a field of study within the Anglo-American academic world and interdisciplinary tensions within and across the study of visual culture, see 'Visual Culture Questionnaire', *October* 77 (1996): 25–70.

2. Nicholas Mirzoeff, 'What is Visual Culture?' in *An Introduction to Visual Culture* (London: Routledge, 1999) offers compelling defence of the postmodernist pole.

3. See W. J. T. Mitchell, *Picture Theory* (Chicago: University of Chicago Press, 1994) and 'Showing Seeing: A Critique of Visual Culture', *The Journal of Visual Culture* 1, no. 2 (2002): 165–81; Marie-José Mondzain, *Image, Icon, Economy: The Byzantine Origins of the Contemporary Imaginary*, trans. Rico Frances (Stanford: Stanford University Press, 2004).

4. Jean-Luc Nancy, 'Painting [and] Presence', *The Birth to Presence* (Stanford: Stanford University Press, 1993), 360.

5. French cognates of the term 'visual culture' ('culture visuelle' or 'études visuelle') have only recently begun to be imported into France to indicate a particular disciplinary configuration correlating to what in North American and Britain is recognised as 'visual culture'. For further discussion of the geographic configurations of the various

disciplinary correlatives to the North American and British fields of visual culture or visual studies see James Elkins, *Visual Studies: A Skeptical Introduction* (New York: Routledge, 2013).

6. See Georges Didi-Huberman, *Confronting Images* (University Park: Pennsylvania State University Press, 2004) and James Elkins and Maja Naef, eds, *What is an Image?* (University Park: Pennsylvania State University Press, 2011). Elkins' introduction addresses the possibilities and limits of such attempts to define the image while Didi-Huberman explores the methodological limitations of art history's interpretation of images as signs.

7. For two important contributions to the hermeneutics of the image as socio-cultural critique of practices of looking and image-making see Marita Sturken and Lisa Cartwright, *Practices of Looking* (New York: Oxford University Press, 2001/2009) and Nicholas Mirzoeff, *The Right to Look: A Counter-History of Visuality* (Duke University Press, 2011).

8. See, Ian James, Patrick ffrench, eds, 'Exposures: Critical Essays on Jean-Luc Nancy', *Oxford Literary Review* 27, no. 1 (2005) and Philip Armstrong, 'From Appearance to Exposure', *Journal of Visual Culture* 9, no. 1 (2010): 11–27.

9. On Nancy's *partes extra partes* as 'intrinsic exteriority', see Jacques Derrida, *Le toucher, Jean-Luc Nancy* (Paris: Galilée, 2000) and *On Touching – Jean-Luc Nancy*, trans. Christine Irizarry (Stanford: Stanford University Press, 2005).

10. Jean-Luc Nancy, 'The Evidence of Film', trans. Christine Irizarry, Verena Andermatt Conley (Brussels: Yves Gevaert, 2001), 18.

11. See Jean-Luc Nancy, 'Why are there several arts and not just one?', *The Muses*, trans. Peggy Kamuf (Stanford: Stanford University Press, 1997).

12. Jean-Luc Nancy, 'Addressee: Avital', trans. Saul Anton, in *Reading Ronnell*, ed. Diane Davis (Champaign: University of Illinois Press, 2009), 14.

13. Jean-Luc Nancy, *The Pleasure in Drawing*, trans. Philip Armstrong (New York: Fordham University Press, 2013).

14. Jean-Luc Nancy, 'The Image: Mimesis and Methexis', in this volume.

15. Jean-Luc Nancy, 'L'art de faire un monde' ('The Art of Making a World'), in *Cosmograms*, eds, Melik Ohanian and Jean-Christophe Royoux (New York: Lukas & Sternberg, 2005).

16. See Hubert Damisch, '8 Theses for (or against?) a semiology of painting', originally given as a talk presented to the International

Associated of Semiotics, Milan 206 June, 1974, translated into English, *Oxford Art Journal* 28, no. 2 (2005), a work which backgrounds Jacques Derrida, *The Truth in Painting*, trans. Geoff Bennington and Ian McLeod (Chicago and London: University of Chicago Press, 1987).

17. Ian James, *The Fragmentary Demand* (Stanford: Stanford University Press, 2006), 230.

18. Jean-Luc Nancy, *Adoration: The Deconstruction of Christianity II* (New York: Fordham University Press, 2012), 11.

19. Nancy, 'The Image: Mimesis and Methexis'.

20. Jean-Luc Nancy, 'Painting [and] Presence', in *The Birth to Presence*, trans. Brian Holmes and others (Stanford: Stanford University Press, 1993), 351.

21. Jean-Luc Nancy, 'Visitation: Of Christian Painting', in *The Ground of the Image*, trans. Jeff Fort (New York: Fordham University Press, 2005), 125.

22. Jean-Luc Nancy, 'The Technique of the Present', (lecture given during the exposition of On Kawara's works *Whole and Parts – 1964–1995*, Nouveau Musée/Institut d'art contemporain, Villeurbanne, France, January 1997, accessed 14 August 2015, http://www.egs.edu/faculty/jean-luc-nancy/articles/the-technique-of-the-present.

23. Jean-Luc Nancy, 'La Comparution/The Compearance: From the existence of "communism" to the community of "existence"', trans. Tracey B. Strong, *Political Theory* 20, no. 3 (1992): 371–98, 373–4.

24. *The Other Portrait*, not yet translated.

25. *Trop*. Jean-Luc Nancy, Rodolphe Burger, Isabelle Décarie, Louise Déry, Jean-Luc Nancy, Georges Leroux, et Ginette Michaud, CD-audio, 2006. See also Ginette Michaud, 'Outlining art: On Jean-Luc Nancy's *Trop* and *Le plaisir au dessin*', *Journal of Visual Culture* 9, no. 1 (2010): 77–90.

26. *Textual knowledge: Readings of an illegible manuscript*, untranslated (Paris: Galilée, 2001).

27. Jean-Luc Nancy, 'Ching Wu' ['Tranquil Thing/Still Life'], Natures Mortes (untranslated), cited in: Ginette Michaud, *Cosa volante: le désir des arts dans la pensée de Jean-Luc Nancy: avec trois entretiens de Jean-Luc Nancy* (Paris: Hermann, 2013), 213 [my translation].

28. Nancy, 'The Image: Mimesis and Methexis'.

29. Nancy, 'Ching Wu', 213 [my translation].

30. Nancy, 'Painting [and] Presence', 350.

31. Nancy, 'Peinture sur... A Bertrand Masse', published for the expo-

sition of the Margeurite Moreau prize, Presses de L'imprimerie Chaterrleraudaise, 2007, cited in Michaud, 212 [my translation].

32. Jean-Luc Nancy, *The Gravity of Thought*, trans. François Raffoul and Gregory Recco (New Jersey: Humanities Press, 1997), 76.

33. Jean-Luc Nancy, 'Lumière Étale', *Wir* (photographs of Anne Immele), 2003, cited in Michaud, *Cosa volante*, 228.

34. 'Nous Autres', in: Nancy, *The Ground of the Image*, 59.

35. See Peter Szendy, 'The Archi-Road Movie', *The Senses and Society* 8, no. 1 (2013): 50–61.

36. On Nancy's debate with Derrida over the consolation/desolation or, as Nancy has it, the 'solation' of film, see 'Penser à vue Jacques Derrida, lettre à Jean-Pierre Rehm', 24 June 2005, journal FIDMarseille (international festival of documentary, Marseille), 4 July 2005. Cited in Michaud, *Cosa volante*, 231.

37. 'Distinct Oscillation', in Nancy, *The Ground of the Image*, 74.

38. Jean-Luc Nancy, 'The Soun-Gui Experience', in *Multiple Arts: The Muses II*, trans. Simon Sparks (Stanford: Stanford University Press, 2006), 215.

39. Mathilde Monnier and Jean-Luc Nancy, *Allitérations: conversations sur la danse* (Paris: Galilée, 2005), 149.

40. Nancy, 'Mimesis and Methexis'.

41. 'Dance has from this point of view a particular privilege ; that is, dance exposes exposition as such. Voilà. There. There is a body which extends and throws itself [se détend et se jette]', Jean-Luc Nancy, interview, 'Entretien avec Jean-Luc Nancy', *Rue Descartes* 2, no. 44 (2004): 62–79, 66. [my translation].

42. Nancy, 'Saisons du monde', *Europe*, cited in Michaud, *Cosa volante*, 230. [my translation].

43. Nancy, Monnier, *Dehors la danse*.

44. Nancy, 'Mimesis and Methexis'.

45. From 'Cléopatre à travers l'historire de la peinture', The Museum of Art and History, Geneva 2004, exhibition catalogue.

46. 'Visitation: Of Christian Painting' in Nancy, *The Ground of the Image*, 108–25.

47. Nancy, 'Art Today', trans. Charlotte Mandell, *Journal of Visual Culture* 9, no. 1 (2010): 91–9, 92.

48. Nancy, 'Addressee: Avital', 5.

49. 'Visitation: Of Christian Painting', in: Nancy, *The Ground of the Image*, 123.

50. 'Image and Violence', in: Nancy, *The Ground of the Image*, 15–26.

51. Nancy, cited in Michaud, 244 [my translation].

52. Gérard Granel, 'Écrits logiques et politiques' (Paris: Éditions Galilée, 1990), cited in Nancy, *Birth to Presence*, 37 [my translation].

53. Rodolphe Burger, Isabelle Décarie, Louise Déry, Jean-Luc Nancy, Georges Leroux and Ginette Michaud, *TROP: Jean-Luc Nancy with François Martin and Rodolphe Burger* (Montréal: Galerie de l'UQAM, 21 October–26 November 2005), exhibition.

54. See Philip Armstrong, *Nancy and the Reticulations of the Political* (Minneapolis and London: University of Minnesota Press, 2009).

55. 'Painting and Presence', in: Nancy, *The Birth to Presence*, 342.

Cutting and Letting-Be

Martin Crowley

In a conversation with Philippe Lacoue-Labarthe published in 1992, Jean-Luc Nancy draws attention to a significant difference between himself and his close friend and long-time collaborator. Lacoue-Labarthe, says Nancy, prefers always to emphasise the paradoxical self-suspension of any figural inscription, the impossibility of the definitive accomplishment of which such figures might dream; whereas for his part, Nancy habitually points to the renewed invention operated by this same incompletion. 'You tend always', says Nancy,

> [. . .] toward an effacement of the 'figure' [. . .] whereas I feel myself continually led back to the exigency of a certain figuration, because the 'interruption' of myth does not appear to me to be a simple cessation, but a cutting movement which, in thus cutting, traces another place of articulation.[1]

If this is a significant difference, it is also, as Nancy's language suggests, a question of two complementary tendencies, twin gestures peeling away from each other in response to a common movement – incomplete and incisive, inseparable and incompatible. Incomplete: the line cannot finally enclose what it is at once enclosing (and so ending, interrupting once and for all) and exposing to an outside its cutting is indicating as such. Incisive: this cutting is nonetheless creating a determinate figure, a kind of inside, however compromised; and the exposure of this kind-of-figure to its constitutive outside both imperfectly closes its own epoch and opens the space – the time: the future – of another moment of possible figuration.

As we know, then, to trace a line is thus both to cut off, to circumscribe, to interrupt; and to open onto an inappropriable

vacancy. To delimit. By definition set right up against this vacancy, the line may also invite its contemplation, its affirmation and perhaps even its maintenance: the incision may also be a form of care for this space beyond colonisation – better, for the spacing, the rhythm of differentiation which makes possible any movement and any presence whatsoever. This chapter considers the operation within Nancy's thought of just these two tendencies: the delineation of forms (here called *cutting*, despite and because of Nancy's ambivalence towards this term, as will be discussed) and the affirmation of the movement of presentation (which will here bear the Heideggerian name *letting-be*). As we have just seen, these tendencies are of course in a relation not of opposition, but of composition: affirmation is in part opened by the active production of forms, precisely in order to affirm the coming-to-presence of any form whatsoever; what matters for Nancy is that this production should understand and offer itself not as a gathering of meaning (the myth of definitive accomplishment), but as an opening to the possibility of any meaningfulness at all, or what Nancy habitually terms sense [*sens*]. After an initial sketch of some of those aspects of Nancy's thinking which are especially relevant here, I will briefly consider his approach to these questions in terms of the question of presentation, as a way finally of opening up some thoughts on the stakes of his approach: the limitations and necessity of this composition of incision and affirmation.

From cutting to spacing

To begin with, let us consider the sort of cutting found in Nancy's essay 'L'Image – le distinct'.[2] Here, he explains that the image is characterised by a movement of simultaneous *décollement* and *découpage*: carried forward away from a background which, thereby constituted as background, falls back while continuing to press invisibly on it, the image is also delineated from what surrounds it, demarcated by its borders, distinguished. The image for Nancy is always at a distance, no matter how close; in Benjaminian terms, we might say that it is always to some extent auratic, however produced and reproduced, however grasped, spoiled, brought near and brought low – always something else, and never just any old thing. 'The image is a thing that is not the thing', Nancy writes: 'it distinguishes itself from it, essentially.'[3] It comes to me, the image, right here, of course, brushing up against

me, 'à fleur de peau'; but it does so with a kind of concentrated intimacy, bound up with itself, offering itself 'in an opening that indissociably forms its presence and its separation [écart]'', bringing its distance with it.[4] The boundary of the image is a kind of heat haze shimmer for Nancy: the border already shares in the force of the image it encloses, this force spilling over to draw in the frame supposed to contain it.

> If it is possible for the same line, the same distinction, to separate and to communicate or connect (communicating also separation itself . . .), that is because the traits and lines of the image (its outline, its form) are themselves (something from) its intimate force . . .[5]

Yet meanwhile, shimmering, this absorbed boundary continues to set the image apart, marking the force carrying it off into the distance from which and with which it touches me. Right here, before my very eyes: the image is cut off.

And, as we know, this cut also opens – right here – the space, the spacing, of an inappropriable vacancy, the rhythm of differentiation thanks to which there is any thing at all, 'the reality of difference – and différance – that is necessary in order for *something and some things* and not merely the identity of a pure inherence', says Nancy in *The Sense of the World*.[6] Writing on poetry, this opening is what Nancy evokes in referring to 'silence as an exact cut across the horizon of language', in affirming that 'Poetry could be said to give in language an account of what [. . .] acts as the margin and cut of language':[7] the exposure of forms, figures, lines (including lines of poetry) to 'something akin to "rhythm", "cadence", "caesura", or "syncope" ("spacing", "pulsating")'[8] – an exposure which these forms, figures, lines also operate.[9] If this operation is recursive, a kind of re-opening, this is because the world is already open to this dimension; or rather, this opening is what we call the world, exposure to the differential possibility of sense [*sens*], as to the primary relationality already there as the unfigurable ground of the sum of innerworldly things: to spacing. According to Nancy, then, 'that is what is at stake in art, that raising of forms that give a possibility of world': 'I would say that art is there every time to open the world, to open the world to itself, to its possibility of world.'[10][11] Image, figure, gesture, line, and so on thus retrace the multiple openings of the world, sketch the movement Alighiero Boetti called *mettere al mondo il mondo*:

bringing the world (as this exposure) into the world (as the total-ity of actually existing beings); and so affirming the births of the world, not as offspring but as pure unpredictability. The brilliance of Boetti's pieces bearing this title – in which sheets of paper covered in scribbled blue biro are punctuated by so many small blanks, and come to appear, from only a few feet away, as gor-geous evocations of the night sky – lies in the relation they propose between the banality of their medium and the sumptuousness of the imagery they imply, scribbled tapestries depicting the starry heavens above. No stars, just gaps: Boetti affirms the opening of the world to the universe – the openness that is the world – in the dynamic between those small intervals which texture the surface of the everyday, and the determinate figures or gestures (here, the thousands upon thousands of lines of ink) which edge them about, and by which they are opened and preserved.

Invoking the wonder of an extra-worldly dimension, Boetti implies that this wonder is nowhere other than here, in our everyday world as the opening that makes it possible. And so it is that the cut – here, a mass of scribbles – both maintains the spacing that gives its line a chance, and suggests a relation of won-derment, or adoration, to this spacing. That this suggestion takes the form of so many Mallarméan blanks – so many fallen stars: just intervals, where we might have dreamt a cosmos – reminds us, further, that this spacing, or this opening is not available for rep-resentation: is in the world as the blind spot that is its condition of possibility; or, as a Heideggerian language would say, as 'nothing'. The line of figuration articulates a relation to the fact and the conditions of existence; but these are nowhere given, are not: we exist exposed to them not as to anything ungraspable or ineffable, but something simply non-existent. As to no thing. Nancy accord-ingly develops Heidegger's account in *Being and Time* and 'What is Metaphysics?' of the nothing, which, for Heidegger, 'makes possible the openedness of beings as such': in Nancy's terms, the spacing which makes possible any coming-to-presence whatsoever is the no-thing whose non-existence provides the rhythm of the existence of all things.[12] Mining the etymology of the French term *rien*, Nancy uses this term to highlight the line between beings, in all their random multiplicity, and the fact of existence: *rien* marks the opening of the various things that there are to the fact of this unpredictable world. First: the French *rien* derives from the Latin *res*, 'thing': with the consequence that for Nancy, *rien* names the

thing simply as thing, as any thing, any old thing, tending towards a degree zero of being. (A sense preserved in the French 'un petit rien', for example; and glimpsed in the English 'sweet nothings'.) Secondly: if we now add in the fact that being, or the fact of existence, or the possibility of meaningfulness, or 'the world' as primary relationality, *is* not within the world of experience (is within this world as not within it, as its constitutive intervals), we get the other side of *rien*: the 'nothing' that in Heidegger names the world as such, the open that *is* not, but in which anything that is, is. As the thing withdraws asymptotically towards its most nondescript being, this movement re-marks the fact of this being; and *rien* is Nancy's name for the line along which this movement is traced. *Rien*, we might say, is the point of existence; as Nancy glosses it, the thing itself as the fact that there is a world, or several worlds, and some thing, or some things, and us, all of us who exist (to be defined as widely as possible). The point of existence – or the line drawn by any old thing.[13]

This is the play of the line of figuration, of configuration, of the finite forms we make and re-make to elaborate our opening towards sense. The line cuts the figure off from its surroundings, then (separates the image from the thing, say; makes the image not just any old thing), but only to declare that this distinction is already that of the thing, of any old thing, inasmuch as any old thing is also 'the intensity of a concentration of world',[14] already an intimacy opaquely irreducible to our instrumental appropriations. The concentration and the opening of a world, which each and any figuration may be said to draw out.[15] To draw, that is, as outside the work; as that outside with which the work is necessarily in relation, but which it cannot inscribe. The work can, however (cannot not, in fact) inscribe this relation: this is the gesture Nancy terms 'exscription', in which any determinate mark is exposed to its constitutive outside, opens to the spacing of primary relationality and meaningfulness as such. Accordingly: 'never is a work of art made for itself, on the contrary its being as work, its character as work always consists of pointing outside the work'.[16] Nancy distinguishes this outside from two possible misunderstandings. It is not the location of the referent of a signification; and nor is it to be thought of as the unspeakable, the unrepresentable. As he puts it when defining exscription in *Une Pensée finie*, this 'outside', exscribed within the mark, is rather the sense which makes meaningful existence possible inasmuch as it is not. Any mark re-marks

sense in this way: being (which Nancy here describes as 'unemployable, inexploitable, unintelligible, ungroundable') is presented through exscription.[17]

So the lines that we draw in the forms that we make, whatever they might be, mark and re-mark the edge of nothing. The specificity of each form, of each gesture, of each intervention and each institution consists in the distinct idiom through which it exscribes the spacing which makes it possible. In the operation of forms, the opening of the world is in play, and replayed, each time differently; each time as nothing, nothing that could be the object of a representation, or the ground or goal of a job of work; but towards which the *any old thing* of this work, this image, this building, this gesture, is charged with opening. All of our works are defined for Nancy by this relation to something non-existent: what in *L'Adoration*, with a nod to Lacoue-Labarthe, he calls 'mimesis sans modèle' (mimesis without model).[18] A figure without figure, then: not the representation of some mythical determinate substance, but just that careful determinate form needed to affirm and maintain the relation to spacing.

Letting, spacing

One imperative here (to the extent that we can formulate one) might be: 'Do something!', 'Do anything!, any old thing: 'Fais n'importe quoi', in the phrase Thierry de Duve, contemplating Duchamp's readymades, gives as the law of modernity. If there is an imperative, it is that of creation, or invention: to act *ex nihilo*, in the absence of rules.[19] Any old thing, but not any old how, as Nancy points out:[20] maintaining an opening towards spacing means drawing out, carefully, the line between the *petit rien* and *la chose même*, along which what there is opens towards the fact of existence. Socially, existentially, creatively. *Fais n'importe quoi*: this careful drawing out is an action, an intervention, an invention, a new incision. But not a grasping, not an appropriation: in Heidegger's terms, it is a boundary, an outline, which is at once a 'fixing in place' and a 'letting happen' – the cut as a way of letting be.[21] Heidegger's motif of letting be (*sein lassen*), deploys *lassen* with a nice eye to its ambiguity, between *acquiescing/allowing* – 'letting be' in the sense of 'leaving alone', not interfering with – and *enabling/effecting* – 'letting be' in the sense of 'having be', as in 'let there be light'.[22] If *Dasein* 'lets entities be', this is anything

but indifference, or disengagement: in Heidegger's conception, it is an active relation through which these entities are freed to be what they are, and freed to be as such. Nor, however, is this a forceful act of production or determination: the entities in question are not brought into being by this relation, rather they are allowed – again, with that nice blend of intervention and non-intervention – to come into their way of being. In the extended account of this in 'On the Essence of Truth' (which develops the version in *Being and Time*, broadening that earlier perspective beyond beings at hand to encompass all sorts of being), Heidegger writes:

> To let be – that is, to let beings be as the beings which they are – means to engage oneself with the open region and its openness into which every being comes to stand, bringing that openness, as it were, along with itself. [. . .] To engage oneself with the disclosedness of beings is not to lose oneself in them; rather, such engagement withdraws in the face of beings in order that they might reveal themselves with respect to what and how they are, and in order than presentative correspondence might take its standard form from them.[23]

Reading Heidegger (along with Lacoue-Labarthe and Nancy) as responding to the Kantian problematic of presentation (that is, the question of the relation between finite material entities and the ideas of reason, which we might also consider as the fact that things appear within a space of potential meaningfulness), Alison Ross thus writes that, for Heidegger, 'before entities are "present" there is a relation to the entity as such which discloses its taking place with and alongside us, and a relation to this relation that frames how "we" and "things" belong together'.[24] In this sense, letting-be can be thought of as a relation to these relations of presentation which is careful enough to allow entities to come to presence – which can itself be an active process, such as when a sculptor discloses the form that was there in the marble all along – without appropriating this coming-to-presence as its own achievement. As Krzysztof Ziarek writes: 'One has to remember that the German term *lassen* has the force of making or getting something done but it is the force that, in Heidegger, unfolds without manipulating, fabricating, or ordering: otherwise than power'.[25]

Ross situates Heidegger, Lacoue-Labarthe, and Nancy as thinkers committed to the generalisation of Kant's treatment of relations of presentation in his account in the *Critique of Judgement*

of aesthetic judgement, in which 'it is in fact a certain perspective on relation to objects that aesthetic judgement establishes'.[26] Independent of practical and cognitive interests, an aesthetic judgement can attend to 'significant features of these objects that would not otherwise be captured'.[27] Particularly significant for Kant is the way in which instances of natural beauty, judged solely according to criteria of taste, can present the idea of freedom thanks to their independence, when judged in this manner, from any determinate purpose or conceptual framing. The crucial element here is that it is the aesthetic judgement that makes this presentation possible: the significant features in question are cap-tured when the relevant objects are looked at in a certain way. This is what Ross, discussing Heidegger, terms a 'reflective rela-tion to relations of presentation':[28] an aesthetic attitude which makes it possible to consider the way in which specific entities come to presence in a specific context. Not to be confused with the classical phenomenological intensification of the perception of particular objects, this is an attention to the way in which these objects appear: a 'relation to relations of presentation'. For Ross, 'Nancy's ontological project identifies in the arts the occasion of a "presentation of meaning"': 'It is in the arts, Nancy believes, that this presentation is staged because it is here that the genesis of meaning as a "coming-to-presence" rather than as a relation to a "present thing" is established'.[29] The independence of Kant's judgement of taste may still be detected in the background here: regardless of any interested relation to 'present things', the arts in this sense enact an attention to the way in which things (these things, each time a singular movement: a shovel, these notes, a circle drawn freehand . . .) come to presence. As Nancy puts it in *Les Muses*, in the arts, we encounter 'the presentation of presenta-tion' [. . .] the 'plural presentation of the singular plural of presen-tation'.[30] Or as he writes in *Une Pensée finie*:

> The issue of 'simulation' changes completely if mimesis becomes the concept, not of any representation, but of a presentation of that which does not have to be presented, of what could not be completed, neither Nature nor Idea, which is to say, finitude itself, insofar as it is a coming to presence without presence (and with secrecy).[31]

Moving rather quickly, we might say that in the arts, Nancy finds the presentation of a relation to presentation we could call a

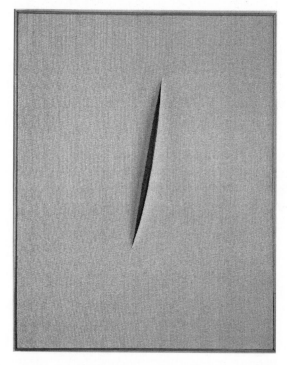

Figure 1.1 Lucio Fontana, *Spatial Concept 'Waiting'*,
1960 © Tate, London 2015.

'letting-be', inasmuch as it entails an attentive relation to the way
in which entities come to presence. But whereas for Heidegger it is
a matter of 'letting beings be' – of a mode of active relation, which
sets entities free to be what they are and to be as such – for Nancy
it is more a matter of letting be the coming-to-presence itself. It
is in this sense that the movement of a determinate form affirms
and maintains the relation to spacing: exscribing this spacing as its
constitutive outside, the form (line, figure: the cut) both indicates
the constitutive role of this spacing and denounces the fantasy of
colonising this immanent exteriority. Lets it be, that is, in the twin
senses of having it come forward as what it is (which is to say: as
always withdrawn), and leaving it alone: opening and maintaining
a non-appropriative relation to the spacing thanks to which there
are any forms, figures or lines at all.

 In some cases, the denunciation of colonisation entailed in this
gesture may occur not so much thanks to the gesture as despite
itself: the figure in question might be doing everything in its

power to enact and encourage a violent, grasping relation to the outside. The careful cut, on the other hand, both indicates the fact of spacing and enacts a non-appropriative relation to this spacing. If it is by definition impossible to appropriate the fact of spacing (which has already made possible any attempted appropriation), it is wholly possible to imagine that we can: the careful cut enacts a relation to spacing, which undercuts the arrogance of this fantasy.[32] We can find both tendencies at work in the series of pieces by Lucio Fontana known as the 'Tagli'. Fontana slashes his canvasses to show us – nothing! Not a mystical nothing which would exist, ominously or gloriously, somewhere else, its power shaming our finitude, reducing us to less than nothing; but the fact that there is nothing anywhere else, there is nothing behind the canvas – there is what there is, and nothing more. That there is what there is, 'and not nothing', as Heidegger puts it:[33] the cut is the line traced by any old thing, between its existence and the fact and spaced rhythm of this existence, those no-things. The dubious gendered violence of Fontana's gesture has at least the merit of suggesting this: that no violence, no heroism of the gesture, no rupture is necessary here. No concealment and no revelation: every line, or gesture, exscribes its constitutive spacing; and any old line, or gesture, will do. 'No rupture' does not mean no disruption, however: it means no fantasy of breaking through, taking off, crossing the line, grasping, colonising, penetrating, or actualising some 'other' space. Any old line will do, then, as long as we attend to it. (And 'we', for Nancy, names precisely this attention.[34]) As Fontana demonstrated – this is the wit of his gesture, which also pulls against its melodrama – we do not have to puncture a veil of appearance to access an invisible truth: there are no appearances, as Lacoue-Labarthe insists, just appearings, and this truth – the simple fact and rhythm of existence – is already here, invisible and inaccessible on this very surface, or the other surface behind it, or the wall behind that, or the street outside.[35] No secret. Any old line will do, as it retraces the exposure of any old thing to the spacing thanks to which there is any thing at all, as well as the possible meaningfulness of the things that are. The gesture that knows itself as exscription, however – the careful cut – opens and maintains an attentive relation to this spacing, lets it be, in the duly qualified sense we saw above. And crucially, the attentive opening towards spacing has to be maintained: the task of the careful work (the figure, the form, the line) is to keep keen the nondescript edge

of nothing, as what Nancy calls 'le mordant du sens': 'the cutting edge of sense'.[36]

Doing nothing

Although he does, as here and as we saw above, use the language of 'cutting' (or literally, in this example, 'biting'), Nancy is often to say the least ambivalent about its metaphorics, concerned – rightly – about its complicity with the fantasy of penetration, its bloody metaphysical opposition of inside and outside, the outside as an envelope to be punctured, the inside as an obscure repository of deep truth. Discussing Bataille, for example, he says that, although he shares Bataille's insistence on the constitutive place of separation – 'the gap' – in any account of communication, 'What I don't share absolutely with Bataille is the way he goes from that gap to the cut and then slowly to the sacrifice' (since the economy of sacrifice reintroduces that metaphysics, abasing a present materiality in the name of a truth located somewhere else). It is to refuse this slippage, Nancy says, that he prefers the language of touching: 'That is the distance in the approach, but it avoids all questions of cutting, sacrifice etc.'. And crucially, he wants in this gesture to reject the dominant gendering of that sacrificial economy of the cut (which we approached above via Fontana):

> I disagree as well with Bataille who is always presenting the sex of the woman as a wound, because it implies that there is some penetration into the flesh. Sex doesn't cut the body any more than the mouth or the anus, or any bodily orifice cuts the body. It is an opening, which is something different.[37]

Against the cut and its abusive dream of penetration, the inappropriable, irreducible distances of the touch, the fold, the body as torus, all surface, all outside, all inside.

If the maintenance of this opening is a generalised imperative, it is always locally inflected: in the idioms of specific works, and also the terms of specific worlds. In Ross's terms (and following here Heidegger), 'relations of presentation' vary historically; and art places us in a 'reflective relation to the *prevailing* relations of presentation'.[38] As Nancy says: 'Art, then, makes us feel. What? A certain formation of the contemporary world, a certain shaping, a certain perception of self in the world.'[39] It is for this reason

that, despite Nancy's dislike of the language of the cut, I want to maintain it here. Despite this dislike, but also in a sense because of it: the unacceptable violence which the language of the cut cannot but evoke, keeps any discussion of figure, line, image or form stuck to the always ethical, sometimes political claims of '*prevailing* relations of presentation', 'a certain formation of the contemporary world'. As determinate movement, the cut negotiates between the conventions of its site (quite possibly by revising or rejecting them, in the conventional gesture of the avant-garde) and the spacing beyond. This opening of the contingent onto the beyond which is its unpresentable rhythm takes us to the situatedness of the cut: the gesture of exscription always takes place here. And so the figure of the careful cut is shadowed, as I write this, by the cut as violation: in our prevailing idioms, by the ineradicable senses of cutting as both the agony of self-harm and the disfigurement of street violence. An unbearable existence or an intoxicating rivalry can both cry out to be reduced to the red line of this blade, whose cut can briefly and horribly hide the horror of the relations we can never escape. The language of the cut recommends itself, in this sense, lest our thinking of our figures forget the weight of their idioms.

The careful cut and the tender touch are situated historically on a continuum with the fantasy of penetration and the horror of violation.[40] As Nancy writes in his piece on Claire Denis's *Trouble Every Day*, 'The truth of a body appears in its dismembering, in its tearing apart, when the blood bursts out of the skin: the skin, instead of an envelope, becomes a surface to break. The mutilated body reveals its interiority, its depth, the secret of its life. Unity is given only to be broken, releasing the infinitely fragile secret.'[41] The desire to cut through everything superficial and reach this revelation is immense; this is the far point of the spectrum of touch, and it is also what is desired in the frenzy of desire: 'The fury wants this secret that is nothing other and that contains nothing other than the tearing apart of the integrity of life. This tearing apart is death, but it is also desire: it is the troubling and tricky proximity of the two.'[42] Access at last to the hidden truth is overwhelmingly tempting, but inevitably self-defeating: even access depends on spacing, and vanishes when it culminates in the dream of fusion. Thus: 'such an access, can but lead to fury: to an exasperation that destroys the skin. In truth, touch desires to destroy, and is destroyed by this desire.'[43] This fury has its truth: it is true that

'the truth of a body' is not to be found on its skin. Accordingly, 'What this fury is after is the truth of a body in so far as it is made up of that which exceeds its enclosing.'[44] But this truth is not to be found beneath the skin, either: the truth of a body is exposure, relationality, spacing – nothing, and nowhere to be found.

Which does nothing to stop this fury, of course: that a body has no inside, is defined as exposed and irremediably open, can on the contrary exacerbate the ultimately murderous desire to find this missing truth (as staged in any number of films, perhaps most unsettlingly in Michael Powell's *Peeping Tom*): 'A body never "penetrates" the opening of another body *except in killing it*', writes Nancy in *Corpus*.[45] And let us not pretend that the arts play any kind of effective role in teaching us this: the invitation to a 'reflective relation to the prevailing relations of presentation' – such as the persistently gendered economy of this murderous desire, which we touched on with Fontana, above – is not justified by an instructive function in this sense. In Nancy's understanding, if there is a connection between art and violence, this connection offers not education but presentation. The 'violence' of art has to do for Nancy with its presentation of the unrepresentable fact of presentation, its imposition of an encounter with the real, with the structure of our relation to existence, with spacing. He writes: 'The violence of art differs from that of blows, not because art is semblance, but, on the contrary, because art touches the real – which is groundless and bottomless while the blow is in itself and in the moment its own ground.'[46] Art thus brings its own kind of revelation, which can only disappoint the fantasy of definitive violation:

> Violence without violence consists in the revelation's not taking place, its remaining imminent. Or rather it is the revelation of this: that there is nothing to reveal. . . . [Art] is the exact knowledge of this: that there is nothing to reveal, not even an abyss, and that the groundless is not the chasm of a conflagration, but imminence infinitely suspended over itself.[47]

Against the violating cut, the careful cut – the line, the figure, the gesture without revelation – seeks to let be. And since letting-be requires action, the cut remains necessary; which leaves the just cut necessarily shadowed by the actual violence which declares the stakes of its commitment to existence as exposure to spacing.

Shadowed by this, tracked by it, bound to it, attentively, and with care. As Nancy writes in *The Ground of the Image*: 'There is something good and something bad in both violence and the image. There is something necessary and something unnecessary.'[48] 'Knowing how to discern a groundless image from an image that is nothing but a blow is an entire art in itself (c'est tout un art, as one says in French); way before or way beyond any aesthetics, this is the responsibility of art in general.'[49] Letting-be can also mean: taking care of the wound, or indeed drawing a line to prevent its infliction.

Marc Grün's documentary film *Le Corps du philosophe* (2003) shows, amongst other things, Nancy chopping wood and swimming. Active in both cases; but incisively in the first, and contemplatively in the second.[50] Apart from the different dispositions of the philosopher's body, Grün thus also poses the question: what might be the relation between these two modes? As we have seen, letting-be requires a cut. And letting-be is not passivity or indifference, but an active, perhaps incisive stance of care. We cannot let spacing be: it is thanks to spacing that there is any thing at all, including any gesture we might make. But Nancy seeks to instil an awareness that the justice of our gestures might be considered in terms of their attentiveness towards this rhythm of differentiation, which defines any gesture as opened, in excess of its guiding intention, to the spacing beyond.[51] And this means all our gestures, from the tracing of a line, to the building of a cathedral, to the formation of a vanguard. Nancy's insistent exscription of the spacing of existence does not resolve, therefore, to what Benjamin Noys, critiquing his thought, calls 'the aesthete's unemployment':[52] this spacing is no less actual for being non-existent, and our opening towards it has to be made, and re-made. As Ziarek writes in relation to Heidegger: 'This letting, while not entirely at human disposition or will, needs to be worked on.'[53] And as Nancy puts it (with reference to poetry):

> Presentation must be made; sense must be made, and perfected. This does not mean: produced, operated, realised, created, enacted, or engendered. It means none of all that, exactly; at least nothing that is not, before all else, what *making* wants to say: what *making* makes language do, when it perfects it in its being, which is the access to sense. When saying is making, and making saying, in the same way that one says 'making love', which is making nothing, but making an access be. Making or letting: simply posing, deposing exactly.[54]

Unworking does not simply reduce to idleness, the *dolce far niente*. As even this expression tells us, the *rien* is a *rien à faire*, nothing to do: the nothing that is spacing cannot be made, but any old thing makes towards it – and the line, the figure, the gesture draw out this trajectory, more or less justly. The quasi-mystical resonances of this language of an asymptotic approach towards 'nothing' will not be to all tastes, and understandably so. But if Nancy's ontological commitment is sometimes thought to equate to a kind of quietism, incapable of thinking the radically new or disruptive, I would argue on the contrary that he both appreciates the reality and necessity of the cut, and offers a way of approaching the question of its justice.

Notes

1. Philippe Lacoue-Labarthe and Jean-Luc Nancy, 'Scène', *Nouvelle revue de psychanalyse*, 17 (1992), 73–98 (74); cited in Simon Sparks, 'Editor's Introduction: *Politica ficta*', in Lacoue-Labarthe and Jean-Luc Nancy, *Retreating the Political* (London: Routledge, 1997), xiv–xxviii (xxii).

2. On this, see the essential account given in Ian James, 'Seeing and Touching: Jean-Luc Nancy and the Ground of the Image', *Modern French Visual Theory: A Critical Reader*, ed. Nigel Saint and Andy Stafford (Manchester: Manchester University Press, 2013), 201–18.

3. Jean-Luc Nancy, *The Ground of the Image*, trans. Jeff Fort (New York: Fordham University Press, 2005), 2. 'L'image est une chose qui n'est pas la chose' . . . 'essentiellement, elle s'en distingue' Nancy, *Au Fond des images*, 13.

4. Nancy, *Ground of the Image*, 3.

5. Nancy, *The Ground of the Image*, 5. Nancy, *Au Fond des images*, 18: 'S'il est possible que le même trait, la même distinction, sépare et fasse communiquer (communiquant ainsi la séparation elle-même . . .), c'est que le trait de l'image (son tracé, sa forme) est lui-même (quelque chose de) sa force intime.'

6. Jean-Luc Nancy, *The Sense of the World*, trans. Jeffrey S. Librett (Minneapolis: Minnesota University Press, 1997), 57–8. Jean-Luc Nancy, *Le Sens du monde* (Paris: Galilée, 1993), 96: 'Réalité de la différence – et de la différance – par laquelle seulement *il y a quelque(s) chose(s)* et non pas seulement l'identité d'une pure inhérence'.

7. Jean-Luc Nancy, *Multiple Arts: The Muses II*, trans. Simon Sparks (Stanford: Stanford University Press, 2006), 20.

8. Nancy, *Multiple Arts*, 17.

9. I thank Ian James for these references.

10. On this connection between art and world in Nancy, see Ginette Michaud's indispensable 'Outlining Art: On Jean-Luc Nancy's *Trop* and *Le Plaisir au dessin*', *Journal of Visual Culture*, 9:1 (2010), 77–90.

11. Jean-Luc Nancy, 'Art Today', trans. Charlotte Mandell, *Journal of Visual Culture* 9, no. 91 (2010): 93.

12. Martin Heidegger, 'What Is Metaphysics?', in *Basic Writings*, ed. David Farrell Krell (London: Routledge, 1999), 89–110 (104).

13. This interpretation of the *rien* may be found in different places throughout Nancy's writings; for the most detailed exposition, see *La Création du monde, ou la mondialisation* (Paris: Galilée, 2002), 159–60.

14. Nancy, *Ground of the Image*, 10.

15. Confirming perhaps its usefulness for thinking here, a variation on this pun is made by Michaud (81).

16. Nancy, 'Art Today', 98.

17. Nancy, *Une Pensée finie* (Paris: Galilée, 1990), 61–2.

18. Nancy, *L'Adoration* (Paris: Galilée, 2010), 127.

19. See Thierry de Duve, *Au Nom de l'art* (Paris: Minuit, 1989); cited in Jean-Luc Nancy, *Les Muses*, édition revue et augmentée (Paris: Galilée, 2001), 49, 158.

20. Nancy, *Les Muses* (Paris: Galilée, 2001), 184.

21. Martin Heidegger, 'The Origin of the Work of Art', in *Basic Writings*, 139–212 (208).

22. This brief exposition draws on the fuller and more expert account in John Haugeland, 'Letting Be', in Steven Cromwell and Jeff Malpas (eds), *Transcendental Heidegger* (Stanford: Stanford University Press, 2007), 93–103.

23. Martin Heidegger, 'On the Essence of Truth', in *Basic Writings*, 111–38 (125). For a discussion of this passage in the context of an illuminating introduction to the development of Heidegger's thinking of the will, see Bret W. Davis, *Heidegger and the Will: On the Way to 'Gelassenheit'* (Evanston: Northwestern University Press, 2007), xxvii. For Heidegger's earlier account of 'letting-be', see *Being and Time*, section 18.

24. Alison Ross, *The Aesthetic Paths of Philosophy: Presentation in Kant, Heidegger, Lacoue-Labarthe and Nancy* (Stanford: Stanford University Press, 2007), 72.

25. Ziarek, Krzysztof, 'Art, Power, and Politics: Heidegger on

Machenschaft and Poiêsis', *The University of Sydney*, accessed 13 January 2015, http://sydney.edu.au/contretemps/3July2002/ziarek. pdf.

26. Ibid., 15.

27. Ibid., 16.

28. Ibid., 95.

29. Ibid., 10.

30. Nancy, *The Muses*, 34.

31. Jean-Luc Nancy, *A Finite Thinking*, ed. Simon Sparks (Stanford: Stanford University Press, 2003), 23. Jean-Luc Nancy, *Une Pensée finie* (Paris: Galilée, 1990), 43: 'Toute affaire de "simulation" change du tout au tout si la *mimesis* devient le concept d'aucune représentation, mais d'une présentation *de ce qui n'a pas à être présenté*, de ce qui ne saurait être achevé, complété, ni Nature, ni Idée, c'est-à-dire de la finitude elle-même, en tant qu'elle est venue *à* la présence, elle-même sans présence (et sans secret).'

32. What I am here calling the careful cut may in this respect be compared to what in *L'Évidence du film* Nancy calls 'le juste regard' ('a rightful look') (which itself can be entailed in the *cutting out* of an image by a frame). See Jean-Luc Nancy, *L'Évidence du film: Abbas Kiarostami/The Evidence of Film: Abbas Kiarostami* (Brussels: Yves Gevaert, 2001), esp. 39/38; and on this, Ian James, 'The Evidence of the Image', *L'Esprit Créateur*, 47:3 (2007), 68–79.

33. Heidegger, 'What is Metaphysics?', 103.

34. See Nancy, *L'Adoration*, 10.

35. Philippe Lacoue-Labarthe, *Préface à 'La Disparition'* (Paris: Christian Bourgois, 2009), 46.

36. *Hegel: L'inquiétude du négatif* (Paris: Hachette, 1997), 10.

37. *Love and Community: A round-table discussion with Jean Luc Nancy, Avital Ronell and Wolfgang Schirmacher, August 2001*, podcast video, European Graduate School, accessed 21 February 2015. http://www.egs.edu/faculty/jean-luc-nancy/articles/love-and-community/.

38. Ross, *Aesthetic Paths*, 108; my emphasis.

39. Nancy, 'Art Today', 92.

40. We might perhaps compare what Heidegger writes in 'On the Essence of Truth': 'because truth is in essence freedom, historical man can, in letting beings be, also *not* let beings be the beings which they are and as they are. Then beings are covered up and distorted. Semblance comes to power.' ('On the Essence of Truth', 127.) 'Semblance comes to power': the violent metaphysics of outside/inside installs its sacrificial economy.

41. Nancy, 'Icon of Fury: Claire Denis's Trouble Every Day,' Film-Philosophy 12, no. 1 (2008):1–9. On this essay, see especially Douglas Morrey, 'Open Wounds: Body and Image in Jean-Luc Nancy and Claire Denis', Film-Philosophy, 12:1 (2008), 10–30, http://www.film-philosophy.com/2008v12n1/morrey2.pdf accessed 21 February 2015.

42. Nancy, 'Icon of Fury', 7.

43. Ibid., 3.

44. Ibid., 8.

45. Nancy, Corpus, trans. Richard A. Rand (New York: Fordham University Press, 2008), 27; also quoted in Morrey, 16.

46. Nancy, The Ground of the Image, 25. Nancy, Au Fond des images, 54: 'La violence de l'art diffère de celle des coups, non pas en ce que l'art resterait dans le semblant, mais au contraire en ce que l'art touche au réel – qui est sans fond – tandis que le coup est à lui-même et dans l'instant son propre fond.'

47. Nancy, The Ground of the Image, 26. Nancy, Au Fond des images, 56: 'La violence sans violence, c'est que la révélation n'ait pas lieu, et reste imminente. Ou bien : elle est révélation de ce qu'il n'y a rien à révéler. [. . . L'art] est le savoir exact de ce qu'il n'y a rien à révéler, pas même un abîme, et que le sans-fond n'est pas le gouffre d'une conflagration, mais l'imminence infiniment suspendue sur soi.'

48. Nancy, The Ground of the Image, 15. Nancy, Au Fond des images, 36: 'de l'image et de la violence, en effet, il y a de la bonne et de la mauvaise. Il y en a qu'il faut, et il y en a qu'il ne faut pas.'

49. Nancy, The Ground of the Image, 25. Nancy, Au Fond des images, 54: 'c'est encore tout un art, comme on dit en français, c'est la responsabilité de l'art en général, très en deça ou très au-delà de toute esthétique, que de savoir discerner entre une image qui est sans fond et une image qui n'est qu'un coup.'

50. I thank Adrienne Janus for this reference.

51. See Nancy, 'Art Today', 97; and on this, Michaud, 80.

52. Benjamin Noys, The Persistence of the Negative: A Critique of Contemporary Continental Theory (Edinburgh: Edinburgh University Press, 2010), 40.

53. Ziarek, 182.

54. Nancy, Multiple Arts, 8.

2

Dancing Equality:
Image, Imitation and Participation[1]
Christopher Watkin

This chapter wagers that dance holds a singular, irreducible place in Nancy's work, that it cannot be reduced to thought about dance, and that it provides a way to understanding Nancy's approach to visual culture in general, to equality, and to the circulation of sense in terms of what he calls singular plural being. The chapter takes its starting point from Nancy's discussions of dance in the as yet untranslated *Allitérations*, a series of email exchanges from 2003 and 2004 followed by transcriptions of face-to-face exchanges between Nancy and choreographer Mathilde Monnier loosely addressing the question of the relation between philosophy and dance, and a conversation between Nancy, Monnier and film-maker Claire Denis.[2] In the first half of the book Nancy raises two questions, each presenting a pair of seemingly irreconcilable demands: 1. How can we understand dance as something open to everyone while retaining the privilege of professional expertise? 2. How can we understand dance in a way that maintains its uniqueness, not reducing it to an example of thought or a vehicle for thought, and yet still allowing for a relation between dance and thought?[3] Both questions invite us to think the privilege of dance together with its openness; its singularity together with its plurality. As Nancy and Monnier grapple with these seemingly contradictory demands in *Allitérations*, their conversation opens up onto a fresh way to think political equality, and a different way to understand – or 'catch', a much more suitable term that I shall introduce later in this chapter – the sense of the world. It is by taking a detour via 'The Image: Mimesis and Methexis'[4] that we can also see how Nancy's approach to dance can open to a new way of engaging with visual culture in general.

The point in this chapter is not simply to use dance as an example or illustration that helps us better to understand Nancy's

approach to visual culture or the Nancean singular plural or his notion of 'sense', for in considering dance in terms of art, singular plurality and sense, we shall also be drawn to reassess sense, art and the singular plural in terms of dance. My aim is to show – or to 'throw forward', as I shall prefer in the closing paragraphs of this chapter – the singular contribution of dance itself to the Nancean project, of dance as dance and not as thought *about* dance, not as an 'example' or 'illustration' of his wider project, nor as a 'translation' of his thought. If our investigation is to follow the pattern of Nancy's own approach we shall find that dance is not merely illustrative of – and reducible to – philosophical concerns and themes, but that it stages the difficulty of the relation between incommensurables in a way that cannot be exhaustively reduced to philosophical language, or to language per se. Dance does not merely provide Nancy with a site for thinking about singularity and plurality, but it challenges the relation of singular plurality to 'thought' itself, and so reflects back on, and inflects differently, his project as a whole.

The double demand of dance

In the first half of *Allitérations* Nancy sketches the problem faced by the arts today in terms of a double truth and a double demand. Art has always been destined for a social purpose, he suggests, but today we face the new demand that its 'provenance, execution and scope' should be 'immediately collective and communal'.[5] Art should be accessible to all not only in its consumption but also in its production; it should be 'made by everyone' and should not be elitist. However, this democratisation of art must sit alongside another truth, a demand that, according to Nancy, is incontestable but difficult to espouse in public: art requires individuality, singularity, difference without reciprocity, and even isolation and secrecy.[6] Taking these two demands together, art must be both plural and singular, egalitarian and privileged: open to be made and consumed by everyone, and born of the uncommon vision, skill or experience of the artist.[7] Nancy insists that neither of these truths is to be dismissed: 'We would like to be able to call ourselves "all artists", because we know there is truth in that. But we know that another truth, equally necessary, announces itself with a "No, only certain people".'[8]

As Nancy notes, this double demand for singularity and plurality in art has implications far beyond the art world, for 'we have

here, I think, an aspect of our general difficulty with equality and democracy'.[9] In terms of these political stakes, the double truth of equality and privilege is expressed in terms of plurality and singularity. Just as it is true that we are all artists, it is true that we are all equal, and just as 'no, only certain people' are artists, it is also the case that some are more gifted, more able in certain areas than others. To find a way of doing full justice to both of these demands together is far from straightforward.

Dance, spacing and equality

In seeking to explore the twin but seemingly contradictory demands of art, Nancy reimagines equality in terms of dance, and dance in terms of the conjunction of universality and privilege. First, dance is in itself a performance and exploration of the difficulty of bringing together universality and privilege. There is an inherent privilege built into professional dance practices and the social institutions of dance in Western societies: Not only is the performer isolated from the spectator, not only does the financial transaction required to view most professional dance reinforce the gulf between the stage and the stalls, but the institutionalised teaching of dance also reinforces the privilege of the performer.

In seeking to understand dance in a way that does not merely reinforce this elitism and provides a way to marry universality with privilege, Nancy meditates on a phrase of Stanislavski's brought to his attention by Monnier: 'to begin from oneself or to leave oneself' (*partir de soi ou* partir *de soi*).[10] For Nancy, the phrase provides not only an excellent formula for understanding the dance solo, but also for the philosophical theme of subjectivity. The first half of the phrase, 'to begin from oneself', offers an understanding of the originary subject as present to itself, existing by itself and for itself, which Nancy will reject. According to this first account, the subject dances always in relation to itself, always beginning from itself, always resembling the self which, itself, is a given. In this understanding, dance draws all its resources from the privileged, isolated self from which every gesture, every mannerism, every rhythm begins. However, this first notion of the self is, for Nancy, a fundamental misunderstanding, for if I ask myself who this 'self' is, this 'me' to which I am to relate and from which everything begins, I can never find it because the only subject that I encounter is the subject of enunciation: 'I' and not 'me'. The

'me' or the 'self' is only ever the product of enunciation, following and not preceding it; the self (*le soi*) is not the origin but is always found in relation 'to itself' (*à soi*).

Having dismissed the first half of Stanislavski's phrase, Nancy then turns to the second: to 'leave the self' or to 'depart from the self' (*partir de soi*). To think about dance as a leaving of the self is to think of it as having nothing substantial or determinate. To leave the self is to leave nothing, for in the self nothing is given save a body. Furthermore, this body, far from constituting an absolute origin, is a finite portion of matter, which is only 'given' to the extent that it is separated from other bodies.[11] As Nancy says elsewhere, the atomised self-sufficient *singulus* does not exist.[12] The self, in turn, is understood not as the origin of movement but as itself a performance of a double movement: the movement of leaving from nothing and returning to nothing in a systolic and diastolic beating that we call 'subject'. The self is a figure not only of gathering and folding (*pliement*), but also of separating (*écartement*). Similarly, dance is now reconfigured not as the expression of a pre-given self but as the extension of the body as it forms, conforms and deforms the space around it. In other words, dance, like the self, is decentred and always already turned outwards.

If the self is always leaving itself, departing from itself, then dance is an extension of this spacing, an extension of the distension that the self already is. We have just seen that there is no immediate self-identicality of the subject, and now we can say the same of dance; non-self-identicality is dance's very condition of possibility.[13] In dance, the body is possessed by separation,[14] the spacing of a presence which itself is separation, 'a presence which would present itself separated from (*à l'écart de*) itself'.[15]

This move away from dance as the outward expression of an inner self and towards an understanding of dance as the spacing of bodies locates the medium of dance not as an isolated practice but as an extension of existence itself:

> Dance would be this inside going outside, in this outside of the world, this outside that is, at the same time, the inside of the world. Something, therefore, for which one cannot tease apart inside and outside, but where it is a case of exposition, a very strong theme in contemporary philosophy. It is linked to the theme of existence, or existence as exposition. That comes straight from Heidegger: it is being as being outside of (*au-dehors de*) itself.[16]

Dance, then, is an exposition of the body, where exposition is an irreducible relation of being 'right up against' (*à meme*) an outside that constitutes the dance as dance, or the self as self; it is an outside without which there is no inside and into which the self and the dance are diastolically moving.

Nevertheless, at the same time – and by the same movement – as dance is a refusal of the privileged self-as-origin and an extension of the exposition of existence itself, it is also a movement of detachment and separation. This is no longer the detachment of privilege, the separation of the dancer from the ungainly masses who are incapable of their own sophisticated movement. What dance is now separated from is the finality that characterises normal instrumental movement, a finality exterior to the movement itself. Dance detaches the body from the pragmatic concerns of its immediate environment. It is a movement in which the dancing body goes out towards nothing but itself,[17] and Nancy identifies this detachment as that which is most characteristic of dance, that which precedes and exceeds even the movement of the body.[18] In dance, the movement of the body is about itself.

It is also this movement without external finality that Nancy identifies as the trait common to both 'popular' and 'choreographed' dance, and it is in terms of this characteristic trait that 'everyone dances someday'.[19] This detachment from external finality does not return us to the isolation of the expressive inner 'self' but rather produces the 'one' which is always understood in terms of its irreducible exposure and opening to the world. The body is detached from the world only as a syncope or rhythm of the world; its detachment is the result of its systolic-diastolic movement and not a precondition of it. In the section of *Allitérations* entitled 'Alone in the World' (*Seul(e) au monde*)[20] Nancy argues that it is dance itself that separates and that brings about (*fait venir*) the one, the solo. The 'one' is produced, not presupposed, and it is produced from (*à partir de*) its opening, not in despite of it.[21] The detachment or privilege of dance, namely its auto-finality, is therefore not set against its universal accessibility; indeed, dance is open to all only insofar as it is understood as detached from determinate finality.

So where has Nancy arrived in journey to think through the twin demands of how dance can be both for everyone and only for the privileged? He has addressed the concerns raised in these demands by rethinking dance not from the expressive individual

self (*moi*) but from the opening/exposition of the dancing body to the outside. What is more, openness and detachment, plurality and singularity, are now both derived from the same movement: Dance is at the same time both communication and separation (two meanings of *partage*), both a crossing (*franchissement*) and a frontier.[22] Nancy's refiguring of dance manages to shed the primacy of the stable, expressive self and preserve both privilege and spacing in a way that makes dance open to everyone while also recognising the necessity of specialist training.

In this refiguring, dance is not taken out of a context of specialist training, but this context is itself set in a wider frame of the spacing and movement of all bodies. Dance is for everyone, Nancy asserts, insofar as the movement without determinate end which characterises dance is a human experience common to all. This changes the dynamic of 'professional' dance. In the elitist model, which Nancy rejects, dance exists in splendid onstage isolation and non-experts pay to watch it; in Nancy's account, dance is shared between spectator and performer, and the public pay to participate in this particularly intense sequence of gestures. It is through shifting the focus from spectacle to participation that dance, in being for everyone, also retains its necessary privilege.

It is the refusal to oppose privilege to universality that also shapes Nancy's response to the concern he only briefly hints at in *Allitérations*: the 'general difficulty with equality and democracy'.[23] The problems are similar to those we have encountered in our discussion of dance: to treat all equally is to flatten important differences; to respect differences is to cease treating all equally. As long as the demand for equality is founded on a generic identity, then equality will never do justice to singularity.[24] What Nancy has done with dance, however, is to rethink ontology not starting with the generic self, but starting with exposition and the double movement of a systolic-diastolic self, such that 'in dance the "=", the equality with itself of the dancing body, gives itself (*se donne*) in an inequality stretched to the extreme'.[25] As all participate in the universal experience that is brought to a higher degree of intensity by professional dancers, the medium of dance allows Nancy to think democracy and privilege, plurality and singularity, not as opposed principles but as moments in the same systolic-diastolic movement.

Nevertheless, an important question arises from this evocation of dance in relation to equality. Could we not have arrived

at exactly the same conclusions about Nancy's thought without having referred to dance at all? Another way of putting the same question would be: is dance serving any function in these reflections apart from illustrating the Nancean ontology that would be perfectly complete and comprehensible without it? It is time to examine the second set of questions identified at the outset, namely how dance can maintain its own privilege, its separation, and yet at the same time be exposed to and in relation with thought. It is a problem addressed directly by Nancy and Monnier in *Allitérations* as they discuss their joint production. What is at stake is the uniqueness and the specificity of dance, as well as the ways in which dance and thought can inform each other without being reduced to each other. We shall see, in addition, that it opens the way to an approach to visual culture in general as a mode of dance.

Dance, thought and participation

Seeking to come to terms with the relation between dance and thought is an exploration of the community of incommensurables: how to do justice to both dance and to thought in their own terms, while still understanding them as related to each other in some way. Monnier describes this task in terms of finding an equality and a sharing. It is a question of:

> Putting on the same level the text, the music, the silences and the movements (direct or indirect) all created by the situation, between us and our postures and movements as dancers. This was also thinking towards (*penser à*) an equality, a sharing (*partage*) of points of view in our different sensorial and perceptive approaches, which also brings us to what you seem to be looking for, namely the correspondence (or not) of the arts between themselves.[26]

One way to approach such a sharing or correspondence between dance and thought is via the question of language. How do both thought and dance relate to language, and how must thought be rethought in the light of these relations? Conjecturing on possible reasons for the Nazi aversion to dance, Nancy ventures that dance lends itself to a greater ambiguity than the other arts and therefore less to the sort of simple decision and predictable model sought by National Socialism.[27] Though dance and recitation can be

choreographed together, it remains that dance is *infans*: it does not speak syntactic language.[28] It does, nevertheless, recount; it has its unfolding, its succession of moments.[29] Each dance sets forth a precise story, but not a narrated story. It is neither a signification nor string of significations but 'a reach, a manner, an arrival, a suspense'.[30]

Dance's story is not to be understood as belonging to the category of the 'danced' communication of information to be found in the natural world, like the 'waggle dance' of the bee, which indicates the route from the hive to pollen-rich plants in relation to the angle of the sun.[31] In fact, the language of dance is further removed from the waggle dance than it is from syntactic language. In the waggle dance there is a necessary and calculable correspondence between the movement and the geography it signifies: so many vibrations for such and such a distance. In syntactic language that correspondence is no longer necessary, but the language of dance – its posture, energy, rhythm and presence – dispenses with a correspondence to a signified reality altogether; it speaks for itself.[32] So it is far too hasty to say that language is a barrier between dance and thought, and that any commerce between the two must be a translation into or out of language per se. Dance and thought are both abstract in relation to the relationship of reference exemplified in the bee's waggle and the location of the pollen; in this respect what they share is greater than what divides them.

Furthermore, Nancy and Monnier are quick to dismiss the paradigm of translation as an adequate figure of the relation between thought and dance. It is emphatically not the case that dance is the contingent carrier of information or code which can be reconstituted in syntactic language. Rather, dance demands a non-intellectual (or at least a not exclusively intellectual, a super-intellectual) experiential understanding. The day a dancer understands their relation to the ground upon which they move is the day we know that they have already misunderstood dance,[33] for what is required is that the ground be grasped with the body, as a fundamental access to the intelligibility of movement, not as an intellection of movement.[34]

This does not mean, however, that language and dance can have no commerce with each other, because dance participates, along with syntactic language, in the circulation of sense. To 'make sense' with movement is not a metaphor, an image or a translation, Nancy insists, and it is not a question of assigning to

each gesture or movement an equivalent in syntactic language, for gestures must be considered as carriers of sense in their own right. Rather than translating sense from another medium dance articulates a new, other and different sense.[35] We can say that Nancy understands dance as a language here, but only on the condition that 'language' itself be understood differently. It is not that ideas count for nothing, but that they do not precede or constrain the language of movement in Monnier's work:

> Your whole work as a choreographer seems to me to be constituted by a ceaseless movement between thoughts, ideas, significations, paces, gestures, spaces, spacings and tensions – without being able to say that it is a 'translation' or an 'interpretation', and without one register really preceding the other.[36]

Nor is it that dance has nothing to do with language. Dance does not utter syntactically organised words obeying grammatical rules, to be sure, but along with the other arts it carries sense to the edge of language,[37] and the way it does this is through gesture. Nancy notes the prevalence of gestural communication between Monnier and her troupe during rehearsals for their joint production:

> I can say that I am very struck, during rehearsal, by your way of speaking: you always point or name obliquely, through images, comparisons or indications which from the start refuse to name, like when you say 'No, it's not that!' – a 'that' that you point towards 'the thing itself', towards the 'sense' to be produced or touched. I noted down more or less accurately some phrases you used with the dancers: 'there, it must be stronger ... longer ... less broken', 'at this point, I didn't know where you were', or again 'in that light it won't do, I lose my bearings'. You point out the identities of place, time and gesture, tiny unities and unities of the whole, but you do not give their significations – or you merely brush past them (*tu les effleures seulement*).[38]

This simultaneous and interacting proliferation of gestural and syntactic languages begins to help us see that it is wrong to assume that gesture and dance form one mode of communication, and language and thought another. We can grasp a little more clearly still the mistakenness of treating thought and dance as a dichotomy by considering the way in which for Nancy, thought too, dances. Whereas 'instruction' is merely the passage of information, a

closed transaction of determinate significations, Nancy argues that all 'education', insofar as it is a case of setting someone on a path rather than imparting certain determinate information, deals not only in linguistic meanings that signify but also in gestures that signal and mobilise without signifying, just like Monnier's instructions to her troupe. These gestures communicate no determinate content but rather communicate themselves, their energy and intensity.[39] To educate is to pass on a way of going outside oneself with an energy that is open to new significations but that cannot be reduced to them. It is to pass on knowledge, but also to pass on the gestures appropriate to that knowledge: its tone, timbre, allure, manner or inclination.[40] Knowledge is caught in a gesturing (*une gestuelle*) that lends it what Nancy calls its colouration. We all remember, he suggests, the pacing, fast or slow gait of some of our former teachers, their ways of moving and holding themselves that became indivisible from that about which they spoke. What is more, this is no idiosyncratic appendage to the process of education but education's necessary participation in what Nancy calls 'dancerly transmission'.[41] In concrete situations of the transmission of thought and ideas, those ideas are danced in a sense that does not reduce 'dance' to a metaphor.

Gestures are communicated otherwise than in the manner of knowledge. They are not given to be reproduced in a one-to-one correspondence (even if they may require a training of the muscles) but their energy itself is passed on.[42] For Nancy, this passage of energy is figured in terms not of imitation (*mimesis*) but in terms of participation (*methexis*), the sharing of a habitus (*hexis*), a disposition to occupy space in a particular way, or a way of holding the body.[43] In the case of two bodies, this participation is a relation in which one body does not observe and imitate the other but the other traverses, mobilises and moves it as it resonates in its joints. I do not perceive the gesture through sight, hearing or touch but I resonate with it: 'its dance has begun in my place. He or she has displaced me, almost replaced me'.[44]

This resonant sharing of gestural energy takes place not only between one dancer and another, but between the dancer and the location, the dancer and him/herself, the dancer and the choreography and the dancer and the spectator. Dance interweaves a whole series of participations that, while they cannot be reduced to mimetic representation, nevertheless provide their own 'representation':

We 'represent' something by 'participating' in it, and we participate through a representation that is not a reproduction but a production, a production of the body as it participates in . . . in what? In sense, in thought, in being, whatever you want . . .[45]

Surely, we might object, some dance is simply telling a story with a sequence of gestures that, like the bee's waggle dance, have a direct and unambiguous correspondence with the reality they are intended to signify. Nancy does not deny that such dance exists but he does argue that, even in the case of ostensibly mimetic dance, a gesture is *danced* before and in order that it be *mimed*, and the mime does not reproduce the mimed act but extracts its sense or essence from the dance, opening a participation with this essence or sense.[46]

The notion of participation allows us to move away from the idea of dance as referring beyond itself to an (intelligible) meaning and towards an understanding of dance as producing sense, where sense escapes (*se dérobe à*) the difference between the intelligible and the sensible.[47] Both dance and thought participate in and produce sense, but neither one is its gatekeeper. Indeed, Nancy insists that it is without any trickery or metaphorical sloppiness that he can claim 'when I think, I dance'.[48] The link between the two is once more the absence of a direct instrumental end. He uses the example of walking onto a stage or a set to illustrate what he means. When I walk on set I produce a thought of walking (*on produit une pensée de la marche*) because my walking is abstracted from direct instrumentality. Nancy equates such a movement deprived of an immediate end with thought, for thought also shares the self-aware abstraction from immediate finality. To say that dance is a thought most emphatically does not mean, however, that dance can be reduced to thought. Dance is a thought *as* dance (*en tant que danse*), and not because it produces or nourishes thoughts.[49] Dance is a dissipation of, or distraction from, thinking in the narrow sense.

Nevertheless, despite all its similarities with thought, dance for Nancy and Monnier entertains a unique relation to sense by virtue of its medium. Dance communicates sense with no brush, no camera, no voice, and therefore it is the art that most fully effaces the effect of signification, of indicating another order or another reality than that of the medium itself.[50] Other arts achieve their end (whether the end is expression, representation or whatever

else) through a particular means, but when the means is nothing more than the artist's own body, we have less occasion to suspect another configuration beyond what is presented.[51] In other words, it is in dance more than in any other medium that sense is passed on for its own sake, not with a view to signifying something outside itself. This is not to say that sense in dance is purely immanent, but rather that there is no intermediary between the artist and the audience.

As well as standing apart among the arts, dance also serves for Nancy as a medium for understanding visual culture more broadly. Perhaps the clearest and most powerful demonstration of this comes in the rich essay 'The Image: Mimesis and Methexis', which can be found in a new translation in this volume. In this chapter Nancy broadens out the notion of participative dance that we have been thus far exploring in relation to the dance-thought nexus, first to a general account of engaging with visual culture and then as a way of understanding the circulating sense of the world. He holds that dance, art and the circulation of sense in singular plural being participate in what he calls the same 'movement' or 'tension'.

It is the notion of 'tension' that allows Nancy to find a commonality between dance and visual art. He rejects the paradigm which understands the image primarily as an object that is contemplated, insisting instead that we participate in the *hexis*, the habit, disposition, posture or accent (*tonos*) of the image,[52] and that 'this disposition is not one of phenomenological intentionality, but one of ontological tension'.[53] It is not that I perceive a tension within the painting or even between myself and the painting, but rather that I am, bodily, in tension with the painting, like two dancers locked in a hold. My muscles, tendons, thoughts, breathing and circulation are held, disposed, accented towards the image in 'a tension, a tone, the vibration between the image and us of a resonance and a setting in motion (*mise en branle*) of a dance'.[54] Nancy also describes this vibration as 'seizing' the image ('la saisie de l'image')[55] and as a resonance through which the image forms 'the sonority of a vision, and the art of the image a music of sight'.[56] Music and vision communicate in this shared trope of resonance, and they both also communicate with dance, 'dance constitutes in the order of the body as such a movement affiliated to a setting in resonance'.[57] Art, music and dance are in turn treated to a further resonance when Nancy sweeps up their

respective movements in the circulation of sense among all enti-
ties of the world, evoking:

> ... The participation in a world before which I am no longer the
> subject of an object, nor give myself over as object to a fantasmatic
> subject: but I myself here become (*j'y deviens moi-même*) a moment of
> the general motion of the world ...[58]

Within this broader context we see that the instrument of dance
is not the body simpliciter but incorporeal sense passing through
the body or holding it in a trance, where trance is understood as
the state in which something passes through me, from before me to
beyond me, shaking me as it does so.[59] This trance is not the pre-
serve of dance alone; it belongs to all the arts and also to thought
(or rather thought belongs to it). Nevertheless, dance does provide
a privileged site for its exploration because in dance there is no
intermediary between the trance and the body of the artist.[60]

The movement of dance; the resonance of art; the sense of the
world. Nancy insists on understanding each of these in terms of
participation, in what we might venture to call a general methexis
of being-there (or of dancing-there). We suggested at the outset
of this investigation that, if we are to respect Nancy's approach
then we will find in dance not merely a contingent illustration of
the concept of the singular plural, not merely a husk which can
be discarded once we extract the idea it contains, but something
that challenges the notion that the singular plural is an idea in
the first place. We can now see that the ontology of the singular
plural is not, in itself, an idea; it is not primarily to be thought
but to be experienced (which includes, but cannot be reduced to
thinking), to be resonated with, or to be 'caught'. To approach
the singular plural as the singular plural (and not as the idea of
the singular plural) is to experience its gestural energy, to let its
motion resonate in one's bones. This is doubly important because
communicating the idea of the singular plural can only ever lead to
a mimetic but uncomprehending repetitious parroting that is char-
acteristic of the worst sort of education. The singular plural is not
imitated but shared, not described but danced, and it is shared and
understood not when it is blindly copied but when it is continued,
when (to use Nancy's own language) its energy is passed from one
to another. The singular plural is only thought as singular plural
when it is danced.

Finally, how can this commonality between dance, art and the sense of the world change the way we understand and engage with visual culture? The short answer is that art is no longer a more or less distant object represented by a skilled copier and observed by a detached viewer, but a movement caught by a participating artist-dancer and passed on to one who catches and dances it in turn. In a slightly longer explanation, it means that an image is not mortified on the canvas by the artistic equivalent of a lepidopterist, and the image is not primarily to be viewed or admired or intellectualised. It means that the artist is not the mimetic eye-hand that fixes a likeness but the methectic body that catches and throws forward the resonances and movements of 'the general motion of the world'. The artist 'catches' these movements not in the sense of trapping, halting or possessing, but in the way that one 'catches on' to a skill or picks up a 'catchy' tune, a sense which resonates more with participation than with mimetic reproduction. The artist does not present an image on the canvas but throws forward 'catchy' movements from her own body through the canvas and beyond. Approaching visual culture through dance means that the image is not destined for a contemplative – and essentially disembodied – eye but for a participative, dancing, twitching body ready to catch the movement of the canvas as it passes by. In the same way that we talk of a catchy tune as an 'earworm', it would not be too far from the mark to talk of such methectically catchy art as a 'bodyworm', subtly re-choreographing the *hexis* of all those who resonate with it. It also means that the circulation of resonance and tension has not ended when gestural movement dances through the canvas and into the bodies of those who resonate with an image, for the movement is in turn thrown forward from those dancing bodies to other bodies or into other works ready to be caught and thrown again in a movement without end.

Notes

1. I am very grateful to Philipa Rothfield for her comments on a previous draft of this chapter.
2. Mathilde Monnier and Jean-Luc Nancy, *Allitérations: conversations sur la danse* (Paris: Galilée, 2005).
3. Nancy, *Allitérations*, 42–3.
4. Jean-Luc Nancy, 'The Image: Mimesis and Methexis', in this volume.

5. Nancy, *Allitérations*, 43.
6. Ibid., 42–3.
7. Ibid., 43.
8. Ibid., 43.
9. Ibid., 43.
10. Ibid., 93.
11. Ibid., 94.
12. Jean-Luc Nancy, *Le Sens du Monde* (Paris: Galilée, 1993), 109.
13. Nancy, *Allitérations*, 33.
14. Ibid., 45.
15. Ibid., 45.
16. Ibid., 90.
17. Ibid., 55.
18. Ibid., 55.
19. Ibid., 55.
20. Ibid., 81–105.
21. Ibid., 86.
22. Ibid., 52.
23. Ibid., 43.
24. Jean-Luc Nancy, *Être Singulier Pluriel* (Paris: Galilée, 1996), 43.
25. Nancy, *Allitérations*, 33.
26. Ibid., 13–14.
27. Ibid., 25.
28. Ibid., 89–90.
29. Ibid., 116.
30. Ibid., 116.
31. Derrida discusses this sort of animal 'language' in *L'Animal que donc je suis* (Paris: Galilée, 2006). He ultimately stops short of calling the bee's dance a language because of the fixed correlation in the dance between the sign and the reality it signifies.
32. Nancy, *Allitérations*, 9.
33. Ibid., 23.
34. Ibid.
35. Ibid., 19.
36. Ibid., 33.
37. Ibid., 98.
38. Ibid., 33–4.
39. Ibid., 53.
40. Ibid., 53–4.
41. Ibid., 54.
42. Ibid., 52–3.

43. Ibid., 54.
44. Ibid., 109.
45. Ibid., 54–5.
46. Ibid., 109.
47. Ibid., 28.
48. Ibid., 101.
49. Ibid., 111.
50. Ibid., 29.
51. Ibid., 29–30.
52. Nancy chooses the word 'tenue' to communicate this sense. From *tenir* (to hold), 'la tenue' can be translated 'style', 'behaviour' or 'conduct' and carries the etymological trace of 'holding oneself' in a particular way.
53. Nancy, 'The Image: Mimesis and Methexis'.
54. Ibid.
55. Ibid.
56. Ibid.
57. Ibid.
58. Ibid.
59. Nancy, *Allitérations*, 60–1.
60. Ibid., 62.

3

A Question of Listening: Nancean Resonance, Return and Relation in Charlie Chaplin

Carrie Giunta

In Jean-Luc Nancy's *The Image: Mimesis and Methexis*,[1] he considers what makes us say that a portrait lacks only speech. This lack speaks, explains Nancy. A portrait 'speaks to us from its privation of speech.'[2] Take the *Mona Lisa*, for instance. For if the *Mona Lisa* lacks only speech of her own, this evokes 'something more and other than the sole privation of verbal expression'. The lack, for Nancy, is rather a transport carrying across a Mona Lisa voice, which is not manifested as speech. As her audience, we recognise her voice. What's more, this voice is understood: 'we understand it ... its sense and its truth'. Mona Lisa can make herself understood; yet she does not make herself heard (*se fait entendre*). Without uttering a word, her voice transports sense.

This bears similarity with listening to the voice of one who is absent. When only a photograph or a film carries the absent person's voice, listening is 'an order other than the order of the visual'.[3] Voice and speech are not the same thing, Nancy articulates in a mock conversation with Jacques Derrida in 'Vox Clamans in Deserto'.[4] 'Because I know you, I recognised your voice as you were coming toward me, long before I could make out what you were actually saying', Nancy says in addressing Derrida.[5] This is to say that voice is prior to intelligibility. Voice comes before language.

In order to recognise Derrida's voice, Nancy listens. For Nancy, the main function of listening (*l'écoute*) is not simply to bear the weight of language as some requirement of intelligibility. Nancy questions a hierarchy of sensible and intelligible forms of listening. His *Listening*[6] begins with an indecision: listening can be *écouter* or *entendre* – *l'écoute* or *l'entente*.[7] A simple translation into English confounds the two terms, as both may be translated to the same word in English: listening. *L'entente* is about hearing

55

and understanding the spoken word. *L'écoute* is more than intelligibility of language; it is attention to others.

Nancean listening is the attentiveness that is characteristic of dialogue. According to this theory, listening does not necessarily implicate hearing, nor is it the reverse of speech or hearing. *L'écoute*, for Nancy, is resonant listening. 'In *écouter,* the ear goes toward the tension, in *entendre,* the tension wins over the ear.'[8] *Écouter* is to stretch towards sense. This implies a motion towards a tension – and an attention – that re-sounds.[9] In his work *Listening*, Nancy calls into question Derrida's specific focus on the immediacy of *entendre*. I will argue in this chapter, Nancy turns around Derrida's critique of Nancean touching by questioning Derrida on listening.

Attention to another's voice cannot always carry sense. Ovid's fabled Echo[10] is forbidden the power to speak herself. Her voice is reduced to a single reflection, as she can only repeat the last words of another's speech. She reflects the last words of her star-crossed lover, Narcissus, who is reduced to seeing only his own reflection. Misunderstanding ensues, as Narcissus hears and wrongly understands Echo's words.[11] Intelligibility fails Echo.

Poor Echo speaks, but lacks the ability to resound another's *tonos*. Portraiture would be lost to her, as she has not the sonority to stretch towards sense. She could only rebound the words of the spectators in the gallery. A portrait, however speechless, has a voice – a *tonos*.[12] As Nancy posits in *The Image: Mimesis and Methexis*, an unheard *tonos* is listened to (*écouté*). The portrait need not speak in order to be listened to and understood:

> In its own way, the image then speaks: it speaks on only one plane, at the surface, without referral to a signified ground [un fond signifié]. But on this unique plane, the image makes its own phrasing reverberate – it brings forth that mode of *ekphrasis* which pushes sound to the surface rather than positing sound upon it.[13]

For Nancy, listening is beyond listening to the signification of sense or language. To regard speech as a privation in the visual arts is a disregard for listening. Nancy's multiple approach to listening will guide the following exploration into cinema's finest listener, Charlie Chaplin.

In Chaplin's time, films came with no soundtrack. They had no shortage of dialogue, however. Actors moved their lips to mime

speech and films carried copious inter-titles on which viewers could read dialogue lines and expository description. Chaplin's Tramp character is by and large mute. He tends not to employ speech, yet he communicates a range of emotions and thoughts. Chaplin accomplishes this in general through pantomime – gestures, facial expressions, body motion and postures. He relies not on words, but on pantomime to express himself.

During the end of the era of silent films, Chaplin resisted the transition to talking pictures, choosing to keep his character's speechlessness unchanged. Instead, he used audience listening to make himself listened to. In this chapter, I will explore how Chaplin's attention to others as a listening subject is a place of resonance. Through a reading of the final scene of *City Lights*,[14] I will consider how, through an interrelationship with the audience and the film, Chaplin refers to himself as other. Using his distinctive powers of attention, Chaplin is a paragon of listening and an archetype for Nancy's thesis on listening.

Visual culture was never silent

Chaplin's craft hearkens back to an age-old form of storytelling. The first moving images shown on a screen originated in China as early as the Han dynasty. In the ancient art of shadow play, leather puppets pierced with holes projected images onto illuminated screens made of cloth or scrim. The audience watches the puppets' silhouettes come alive on the screen. This works much like the shadow puppetry the prisoners see on the cave wall in Plato's *Republic*.[15]

In the *Republic*, Nancy reminds us[16] voices reverberated, because a cave is a reverberation room as well as a place to throw shadows on the wall. The voices and movements of the people would reverberate in the cave, making audible echoes. Shadow play shows us visual culture was never silent. Cinema audiences have always listened and early cinema was anything but silent. Ever since the early days of motion pictures, cinema has relied on a juxtaposition of visual and sound image. The first films were projected while musical accompanists sat between the audience and the screen, playing alongside the action on the screen.[17] Early cinema defied language barriers. In the late 1920s, the 'talkies revolution' gave rise to an obsession with spoken language and its comprehensibility when synchronised sound eclipsed silent

cinema.[18] Synchronised sound works by separating word and image and then marrying them together.

Rather than juxtaposition, Nancean resonance ex-poses the subject. The image enters into resonance with the self. 'One could say here, not that 'it lacks only speech', but rather that 'it makes heard its lack of speech'.[19]

A prelude to language

A recent resurgence of early cinema in popular film narrative recalls this immediacy of word and image that talkies introduced to cinema. Michel Hazanavicius's *The Artist* (2011)[20] and Martin Scorsese's *Hugo* (2011)[21] momentarily renewed interest in silent cinema,[22] while the minimal synch, no dialogue, animated films of Sylvain Chomet[23] pay homage to the early work of Chaplin.[24] For a moment, silent cinema was contemporary again. But popular interest in 'the new silents' has not been sustained.

The Artist illustrates how the transition to the talkies was not an obsession with speech, with technology or with sound, but an obsession with language. The film's downfall, however, is its use of spoken language. Actors move their lips constantly and wordy title cards are frequent. This groundbreaking new silent film still employs copious dialogue. Is contemporary visual culture as fixated with spoken language today as it was in 1927?

The bias of logocentric thinking, in which higher value is given to the spoken word, has a tendency to ignore the notion of listening. Philosopher Gemma Corradi Fiumara sees an active move towards non-listening in which 'a culture intoxicated by the effectiveness of its own "saying"' is 'increasingly incapable of paying heed'.[25] A culture governed by *logos*, she holds, is oblivious to what it means to listen.

The origin of truth in Derrida's deconstruction of logocentrism is always assigned to *logos*. In logocentric thinking, *logos* is a moment of presence and pure intelligibility. This is when one hears oneself speaking while one is speaking (*s'entendre-parler*). *S'entendre-parler* makes speaker and listener immediately present both temporally and spatially, because in this scenario, there is no difference between the speaker and the one speaking. In *Speech and Phenomena*,[26] Derrida tends towards *entendre* over *écouter*, thus giving privileged status to hearing (understanding) the spoken word, which he claims is the perpetrator in phono-logocentrism.[27]

For Derrida, when the voice is heard (understood) in this way, this is consciousness – the experience of pure auto-affection.[28]

By arguing in 'Vox Clamans in Deserto' that the voice is a prelude to language and prior to speech,[29] is Nancy saying the voice is 'fit for universality'? This fitness for universality occurs in a self-proximity, 'the absolute reduction of space' in which 'no obstacle' meets the voice.[30] Space is reduced, as the voice does not pass through the world. Proximity between listener and speaker creates self-presence.

Voice, Nancy proposes, is the 'resonant side of speech'.[31] Voice resonates, thus avoiding its own contradiction. In always addressing the other, the voice can make itself listened to, but not by itself.[32] If *l'écoute* is attention to the other, then it is not a matter of listening to oneself as one is speaking, but of listening to the other and to oneself. Nancean listening is a relation to self and between self and other in which the self is also the other.

What becomes apparent in Nancy's multiple senses of listening is Derrida's indifference to *l'écoute*. In complicating listening as *l'écoute* and *l'entente*, Nancy could deconstruct the undervalued position of *l'écoute*, thus proving the premise of listening's

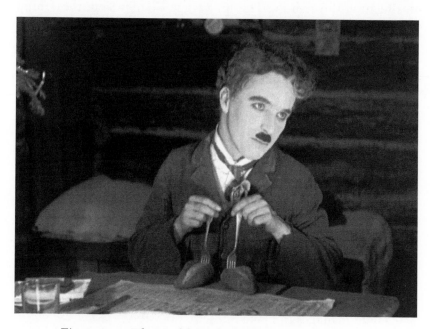

Figure 3.1 *The Gold Rush* © Roy Export S.A.S. Scan Courtesy Cineteca di Bologna.

essentiality to speech. Rather than creating a reversal of speech and listening, or hearing and listening, Nancy reveals a false dichotomy of spoken word (*logos*) and listening. He poses a question, asking what kind of listening philosophy is capable of.[33] In asking this, Nancy questions Derrida's neglect of *l'écoute*.

S'écouter

The speechless protagonist from silent Chaplin films offers a corpus of texts for investigating questions about *l'écoute* and *l'entente*. Chaplin's engagement with the audience does not separate himself and the audience as subject and object. Their dialogue is instead a relation among audience, Chaplin and his self as other. What makes Chaplin unique, as an actor, is his direct access to self and other at the same time.

The Tramp character's unspokenness was hugely successful and overcame language barriers. Chaplin communicates with his audience directly and identifies with the audience by skilfully confiding in the audience via non-verbal dialogue. The large part of his comedy is that relationship he forges with the audience. He builds this relation through the Tramp. I argue Chaplin kept the Tramp silent, refusing to make a talking film because speech would have severed his connection with the audience. It would have obstructed the interrelation between Chaplin and audience.

The problem with bringing the Tramp character into the talkies is with immediacy. The Tramp's voice would have been in absolute proximity with himself speaking. Through his listening, the speechless Tramp's voice passes through a difference via the audience, clearing him of immediate self-presence. The Tramp could not, in a talkie, have this difference with, and interrelationship with the audience because in *s'entendre-parler*, the Tramp would hear himself speak in self-proximity. This ruins Derrida's argument in *Speech and Phenomena*. For if a voice keeps silent, thereby eschewing the self-proximity of hearing (understanding)-oneself-speak (*s'entendre-parler*), then it is not present to itself.

With non-verbal, speechless gestures enough to rival the Mona Lisa's arch facial expression, can Chaplin listen the same way she listens?

Chaplin manages to make himself understood (*se fait entendre*) as he makes himself listened to (*se fait écouter*).[34] With each silent movement, he stretches towards sonority, returning a voice that

has nothing to do with speech or sound, but is inclined towards the opening of sense. Chaplin listens to himself-as-other, and by transmitting this in his films, makes his listening listened to. This is his *s'écouter*.

To illustrate what *s'écouter* means I will examine Chaplin's attention to others. In the Tramp character there is difference between the audience and Chaplin's self as other. There is no immediate presence or presence to self in this difference because there is temporal and spatial difference, unlike in *s'entendre-parler*, which is immediate self-presence between self and speaker. The voice of the other is already shared within the Tramp's own voice. This presence of the other means the Tramp's voice is not in absolute proximity to Chaplin or the other. Chaplin listens not as a hearing-oneself-speak form of auto-affection, but his listening-to-himself decentres difference. With this difference, immediate self-presence is inhibited both as a spatial presence and as a temporal one. In short, the Tramp character is present to his self neither temporally nor spatially in *s'écouter*.

This is evident when the Tramp partakes in a silent dialogue with objects. In the 'Oceana Roll', a scene also known as 'the dance of the dinner rolls' in *The Gold Rush*,[35] the action takes place on New Year's Eve. Chaplin's character has prepared a special meal for invited dinner guests, including love interest Georgia. However, his guests have forgotten about the invitation, leaving the Tramp crestfallen and alone at the dinner table. While seated there, he imagines that he is entertaining his guests and they are dancing. He enacts his fantasy dance using two forks stabbed into two bread rolls. Manipulating the forks with his hands, the bread rolls approximate his oversized clown shoes and the forks function as legs. Though his hand movements are simple, Chaplin's dreamy facial expressions animate the bread rolls' simple 'steps'. He does not merely play with his food; by appropriating objects from the dinner table through which he converses, he makes his daydream listened to via a voice otherwise conveyed through his feet.

By way of the other, he listens to himself through a movement of resonance. This movement is *s'écouter* in that Chaplin listens to himself resounding. Nancy envisions a place where vibrations resound as their natural frequencies are combined with other vibrations. Nancy treats the body as a vibrating system, in which sense opens up, amplifies and extends.

A place of resonance

Who is listening for Nancy is a place of resonance. Listening as *s'écouter* by way of the movement of Nancean resonance is not an absence to speech's presence. It attends to the other and to the self as other. This theory of resonance is key to Nancy's argument in *Listening* because resonance gives alterity to *s'écouter*. Resonance makes the subject as other because it refers back to a self as other. Whereas Echo loses her place of resonance, and as a result, cannot listen, resonance puts the other in Chaplin.

Practically, resonance is when a frequency is applied at or near the natural frequency of a vibrating system and forces vibrations at the frequency of the one applied, resulting in vibrations of higher amplitude and longer duration. This means a vibrating system will pick out tones that correspond to its natural frequencies and exaggerate those frequencies. For instance, most stringed instruments have a hollow wooden case filled with nothing but air. The air in the box, forced into vibration by the string, emits vibrations similar to those of the string. As string tension causes the air inside the violin's wooden body to vibrate, this movement of vibrations amplifies volume (spatialisation) and prolongs duration (temporalisation) of the vibrations.[36]

The movement of resonance is a spacing movement without interval. It is an extension in space and a lengthening in time. Vibrations, however, in order to change in intensity, and in order to be listened to, undergo a back-turning (*rebroussement*), referring back (*renvoi*) movement. Chaplin resounds as he listens to himself (*s'écoute*). Then, turning back, he resounds further away.[37] Chaplin spatialises in his resounding, though not via an interval or by expanding. He extends within the available space of his body and fills that space. The violin, out of whose body resonance resounds, illustrates this type of extension. Resonance extends first within the space of the violin, causing the intensified vibrations to then leave the violin's body. Vibrations do not separate; they intensify. Resonance is a spacing movement that does not create an interval connecting or separating disparate elements.

In a place of resonance, a subject returns to or refers back to its self as another subject and not as self-presence.[38] The return is the space of a self, and not presence to the self. Therefore, listening is a referring, and not a deferring. This improves on Nancy's discussion in *Corpus*, about the impenetrability of bodies: 'Two bodies can't

occupy the same place simultaneously . . . I can't speak from where you listen, and you can't hear [listen] from where I speak . . .'[39] In a place of resonance, a subject refers back to its self as other, and not as two bodies. Nancy thinks of the listening subject not as a subject, except as the place of resonance, where vibrations resound.

The subject – the place of resonance – is the part of the body that is listening as a means of approaching the self.[40] For Nancy, the self is a referral. As a subject, Chaplin's self is other, another subject and not another self or a split self. He and audience are not separated in a Cartesian sense. Chaplin becomes a subject through s'écouter, speaking as himself and as audience. He resounds as the audience – an other, but not an object. His dialogue with the audience is between a self and a 'you'. It is not an inner dialogue or a split self. In Nancy's theory of listening, the subject that is listening touches itself as a 'means of approaching the self'.[41] In listening, a subject occurs in the space or resonance of the referral. It touches itself (il se touche).

Se toucher toi

As Nancy's s'écouter is a means of questioning the logocentric thinking in Derrida's deconstruction of logocentrism, Derrida discusses a similar phrase, se toucher toi, in his critique questioning the immediacy in Nancy's theory of touching. Derrida deems logocentrism a bias in the tradition of a metaphysics of presence where word is primary. It follows that in the metaphysics of presence of touching, touch is primary. Derrida speaks about se toucher toi in which the link between the 'you' and the self is indissociable.

On Touching – Jean-Luc Nancy[42] is Derrida's deconstruction of haptocentrism or a privileging of the figure of touch, which he proposes forms a pattern in many traditions of thought. Haptocentric thinking deems touch as a centre or moment of presence. The whole tradition of European philosophy, Derrida argues, privileges this haptology or figure of touch based in Christian theology.[43] In On Touching, Derrida asserts Nancy bases his figure of touch on Christian theology, which emphasises the distance and discontinuity between touch and touched.[44] Derrida questions the possibility of immediacy between touching and what is touched. This implies unity, immediacy and continuity between touching and the touched, despite Nancy's claim to think of touch as fragmented and discontinuous:[45]

Nancy seems to break away from haptocentrist metaphysics, or at least to distance himself from it. His discourse about touch is neither intuitionistic nor continuistic, homogenistic, or indivisibilistic. What it first recalls is sharing, parting, partitioning, and discontinuity, interruption, caesura – in a word, syncope.

Nancy wants a touching that is independent from haptocentrist metaphysics, 'part of the great tradition that accords an absolute privilege to touch and does not let itself be encroached upon by the possibility . . . of any vicariousness of the senses'.[46] This contact through interruption is for Derrida, manifested in a self-touching auto-affection that interrupts itself as itself. In this way, touch is not only contact; it is also non-contact.

For Nancy, touching is outside of or in excess of a haptocentric tradition. Derrida argues touching is a self-interrupting contact that is more of a self-touching (se toucher) that adheres to a haptocentric tradition indicating continuity, unity and immediacy.[47]

> It is a certain way of self-touching without touching, or touching oneself and interrupting the contact, but a contact, a tactility, that nevertheless *succeeds in interrupting itself*. It succeeds in setting up contact, in setting itself up *as* contact, in thus touching itself *in interrupting itself*, at the moment when it's suspending – or even forbidding or abstaining – itself, to such a point that it's holding its breath, so as to give itself, still, within the syncope, the pleasure of which it is depriving itself.

The material, proximate, relational contact is broken by a non-contact in which a self interrupts itself as itself and not as some other. This special type of interruption, Derrida claims, is actually a unity and continuity perpetuated in auto-affection. Therefore, Nancy's questioning of touch is a certain loyalty to the very tradition of haptocentrism that he distances himself from.[48] Derrida asserts that Nancy bases his figure of touch on Christian theology, which emphasises the distance and discontinuity between touch and touched. Derrida's idea of touching has temporal and spatial difference and is not auto-affection.

The difficulty of presence in the figure of touch[49] is that just as sense does not sense itself, for Derrida 'touching' touches on the 'untouchable'. Thus, touching is both touchable and untouchable – it is an 'untouchable touchable'.[50] He points to the double

meaning of the phrase *il se touche*, due to its variable reflexivity and reciprocality. In *il se touche*, the phrase could either mean he/it self-touches it/himself or, it/he is touchable by an other.[51] The untranslatable original title of the text, *Le Toucher, Jean-Luc Nancy*,[52] has a double meaning. *Le toucher* means both 'touch' and 'to touch him'. *Se toucher*, however, is more complex. Translator Christine Irizarry explains *se toucher* can work in either reflexive or reciprocal modes.[53] It 'can turn the subject toward itself . . . or toward the other, according to a reciprocity that is easier to say than to attain'.[54] In short, this grammatical aspect 'puts transitivity in reflexivity'.[55]

This critique of haptocentrism emphasises separation and difference. Derrida uses the phrase *se toucher toi* not as a reflexive gesture, but as a phrase of unity and dissymmetry that also has transitivity. *Se toucher toi* has two meanings: 'self-touching-you' and 'to self-touch you'.[56] In *se toucher toi*, touching is in contact with oneself as well as with the other. In order to be touched this way, 'I have to touch *myself.*' 'When I speak to you, I touch you, and you touch me when I hear you, from however far off it comes to me . . .'[57] Derrida sees the 'self' and the 'you' as equally 'indispensable', suggesting connection or relation rather than rupture or separation.[58] In this scenario, the self and the 'you' are not the same and not in symmetry. Self and 'you' refer to two different people together in dissymmetry.

Se toucher toi cannot work in reflexive mode. To do so would be to split the self into two selves. In other words, an attempt to form a reflexive version of *se toucher toi* would produce 'to self-touch yourself' or 'self-touching yourself'. The 'you' and the 'self', however, are not interchangeable.[59]

The 'you' and the 'self' in *se toucher toi* are not self-present subjects, but they do have potential duality. *Se toucher toi*, therefore, is both immediacy and interruption at the same time, where 'at the same time' means indissociably. The gap and the interrupting movement of touching are indissociable; making an immediacy possible that is not based on time.

The non-reflexive basis of *se toucher toi* provides a different expression of Chaplin's interaction with himself as other (*s'écouter*). *S'écouter* could denote a self-reflexivity that implies an interior dialogue between Chaplin and himself. Chaplin's dialogue, however, does not occur by means of a splitting of his Tramp self into a self and 'my other self'. Alternatively, Chaplin's

self is in dialogue not with another self, but instead, with a 'you'. Derrida explains the 'you' is not susceptible to a relation to self or to self-touching. While the self and the 'you' remain balanced in *se toucher toi*, the phrase conveys dissymmetry by maintaining first and second person pronouns. 'You' stays in the second person and does not change to the first person.[60] *Se toucher toi* reveals a self that is as crucial as the 'you'.

Like *s'écouter*, *se toucher toi* shares a commonality with the turning back movement that vibrations undergo when a sonorous body resounds. In a similar motion to the oscillation of resonance, *se toucher toi* goes back and forth between the self and the 'you'. 'When I speak to you, I touch you.' 'You touch me when I hear you.'[61] This supports the argument that self and 'you' are not opposed, but linked. If the self were split, it would undermine the movement of resonance because a divided self, as subject and object, prevents the referring back of resonance.

What happens when the Tramp speaks?

This self that Chaplin approaches touches its self as other. His touching is reciprocal without being an auto-affection. There is a kind of mutual touching that occurs in the last scene of the film *City Lights*. The scene is known as one of Chaplin's most sentimental – 'that cliché that so many critics use to avoid dealing with Chaplin's actual complexity'.[62] By seeing beyond the sentimentality of this scene, we may understand how the scene addresses Derrida's question in *On Touching*: 'What happens when our eyes touch'?[63]

In this scene, the Flower Girl, who was blind up until this point in the film, finally sees the Tramp with her newfound vision. Before screen testing Virginia Cherrill, who plays the Flower Girl in *City Lights*, Chaplin had difficulty finding an actress who could act blind without contorting her face. Cherrill's ability to 'look inwardly' is what got her the part. 'To my surprise she had the faculty of looking blind. I instructed her to look at me but to look inwardly and not to see me, and she could do it.'[64]

The Flower Girl looks at the Tramp, yet she does not recognise him. Throughout the film, she believed that the benefactor who funded the operation that restored her sight was a millionaire. Here, she discovers that the Tramp is in fact the person that cared for her when she was ill and who funded the operation that gave her the ability to lift herself out of poverty. In the denouement, the

Flower Girl and the Tramp meet each other again through a plate glass window after the Tramp's release from prison. She looks out of the shop window at the Tramp and laughs. She looks out with two eyes, as she could never have done before when she was blind. The Tramp, looking in, sees her.

When she was blind, the Flower Girl recognised the Tramp by touch. She sees him for the first time when she touches his hand because sight for her when she knew him before was touch. What happens when their eyes touch is an interruption to touching. To touch without touching, 'to embrace eyes', *se toucher toi*, Derrida says, is 'a break with immediacy'.[65] It interrupts self-presence, as the Tramp no longer sets his eyes on a blind flower girl who looks inwardly. The other is 'touched by your eyes' without touching itself or being touched.[66]

'Nancy wants to go back before sight . . .' says Derrida towards the end of *On Touching*.[67] Similarly, Chaplin wants to go back before cinema. In *City Lights*, Chaplin directly addresses the overhaul of the cinema industry, which by the time of *City Lights*'s release was at the peak of the 'talkies revolution', and at the twilight of silent cinema.[68] *City Lights* was the next to last appearance of the Tramp. Chaplin resisted the change from silent films to talkies because the talkies would institute a change in the way in which his work would be listened to. To go back before cinema is to ask the question, 'what happens when the Tramp speaks'? In the first chapter of *On Touching*, Derrida extends the question: 'When our eyes touch, is it day or is it night'? When the Tramp speaks, is it day or is it night; is it *l'écoute* or is it *l'entente*?[69] Mutually touched by your eyes, Chaplin manages to balance the harmonious pair. He makes himself understood (*se fait entendre*) and he makes himself listened to (*se fait écouter*) without actually speaking.

In his critique that Nancy offers no relation or mediation between a presenting and the thing that is presented, except from itself, Derrida asks if Nancean touching implies unity, immediacy and continuity between touching and the touched despite Nancy's claim to think of touch as fragmented and discontinuous. Nancy's theory in which resonance is non-presence that is also immediacy improves on his thesis on touching that Derrida deems haptocentrism. As Derrida points to a metaphysics of presence of touching in which touch is primary, Nancy brings attention to the neglect for *l'écoute* and emphasis on *l'entente* in Derrida's deconstruction

of logocentrism that claims speech as primary. In short, Nancy turns around Derrida's critique of touching by questioning Derrida on listening.

More than a privation of speech

How does visual culture listen? When the former silent film star, Norma Desmond, says in *Sunset Boulevard.*: 'We didn't need dialogue. We had faces.',[70] she means 'the *tonos* of the image' resounds without words. The *Mona Lisa* can even resound without being seen. After she was stolen from the Louvre in 1911, crowds gathered to stare at the empty space on a blank wall where the painting once hung on display. Many of the people who queued to see the empty space had never visited the Louvre before and had never seen the painting in the first place.[71] She became more popular while in exile. 'That which resonates in this case is nothing other than painting itself.'[72] Does Mona Lisa listen as a place of Nancean resonance, as Chaplin listens?

Moving in resonance, Chaplin, through his direct engagement with the audience, attends to and answers the demand of the other. He listens to the audience, makes his listening listened to (*s'écouter*) and at the same time makes himself understood (*se fait entendre*). Chaplin's connection with himself as other and audience as other is a *mutuus contactus*. *Se toucher toi*, like *s'écouter*, breaks with immediacy when it interrupts self-presence. A talking Tramp character would create auto-affection, which would interfere with his interrelation with the audience. It would ruin his difference and make him immediately present to himself.

Audiences coming to silent cinema for the first time may experience similar powers of attention. If a new silent cinema resounds without words, its lack of speech can be listened to.

Notes

1. Jean-Luc Nancy, 'The Image: Mimesis and Methexis', in this volume.
2. Ibid.
3. Ibid.
4. Jean-Luc Nancy, *Multiple Arts: The Muses II*, trans. Simon Sparks (Stanford: Stanford University Press, 2006), 38–49.
5. Nancy, *Multiple Arts*, 38.

6. First published in 2002 in Paris as *À L'écoute*. Jean-Luc, Nancy, *À L'écoute* (Paris: Gallilé, 2002).

7. 'La mince indecision tranchante . . . entre écoute et entente' 'Entre une tension et une adéquation', where *adéquation* means 'perfect adaptation'. This could imply that *entendre* means to adapt to the circumstances in order to grasp some meaning. Nancy, *À L'écoute*, 12–13.

8. Jean-Luc Nancy, *Listening*, trans. Charlotte Mandell (New York: Fordham University Press, 2007), 1, 69.

9. *Entendre* and *entente* share the Latin root, *ten*, 'to stretch, stretch out, distend, extend'. The root 'to stretch' implies that listening has potential to expand and create space for something else.

10. The fable of Echo and Narcissus in Ovid, in which Echo is doomed by an angry goddess never to speak for herself again. Ovid, *Ovid's Metamorphoses in Fifteen Books* (Cambridge: Chadwyck-Healey, 1992).

11. Gayatri Chakravorty Spivak, 'Echo', in *The Spivak Reader*, ed. Donna Landry and Gerald MacLean (London and New York: Routledge, 1996), 183–5. In Spivak's reading, a difference and a deferment occur when Echo speaks independently of Narcissus's intention.

12. Nancy, 'The Image', in this volume.

13. Ibid.

14. Charlie Chaplin, *City Lights*, film, directed by Charlie Chaplin (1931, UK: Warner Home Video UK, 2003), DVD.

15. 'Just as puppet showmen have screens in front of them at which they work their puppets.' Plato, *Republic*, 514a, trans. G. M. A. Grube (Indianapolis: Hackett Publishing Company, 1992).

16. Plato, *Republic*, 515c. Nancy, *Listening*, 75. Nancy states precisely the echo of voices in the cave is forgotten due to Plato's heavy emphasis on vision and light.

17. Carrie Giunta, review of *Beyond the Soundtrack: representing music in cinema*, ed. Daniel Goldmark et al., *Historical Journal of Film, Radio and Television* 30 (2010): 132–3.

18. Laura Mulvey, 'Cinema Sync Sound and Europe 1929: Reflections on Coincidence', in *Soundscape: The School of Sound Lectures 1998–2001*, ed. Larry Sider et al. (London: Wallflower, 2003), 23–4.

19. Nancy, 'The Image', in this volume.

20. Michel Hazanavicius, *The Artist*, film, directed by Michel Hazanavicius (2011, USA: The Weinstein Company, 2011).

21. Martin Scorsese, *Hugo*, film, directed by Martin Scorsese (2011, USA: GK Films, 2011), DVD.

22. Paul Flaig and Katherine Groo, *New Silent Cinema* (New York and Abingdon: Routledge, 2015).

23. Sylvain Chomet, *L'illusionniste*, film, directed by Sylvain Chomet (France: Pathé, 2010) DVD. Sylvain Chomet, *Les triplettes de Belleville*, film, directed by Sylvain Chomet (S. France: Celluloid Dreams, 2003) DVD. Sylvain Chomet, *La vieille dame et les pigeons*, film, directed by Sylvain Chomet (S. France: GFC, 1998) DVD.

24. Sylvain Chomet's animation films have been inspired by Chaplin and by the silent comedy work of 1960s film-maker and actor Jacques Tati.

25. Gemma Corradi Fiumara, *The Other Side of Language: A philosophy of listening* (London: Routledge, 1990), 8, 17, 23, 29, 31. Fiumara attributes the tendency in Western philosophy to ignore the notion of listening to logocentric thinking, a bias in which higher value is given to the spoken word.

26. Jacques Derrida, *Speech and Phenomena: And Other Essays on Husserl's Theory of Signs*, trans. David B. Allison (Evanston: Northwestern University Press, 1973). This is Derrida's critique of logocentric thinking as hearing-oneself-speak (*s'entendre-parler*).

27. Phonocentrism prioritises speech or voice (*phone*) and debases writing.

28. Jacques Derrida, *Of Grammatology*, trans. Gayatri Chakravorty Spivak (Baltimore and London: The Johns Hopkins University Press, 1997), 3, 20, 98.

29. Nancy, *Multiple Arts*, 39, 41.

30. Nancy, *Multiple Arts*, 79.

31. Nancy, *Multiple Arts*, 47.

32. Derrida, *Speech and Phenomena*, 86. This is consonant with Derrida's further argument that 'Hearing oneself speak is not the inwardness of an inside that is closed in upon itself; it is the irreducible openness in the inside . . .' This openness is made possible by time.

33. Nancy, *Listening*, 1. Nancy asks: Can philosophy listen as *l'écoute* or as *l'entente*?

34. In: Jean-Luc Nancy, 'Ascoltando', foreword to *Listen: A history of our ears*, by Peter Szendy, ix–xiii, 146, trans. Charlotte Mandell (New York: Fordham University Press, 2008), Nancy discusses a reflexive listening in which he believes music listens to itself (*il s'écoute*), setting the stage for Szendy's question: 'Can one make a listening listened to?'

35. Charlie Chaplin, *The Gold Rush*, film, directed by Charlie Chaplin (1925, UK: Warner Home Video UK, 2003), DVD.

36. Firth et al., Wray, *Waves and Vibrations* (Middlesex: Penguin Education, 1973), 237–8. Edward Gick Richardson, *Sound: A physical text-book* (London: Edward Arnold & Co., 1947), 56, 76, 98.

37. Nancy, *Listening*, 35.

38. Nancy, *Listening*, 8, 12–16.

39. Nancy *Corpus*, trans. Richard A. Rand (New York: Fordham University Press, 2008), 56–7. Richard A. Rand translates *écouter* as 'hear'. Mais je ne peux pas parler d'où vous écoutez, ni vous, écouter d'où je parle – ni chacun d'entre nous écouter d'où il parle (et se parle).

40. Nancy, *Listening*, 8–9, 12–13.

41. Nancy, *Listening*, 8–13.

42. Jacques Derrida, *On Touching – Jean-Luc Nancy*, trans. Christine Irizarry, (Stanford: Stanford University Press, 2005).

43. Derrida, *On Touching*, 243.

44. Jack Reynolds, *Merleau-Ponty and Derrida: Intertwining Embodiment and Alterity*, (Athens: Ohio University Press, 2004), 57–8. Jack Reynolds, however, offers a reading of Maurice Merleau-Ponty's work on touching that considers wrong Derrida's claim that touching is a metaphysics of presence, by asserting touching is a non-dualistic difference between self and other.

45. Derrida, *On Touching*, 156.

46. Ibid., 41.

47. Ibid., 38.

48. Ibid., 128. Ian James, *The Fragmentary Demand: An introduction to the philosophy of Jean-Luc Nancy* (Stanford: Stanford University Press, 2006), 120, 130.

49. James, *Fragmentary Demand*, 47.

50. Derrida, *On Touching*, 113.

51. Ibid., 6, 18, 34.

52. Jacques Derrida, *Le toucher, Jean-Luc Nancy* (Paris: Éditions Galilée, 2000).

53. Christine Irizarry, translator's note, *On Touching – Jean-Luc Nancy* by Jacques Derrida (Stanford: Stanford University Press, 2005), 317–18.

54. Derrida, *On Touching*, 108. See also: Jacques Derrida, '*Le Toucher*: Touch/to touch him'. *Paragraph* 16 (1993): 152.

55. Derrida, *On Touching*, 291.

56. Ibid., 34.

57. Ibid., 291.
58. Ibid., 115, 291.
59. Ibid., 281.
60. Ibid., 281–2.
61. Ibid., 291.
62. Tom Gunning, 'Chaplin and the body of modernity', *Early Popular Visual Culture* 8 (2010): 240.
63. Derrida, *On Touching*, 281.
64. Charles Chaplin, *My Autobiography* (London: Penguin, 2003), 323.
65. Ibid., 292–3.
66. Derrida, *On Touching*, 283.
67. Ibid., 305.
68. However, Yasujirō Ozu, Dziga Vertov, F. W. Murnau, and Charlie Chaplin all released non-talking films in 1931. In January 1931, *City Lights* was released, a film with no dialogue and few sounds.
69. Derrida, *On Touching*, 2. Jean-Luc Nancy, '*Le Toucher*: Touch/to touch him', *Paragraph* 16 (1993): 122–57.
70. Billy Wilder, *Sunset Blvd*, film, directed by Billy Wilder (1950, USA: Paramount Pictures, 2003), DVD.
71. Darian Leader, *Stealing the Mona Lisa: what art stops us from seeing* (New York: Counterpoint, 2002).
72. Nancy, 'The Image', in this volume.

4

The Image: Mimesis and Methexis

Jean-Luc Nancy
Translated by Adrienne Janus

I opened my eyes; what an increase of sensation! The light, the celestial vault, the verdure of the earth, the transparency of the waters, gave animation to my spirits, and conveyed pleasures which exceed the powers of expression. I at first believed that all these objects existed within me, and formed a part of myself. – Buffon, *Natural History: Of Man* (1785)[1]

The use of a medium to experience an image is analogous to the way in which we experience our own bodies as media through which we both give birth to inner images and receive images from the outside world. These mental images happen within our bodies, like dreams, and in both cases – that is, in the case of dream and mental images – we perceive the image as if it were using our body as a host medium. – Hans Belting, *An Anthropology of Images: Picture, Medium, Body* [2]

When we say of a portrait that it lacks only speech, we evoke something more and other than the sole privation of verbal expression.[3] This very privation, in manifesting itself as the unique lack that would separate representation from life, already transports us into the sentiment or the sensation of a speech of the portrait. The lack affecting the portrait is designated at the same time as considerable and imponderable, so much does its annulment appear accessible and even imminent. In fact, the portrait speaks, it is already in the midst of speaking and it speaks to us from its privation of speech. It makes us hear a speaking before or after speech, the very speaking of the lack of speech. And we understand it, it communicates this saying, its sense and its truth.[4]

In a similar manner, we desire to hear the voice of she or of he who is absent. Their aspect can be carried with us in a photograph, or indeed a film, to which the recording of the voice can also be

associated. But listening to this voice still remains of an order other than the order of the visual. Its resonance attunes us to an order of sense and of truth whose essence differs from the visual order of recognition. Love and hate are always that by which recognition is judged indigent.[5] In the voice, there is always a movement that exceeds identification: a participation in that which the aspect presents, but whose presence sound hollows out, pulling it away from itself and sending it to resound in a very intimate distance where the lines of flight of all presences are lost. However, this incisive dehiscence of the visual and of the sonorous does not divide the image. It does not separate painting from music, to use those categories that are convenient yet precisely suspect in submitting to the very division that is to be destabilised [ébranler]. In the image, the visual and the sonorous share their valences with one another, communicate their accents to each other. The voice lacks only the face. Nonetheless, and this is decisive, it is only thanks to such a lack, each time crucial and imponderable, that these accents, these modulations of sense and of truth can indicate themselves. And this is why the arts work to cultivate their differences: not by lack of completeness but rather by excess profusion of an original sharing of sense and of truth. Each one of the arts constitutes the invention or intensification of a register of sense to the exclusion of the other registers. From this same fact, the privileged register releases in its order an evocation of the other orders through what could be called a contrasted proximity: the image makes resonate a sonority of muteness (where music, for its part, causes a visuality of the invisible to be refracted). This general axiom of the arts justifies and disqualifies in the same gesture all attempts at 'correspondences', even as it eludes in advance all the traps of a 'total art'. If there is some such thing as a principle of art, it is its irreducible non-totality: but a corollary principle opens between the arts an interminable mutual resonance.

Mimesis and methexis of the image, this then is the theme (one that for today I will limit to the 'image' in the most common, that is to say visual, sense of the term). Mimesis and methexis: not in the sense of a juxtaposition of concepts in confrontation or in dialectic, but in the sense of an implication of one in the other. That is to say an implication – in the most proper sense of the word, an envelopment by internal folding – of methexis in mimesis, and an implication that is necessary, fundamental and even in some way generative. That no mimesis occurs without methexis – or else be

merely copy, reproduction – that is the principle. Reciprocally, no doubt, no *methexis* without implicating *mimesis*, that is to say precisely production (not reproduction) in a form of the force communicated in participation. We always consider the image under the transcendental scheme of *mimesis*. As known by the considerable work that in the last decades was needed to accompany the general displacement of the practices and problematics of representation (artistic, literary, conceptual and political), *mimesis* does not indicate imitation in the sense of reproduction *of* or *in* a form; nor does it indicate representation in the sense of the constitution of an object before a subject – representation which corresponds to imitation insofar as the object leaves behind it, inimitable, the obscure ground[6] [*fond*] of the thing in itself, even as its 'form' cuts itself out in detaching itself from the ground of matter, matter drawn together as much as drawn out in its impenetrable density. Imitation presupposes the abandon of an inimitable, *mimesis* on the contrary expresses the desire for it. Around the topic of *mimesis*, Plato inaugurated the interminable debate and even the combat of philosophy with its polymorphic other: myth, poetry, enthusiasm and also, at the intimate heart of philosophy itself, one of the aspects or one of the senses capable of erotic fury. Plato does not want to banish *mimesis*, but he wants it to be regulated by truth, by the Idea and the good, that is to say always by that which shows itself and shines of itself, like the sun above and outside of the cave. There, the inimitable must imitate its self-sameness: it must of itself produce the same anew, that which forms the law of the same if it must be the 'same'.[7] It must engender or let be engendered from itself, anew, that which of itself poses itself and conforms to itself – that is to say precisely the Idea, Form itself as conformity to self in itself. And even for this, desire is necessary – the desire to marry the Idea, as Mallarmé said so well.[8] Desire is called for and is possible because the generation of conformity implies alterity. Alterity constitutes the internal difference of the Idea, that is to say the fact that form must be the form *of* (of the truth, of the good, of whatever it may be). The form of the fundamental [*le fond*] or of what is there where the fundamental is grounded [*ce qui est au fond*], if something at least *is* in this place, or indeed if it is a *place*. It is not, in any case, an existing place, and in fact, as one already knows, *agathon* is situated where *epikeina tès ousias* goes astray.[9] Desire forms difference mobilised (différante) as the formation of the ground [*fond*] and as the way by

which the ground can be diffused [*fondre*] and come to fuse (itself) [*se fondre*] in the form.[10]

Here I will introduce a necessary remark. We have gotten into the habit of disdainfully brushing aside the opposition of form and grounding content [*fond*]. It's a good habit on the condition of always thinking each time that the opposition must not be brushed aside in favour of an indifference between the two, but in order to better manifest the incessant tension that differentiates one in the other, that at each turn dissipates the ground in the form and dissolves the form in the ground. The element of this dissipation and dissolution is what Plato calls *beauty*. Since then until our day, beauty is the name of the opening that traverses a desire. (I don't distinguish beauty here from the sublime, if sublimity designates nothing other than the necessity for beauty to be more than beautiful, to be properly that which exceeds itself from fundament to form [*de fond en forme*] and vice versa.)

The image gives form to some such ground, to some such presence held back in the ground where nothing is present unless all there is presence equal to itself without difference. The image draws out, defers, desires a presence of this precedence of ground [*préséance du fond*] by which, fundamentally [*au fond*], each form cannot be but held back and buried, originally and eschatologically inform as much as informulable. Thus the roman *imago* is the appearance of the dead, its compearance[11] among us: not the copy of its traits, but its presence as the dead. If the 'imago' forms itself first of all on the principle of a death mask, it is because from the moment of its moulding *mimesis* modulates *methexis* by which the living share the death of the dead. It is this sharing of death – of its rending, hallucinatory force – this *methexis* of disappearance that properly serves as model for *mimesis*. The image is the effect of desire (the desire to re-join the other), or better: the image opens the space for this desire, opening out for it a gaping hollow [*béance*]. Every image is the Idea of a desire. Every image is conformity to itself as the 'self' of a desire, not of a posited being [*étant-posé*]. Here, the *methexis* of *mimesis* is truly brought to life. With the image, and as long as one does not enter into relation with it as an object, one enters into a desire. One participates – *meta* – in the *hexis*, in the dis-position (*eko, ekomai*, to hold and to hold back, to be disposed to, to be attached to . . .) and in the desiring disposition, that is to say in the tension, in the *tonos* of the image. This disposition is not one of phenomenological inten-

tionality, but one of ontological tension. Unless this ontological tension constitutes, definitively, the truth of the former. A tension, a tone, the vibration between the image and us of a resonance and a setting in motion of a dance. We will return to this.

But desire presupposes its pleasure, and it is here that we must pass from Plato to Aristotle. The latter declares, as we know, that it is natural for man to take pleasure in the productions of *mimesis*. In order for this to involve pleasure, something other must be at stake than the object of a representation. We do not take pleasure in the ordinary perception of things, nor in the constitution and identification of their representation. But we do take pleasure in the image, or even no doubt it would be better to say, against the grain: that which we name 'image', is that with which we enter into a relation of pleasure. First the image pleases, that is to say draws us into the attraction from which it emerges. (Nothing can foreclose from any aesthetics or from any ethics of the aesthetic this principle of pleasure which reigns over classicism and that the romantics and the symbolists believed they could ignore. In this way, aesthetic movements without a principle of pleasure are also always threatened by wanting to claim for themselves a *mimesis* of pure Ideas, a conformity to concepts [notions][12] without a touch of emotion, even when they want to excite the soul . . .) If I say that desire presupposes its pleasure, it is not with regard to a satisfaction which desire must accomplish. This presupposition is neither final nor teleological. In desire, pleasure precedes itself. It is *Vorlust*, fore-pleasure to use the Freudian term, pleasure before the final pleasure. The pleasure of tension, Freud also says, before the pleasure of release, which puts an end to pleasure. It is useful to note, at this point, that with Freud the question of pleasure plays in parallel and in chiasm, simultaneously, upon the sexual register and upon the aesthetic register. From one part to the other this has to do with forms (of beauty) or of zones (of seduction) insofar as they lead to the ground (of the sexual) in which or rather as which they discharge their tension. From one to the other this has to do with 'beauty', one part qualified as aesthetic and the other as erogenous without it ever being possible to disentangle without remainder one from the other. (To be precise, let us say that even Freud befuddled himself here.) Leaving Freud aside for today, I propose only to consider, if not sexuality, then at least the motif of an erotics of the image. This motif is at any rate unsurprising. Nevertheless it is necessary to know what it conceals.

The pleasure of the image is not one of recognition, as one sometimes says, unless we attempt to find in recognition itself the effect of a mimetic and methexical movement of the kind that I am analysing. This is not impossible (Freud will help us here, and even Kant as well as Plato). For the moment, I'll keep to the distinction that puts recognition on the side of the object, of representation, or indeed to use another discriminating term, of the *figure* rather than of the *image*. The figure shapes an identity, the image desires an alterity. The pleasure of the image is one which solicits the desire by which form and ground enter into mutual tension, the ground raising itself in the form, the form sinking back into the ground. Or rather, this pleasure solicits the desire by which there is form and ground, that which opens their spacing or even this force, which I would say *distinguishes the ground of things*. With this formula, I'm attempting to gather together at least the following values: 1. that the ground of things as such – as ground [fond], 'fundamentally', or 'down to the ground' [*à fond*],[13] if I dare say – becomes distinct, detaching itself (from) behind or beyond all objects, representations and figures; 2. that this ground therefore distances itself, in its distinction, from the forms which rise from it and detach themselves from it, never becoming or taking on a form properly itself, staying always grounded [*au fond*]; 3. that this ground presents itself at the same time, moreover, as the ground *of* forms held outside of it in their *status nascendi* as well as vibrating at the same time in the correlative imminence of a *staus moriendi* by which they slide back anew to ground. Here I cite Blanchot: 'The image, present behind each thing, and which is like the dissolution of this thing and its subsistence in its dissolution, also has behind it that heavy sleep of death in which dreams threaten. The image can, when it awakens or when we waken it, represent the object to us in a luminous *formal* aura; but it is nonetheless with substance [*fond*] that the image is allied – with the fundamental materiality, the still undetermined absence of form . . .'[14] I'll follow on by saying that the relation between the thing in dissolution and the element in which it dissolves is a relation of resonance: the 'formal aura' indefinitely propagates in the ground concentric, fading waves that it gives rise to by this same formation. The ground of things, or the resonance of forms: the tone, the vibration, the relation of coming and withdrawal [*retrait*] that the sonorous seems to isolate for itself is replayed or resounds in the silence that the image claims. Thus the portrait speaks to that

which lacks only speech (and in a similar manner sound solicits its own images, as I have already suggested, but this will be discussed elsewhere).

Such resonance can also be understood thus: sight presents its visions to us before or outside of us without our experiencing the movement by which our eye seeks them out or produces them (or indeed the two together), and also without the movement by which, to use the terms of Lucretius, the *simulacra* of things fly towards us. For us, the speed of light is infinite and the movement of the visible is instantaneous, just as they still were to the eyes of Descartes. Hearing, on the other hand, offers us from the outset two specific impressions: one, we are more sensitised to distancing from the source of sound as to the propagation of its resonance, and the other, amidst the sounds that present themselves there are certain kinds whose emission we can experience ourselves. We hear ourselves resonate, we do not see ourselves look. Moreover one of the properties or one of the critical coincidences of birth is that of suddenly giving rise at the same time to a vision of the outside and a hearing of our own cries. Differently to the sight of an object, our seizing of the image – or indeed the imagination understood as faculty for seizing and producing images – would represent a vision operating as a mode of listening: a vision that would experience in sight [*la vue*] (*la veduta, le Bild, le tableau*) the movement of its rising in me and its return towards me. Experiencing its resonance in this way the image would form the sonority of a vision, and the art of the image a music of sight. Or even indeed a dance, if dance constitutes in the order of the body as such a movement affiliated to a setting in resonance. To articulate it yet another way, I would propose this: when in the Kantian formula the punctual and empty 'I think' 'accompanies my representations',[15] it has to do with a relation where vision is the paradigm (a paradigm under which all sensible and intelligible regimes can be evaluated), a relation of representation or of the figure connected to a *punctum caecum*; whereas when resonance resounds – itself shared out according to listening or to the image or to the step of dance (to say nothing here of taste, smell or touch) – then the 'I think' mingles with that which is no longer its representation but its re-sounding. It no longer remains fixed to its point [of view] but is exposed, pushed outside and returning to itself, it is literally e-moved[16] [*é-mu*] not before but in resonance: no longer *punctum caecum* but *corpus sensitivus*.

That which resounds and that which moves (us), is the *methexis* of *mimesis*, that is to say the desire to get to the bottom [*aller au fond*] of things, or even, which is nothing but another way of saying it, the desire to let this ground rise to the surface. From the time he engraved and painted caves, instead of contenting himself with looking at the figures of objects, as Plato wanted, man has prac-tised nothing other, or is not himself exercised by anything other, than by his own desire and pleasure to go to (the) ground [*aller au fond*].[17] It is therefore not exactly correct to say as Nietzsche did that art preserves us from foundering in or of the truth: art always makes us founder, and the shipwreck is in this sense assured.[18] But to founder or go to (the) ground remains an illusory formula if one assumes that the ground is something, a unique and singular thing behind the others. It is only ground in reality inasmuch as forms draw themselves from and upon it – releasing it from itself, from its inconsistent consistence. Just as the erotic body is not one and is not 'a body', but a range of intensities where each zone becomes a discontinuous whole from the others, without there being a total-ity of any part, so too the image, the body of images one could say (the imaginal body, if one likes) or the ground of the image is not one and is not 'a ground'. It also is discontinuous and shares itself indefinitely with – ceaselessly remodelling or replaying the sharing out of – erogenous or *eidogenous* zones. Each *eidos*, here, is an *eros*: each form marries a force that moves it. Being neither one, nor a back-ground, that which I refer to here as the ground [*le fond*] forms for each image its sudden emergence in which the image is solely and entirely for itself, without however any other unity than the multiplicity of its exposed surface. But it is thus, in the unique event of its multiple exposition, that it is an image and it is beautiful. The more beautiful it is, the stronger it is, the more it is sudden and total – and the more this surging forth projects its unity in multiple bursts, never entirely reducible to a background of either sense or sensation. Our pleasure is to take pleasure [*jouir*] in this jolt by which the ground suddenly surges forth and loses itself in forms and in zones. In the same present – in the sense of instant and in the sense of gift – from the image is exposed that which is the condition of pleasure and of truth: an immeasurable opening, escaping all given measure, measuring itself only against itself. Who then would be inclined to say, in effect, that any paint-ing, let's say Manet's *Le Torero mort/The Dead Bullfighter*, is too large or not light enough? But above all, who would then be

inclined to measure painting by anything other than itself, and by the way it resonates with and against itself? But at this point we will need to say that each regime of art constitutes precisely in turn a zone or a zoning of this pleasure that only surges forth by dissolving the unity of a substantial ground or of a principle of reason in a resonance of its forms stretching out over the emptiness of the ground. The image represents then the proper regime of surface distinguished from ground, whereas musical sonority represents a regime of the outside and the inside, whereas the dancing body would be of the regime of traction, contraction and attraction. From one regime to the other there is irrevocable distinction as long as there is resonance among multiple resonances. What is named by the very indistinct term 'art' is nothing but this resonance of resonances, this refraction of refractions between zones of emotion.

The same applies here to the image as well as to dream, which incidentally is not by chance one of the chosen sites of *eros*: not because it would allow fantasies to be satisfied, but because *eros* possesses at least certain properties of the dream. Thus, the ground doesn't distinguish itself from the surface of the dream – in other words, from the visions discernible in dream – and does not cease to act as the presence and as the pressure of a ground that is not a vision but an *impression* in the most dynamic sense of the word, or even a *sentiment*, if it is possible to reunite under this word all these senses of the 'senses' themselves reunited with the power of emotion. (To try another word, as a passing provocation, I would say that the dream is the rule of the *sensational* . . . Only to suggest that it is not always as easy as one likes to think to distinguish between 'the impressive' and the 'spectacular', between being moved and being blown away, between touch and the touching . . .) In fact this ground thus surfacing entirely in dream dissipates its grounding unity (a grounding which never takes place but in being subtracted, pulled away) in the mosaic of images which press contiguously and distinctly upon each other, emptying out perceptual relations as much as logical ones in favour of a 'substitution of the 'the same as' in all relations'.[19] This is *also* that *the same as* this other thing *and again still* this other. The *continuum* that one would be tempted to posit at the ground breaks itself off without cease in this equivalence that is at the same time substitutive and coalesceant, permutative and agglomerative. The polyvalence of the impression – one could say: of the expressive impression – that

blurs figures and annuls the distance of waking consciousness (the distance which permits consciousness a depth of field lacking from the dream as from the image) forbids that there be 'a ground' and responds on the contrary to a formula like this one, by Blanchot: 'Profound depth is nothing but appearance that uncovers itself'.[20] One could equally say that waking consciousness has at its disposal a depth of field, whereas the consciousness or impression of the dream, and of the image, consists in the surface upon which depth [*profondeur*] comes to float in the movement of shimmering ripples. (Here, once again, one cannot but founder – without sinking to the bottom, but just touching the surface bloom of the image [sans couler à pic, mais à fleur de l'image].[21] The appearance that uncovers itself designates the impossibility to fix a present of signification to a figure (this is that, this means that). In the same way, for Freud, the dream uncovers the possibility of a last, or first, signification, in that 'umbilicus of the dream' – a metaphor from which can be inferred the theme of a cutting out from a matricial ground or even from a rootedness in favour of that which Freud designates as the 'mycelium' from which the desire of the dream suddenly emerges like a mushroom.[22] The *mycelium* is the filamental intercellular tissue that forms the stalk of the mushroom. The image of the dream is formed in the same manner as this unforeseen, erratic and parasitical growth rather than by a process that is organic, autonomous and complete. The sudden emergence of images is doubled by their unconcealment in an uncertain ground, where no seeds are fixed but where proximities react, where contagions are produced, where echoes resound. The more an image raises itself up and blossoms, the more it embeds itself [*s'enfonce*].[23] That which is put into play constitutes neither a presence before, nor an absence behind. It is an interminable absencing that comes and returns to presence in the undertow by which the image touches us, strikes us and fascinates us, in other words draws us into the swell of its surfacing depth. It is in fascination that *methexis* takes place. This is not a kind of hypnotism that would at the same time suspend the world of perception and dream in favour of a dry signifying injunction (as happens in the hallucinatory identification with a master figure).[24] It is on the contrary participation in a world before which I am no longer the subject of an object, nor give myself over as object to a fantasmatic subject: but I myself here become a moment of the general motion of the world, myself a moment in the general commerce

of the senses, of sentiments, of significances. This commerce, this communication, this sharing, this is what makes the image. It is this that draws me towards the image at the same time as the image penetrates me. In this fundal embedding [*enfoncement*],[25] at once a distancing and drawing together, a strangeness in intimacy – resounds the *tonos* of the image, its timbre, its murmur, its fundamental noise [*bruit de fond*], its attraction to a language which would be destined to remain a dream of language: where sense would be given as the indefinite contiguity and substitutability of the forms and zones of the image, by whose play the image enters into resonance with the self. This 'fundamental noise' constitutes definitely the content [*teneur*], the structure and even the matter of the ground: since it is neither the support, the foundation, nor the background, the ground of forms is made of the murmuring rustle [*bruissement*] of their interweaving. Not yet a world, so not yet properly an 'other', and yet not me alone with myself. But an outside the image exposes me (to) as coming from the more profound in me than me. And this outside works its suspension right up through the continuity of language: it rhythms it, scans it. I fall silent, in the manner of and under the pressure of the image. The image draws me into the rhythm that it imprints in (the) sense(s) by cutting and opening sense anew. In its own way, the image then speaks: it speaks on only one plane, at the surface, without referral to a signified ground [*un fond signifié*]. But on this unique plane, the image makes its own phrasing reverberate – it brings forth that mode of *ekphrasis* which pushes sound to the surface rather than positing sound upon it.

Let us now speak of an image. I will consider a canvas by Cézanne, *Young Man and Skull/Jeune homme à la tête morte*, which dates from around 1895. It is a silent image, if there is such, since it is at the same time an image of silence: the silence of the skull as well as the silence upon which, with lassitude and melancholy, the mouth of the young man encloses itself. With these marks, the image exhales or exudes silence, in the same way again as it does with the presence of books and papers – words that are frozen and closed – and by the general spatial enclosure, with no viewscape to the outside and with the wall-hanging confining space as it cuts the lines of flight of the room's angles, angles we can surmise by the position of the table and the piece of skirting board visible below on the right. Following all these *vanities*, this canvas appears to expose the image of an ultimate silence as a

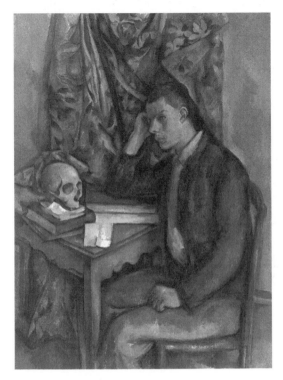

Figure 4.1 Paul Cézanne, French, 1839–1906 *Young Man and Skull (Jeune homme à la tête de mort)* 1896–1898, Oil on canvas, 51 3/16×38 3/8 in. (130×97.5 cm), The Barnes Foundation, BF929, Image © 2015 The Barnes Foundation.

privileged destination of painting insofar as it assumes in order to intensify – rather than to circumvent – the silence of the image. One could say here, not that 'it lacks only speech', but rather that 'it makes heard its lack of speech'.

The image shows that there is nothing to say, that all has already been said and effaced, just as one can see from the leaf of paper lying on the table and from the page of the book curled under the skull: neither one nor the other shows writing. Less than ever, surely, is writing needed, since we already know what might have been traced: words such as *vanitas* and *memento mori*, or others still that we have already read on so many old paintings of the *vanities*. The words are already there, silently loquacious in the whole tradition that Cézanne cites and recites for us. (I will mention in

passing: with Cézanne, the citation and recitation of the skull is frequent, but most often without an adjoining person, which makes this tableau an exception. But there is no question of my studying the theme of *vanitas* in Cézanne for its own sake.) From the sole fact of its nature as citation, the image has already made something heard. It makes resonate the words of Ecclesiastes, the *vanitus vanitatum* ['vanity of vanities'] that cannot but resonate because it is pronounced rather than written, addressed and cast out as a warning, as an admonition, as an announcement and a recall, as a call to meditate on the inconstancy of the world. But at the same time, this resonance – underlined by the doubling of the word as the genitive of itself, 'vanity of vanities' – resounds as an echo and thus as a voice losing itself by repeating itself, since it is manifestly the belated recitation of a citation already so often present in the history of painting. The canvas thus also makes these words resound with the sense of 'painting of the paintings of vanity' . . . Unless one might also almost discern Pascal's well-known phrase, 'what vanity is painting'. This recitation is evident, as established by the modern dress of the young man. It produces a marked contrast with the archaism of the setting of the skull and books. What is more, this young man is not only modern, he is also not one of those young aristocrats one finds in archetypal scenes of the genre. He is rather a peasant, a villager as always with Cézanne. (The hypothesis that it's about Paul, Cézanne's son, is still without convincing proof.) It must be understood that he too was also placed there as setting, with the skull, by the painter. This last signals his *'mise en scène'*: he is letting us know that he is evoking for us the history of painting. This *evocation* is a new element of resonance: all that is lacking is the voice of the painter, saying, here is painting, what it was, what it is no longer, how it is an echo of itself, how it resounds for us. This is also why the painter hung a tapestry that cites and recites the veil or the drapery whose folds so often adorn the ground of the classic tableau. (More precisely, perhaps it is permissible here to evoke Vermeer. The forms and the colours of many of his wall hangings can be suggested here.) This drapery at the same time opens and closes the canvas with its own ornamental cloth. It encloses its space towards the back – eliminating the back-ground in order to bring to the fore this cloaked ground by which the drapery delimits the space of presentation, and in the same movement the unfolding and enfolding tissue lends its volume to the ground of the tableau, raising this ground and bringing it to

the fore all the while rendering it sensible as ground. Rendering the ground sensible comes back to hollowing it out and raising it at the same time, bringing it closer to us while drawing it back or folding it back again, so that its proximity distances itself while surfacing and so that the canvas, in this way, enters in resonance with itself. This drapery moreover also constitutes, with its floral motifs, the recall of painting – considered as the art of the image – from which the flattening blues, whites and beige of the foreplan are cut out. The flowers of the drapery simultaneously recall (the) painting and send it back to (the) ground, all the while making resound at the blossoming surface of the image [à fleur d'image] this mute question: where (in this) is painting? Where (in this) am I with painting?

Here the image resonates at the same time as citation of a classical scene and as the image that it forms for itself. The first resonance gives itself expressly as echo, a murmur altogether distinct and indistinct proposing that an epoch of painting has passed, that another invents itself, without however allowing any decision as to whether one holds this proposition with joy or with regret. The second resonance also departs from the most distant, not in time but in space: from the pastel tints of the wall, visible from either partition of the drapery, up until the return of these same tints to the very forefront, on the left trouser leg. This second resonance repeats the first and annuls it at the same time: for the history of painting, it substitutes – or rather it assumes, as a still more ancient ground – the repetition of a unique gesture, one older and younger than all painting so defined, that of drawing the ground out from under itself while retaining, if one can say, its force and its flight of ground [fuite de fond].[26] The image puts the ground in resonance, ceaselessly, and for this the image sets itself in resonance with its history, this is what is said. But this is not said, precisely. This passes from the silence of death, the silence of the books and the silence of he who enacts before us at once the scene of vanity and the scene of the painter who paints his own scene. A silent man, his eyes lost in a distance, which rejoins, all the while straying from, that in which the empty sockets plunge. But if we listen to this silence, as we are invited to do so by the visibly drawn and coloured ear of the young man, that ear turned towards us where often, with the classicists, it is rather a look or glance that is thrown our way, then we can perceive what it is that resonates. Then our eye begins to hear. It is not only speech or the groanings expressed by that bony jaw which bites and chews the

paper. Without a doubt, these expiring words repeat themselves with Cézanne, upon whom the thought of death weighed heavily in these years. But at the same time another resonance again resounds, one which gives to the first its own proper timbre, the harmonics and modalities of its resonance. That which resonates in this case is nothing other than painting itself. The forms of colour and of design mobilise desire, the desiring pleasure of a ground whose consistence is not, definitively, the contour of the figure, but the rustling of the image. In relation to another painting from the same period, of another sad young man in a red waistcoat, Meyer Schapiro evokes 'the sonority of colours'.[27] Here, sonority is more muted, but nonetheless audible. It is a rustling or ruffling [*froissement*] in the heavy folds and hollows of the drapery, of its crevasses or its peaks which unfold to the floor, under the table, while other folds and slopes respond to the roundness of the skull as well as to the stiffness of the pensive neck. The canvas organises itself in the rustling of ruffled tissue. It is this rustling that Breton referred to when he wrote of this tableau: 'Metaphysical disquiet falls upon the tableau by the folds of drapery.'[28]

The word 'ruffling' [*froissement*] shares itself out precisely between its sonorous value and its textile and tactile value. The silence of the canvas blossoms [*affleure*] in this rustling of ruffled tissue set in counterpoint with the still more discrete brush-strokes of softened, faded mauves and the pale blue-green of the (back)ground and the trousers. Between these two, as though tied together by tracks of white, are the hard lines of the *caput mortuum* and the midnight blue of a vest of course wool.

The resonance of this image is not more sonorous than visual and does not resound more in the order of sentiment than in the order of the idea. But it is a rustling of soul and colour together, and a rustling or ruffling of one sense against the other, a mingling of the sonorous in the visible. This rustling mingles and weaves threads and filaments like the *mycelium* of the desire of the dream (the desire of the dream, this genitive construction must be taken according to its two values). The accomplishment of desire is not in a final discharge but in more desire still, in the rise of the image in its proper element and its proper resonance. The proper element – the 'imaginal' – is not of the order of the visible except inasmuch as the visible brushes and rustles against itself, enters into response and reflection with itself. We cannot stop at the visual any more than at the auditory: we are suspended there where one is touched

by the other, without ever being transported there. We should only say: the one rhythms the other. Or again: the rhythm is always this, that one sensible order interrupts (itself) and resonates from another (or against the other of all the senses). As Freud has it, the umbilicus where signifying articulation loses itself is equally that through which Ariane's thread passes, forming the umbilical cord, the passage of a tortuous birth through the meandering labyrinth. Condensing these images in turn, I will mingle this thread with the filaments of the *mycelium*. That towards which Ariane's thread leads and in which it will lose itself (for Freud, in the fantasy of an anal, intestinal birth), is the monster at the obscure ground of the labyrinth. The *monstrum* constitutes a prodigious sign. The monster of the labyrinth is the beast born of a prodigious desire for the animal – that is to say, for the shadowy ground of desire itself. Not even truly desire, but the drive, the powerful *conatus* by which, well before Pasiphaé, a first painter brought to the fore, made surge forth a bull from the depths [*fond*] of a grotto, in the light of fattened wicks.[29] The silent bellowing that then resounded reverberates down the centuries and through the most withdrawn chambers of the labyrinth all the way to her, she who unravels the thread, the half-sister of the Minotaur. The name Ariane can have the sense, among others, of 'the light or bright one' [*la très claire*]. And as one knows, the proper name of her brother is not his monstrous surname, but Astérion. If one recalls that Ariane carries the bright, boreal crown, one understands that all here resounds from aster to aster [*d'astre en astre*], like the 'obscure disaster carried by light' which again Blanchot says 'replaces ordinary silence, that for which speech is lacking' (as one says commonly of the portrait) 'with a separate silence [*à part*], withdrawn, where it is the other who announces themselves in keeping silent'.[30] Ariane and the Minotaur share the obscurity, the ground of light, the inside as absolute outside, the mother, the belly without ground which always contains another just like the bovine-simulacra in whose belly Pasiphae dissimulated her own. This belly resonates from the brother to the sister, from the monster to the light. The presence of the most profound comes to resonate in the nearest and that which is most mute comes to beat in that which is most luminous. Fort-da, such is the sonorous beating by which Freud recognised the game, which he called *Vorstellungsrepräsentanz*, the taking-place of presentation, of the idea or of the image of the mother. The beaten vocalisation takes its place from that which has no place

and which properly does not take place. O-a, Minotaure-Ariane, memento-vanitas, the monster and the image, the monster in the image. The face of one resounds with the bellowing of the other and mimesis has its belly or its throat in *methexis*.

Notes

1. Georges Louis Leclerc de Buffon, *Natural History*, trans. William Smellie (Edinburgh: William Creech, 1785), 50.
2. Hans Belting, *An Anthropology of Images: Picture, Medium, Body*, trans. Thomas Dunlap (Princeton: Princeton University Press, 2011), 19.
3. [The first recorded description of the Mona Lisa, by Cassiano dal Pozzo, from 1625, describes it as 'a life-sized portrait [and] the most complete work of the painter that one can see, for it lacks only speech and all else is there' [perchè dalla parola in poi altro non gli manca]. See Claire Farago, *Leonardo da Vinci: Selected Scholarship*, (London: Taylor and Francis, 1999) and Carlo Pedretti, *Studi Vinciani: documenti, analisi e inediti leonardeschi* (Geneva: Librarie Droz, 1957). – Trans.]
4. [See Jacques Derrida, *The Truth in Painting*, trans. Geoff Bennington and Ian McLeod (Chicago and London: The University of Chicago Press, 1987) and Hubert Damisch, '8 Theses for (or against?) a Semiology of Painting', *Oxford Art Journal* 28, no. 2 (2005). – Trans.]
5. [See Jean-Luc Nancy, 'Shattered Love', *The Inoperative Community* (University of Minnesota Press, 1991), 163. – Trans.]
6. [The French word Nancy uses here is *le fond*, a term which shares its Latin etymological roots with the English term 'fundament', to which the cognate terms 'fundamental' and 'foundation' are also associated, and which also has the sense of 'depth' or 'bottom' in French. I have most commonly translated the French term as 'ground', following Jeff Fort's English translation of Nancy's book *Au fond des images* as *The Ground of the Image*, in keeping with the sense of 'le fond' in art as the background or 'ground' of a painting or visual image. It would be important to keep in mind, however, that throughout this essay, as throughout his work as a whole, Nancy plays upon the multiple senses of the term in order to deconstruct concepts of foundation and to destabilize the idea of the 'ground' as foundational. – Trans.]
7. [Nancy here follows Plato and Aristotle in distinguishing sameness

from identity, where sameness partakes of plurality and identity comes under the order of 'one' or singularity. See Plato, 'Parmenides', 158b–159b; Aristotle, *Metaphysics*, 1.3, 1054a–1055a. See also: Jean-Luc Nancy, *Being Singular Plural*, trans. Robert D. Richardson and Anne E. O'Bryne (Stanford: Stanford University Press, 2000), 97. Phillip Armstrong, *Reticulations: Jean-Luc Nancy and the Networks of the Political* (Minneapolis: University of Minnesota Press, 2009), 130. – Trans.]

8. [Nancy is referring here to an unfinished poem by Stéphane Mallarmé whose opening line reads 'Je veux épouser la notion' ('I want to marry the notion'/'idea'). 'Notion' is the term used in French to translate the Hegelian term 'Concept' or 'Begriff' and as such does not have the meaning of a vague or unsubstantiated idea that it has in English. See Stéphane Mallarmé, *Oeuvres Complètes* (Paris: Gallimard, 2003).

9. [Plato's *Republic*, Book VI, 509b9. The Good (agathon) is beyond being (epekeina tès ousias). See also Derrida's analysis in Dissemination (University of Chicago Press, 1983). – Trans.]

10. [Here, *le fond* as 'ground' or 'foundation' in relation to abstract idea or cause and substantial, material space, and 'depth' or 'bottom' in relation to abstract space, is set against related verbal forms, *fondre* and *se fondre*, meaning to collapse to its foundations and to melt, meld or to fuse, including the figurative sense of 'to melt', or to be seduced, as in the English colloquialism, 'to melt my heart'. – Trans]

11. [See Nancy, 'La Comparution/The Compearance: From the Existence of 'Communism' to the Community of Existence', Jean-Luc Nancy and Tracy B. Strong, *Political Theory* 20, no. 3 (1992): 371–98. – Trans.]

12. [See note 8 – Trans.]

13. [Here, *le fond* as 'ground', 'depth', or 'bottom', combines with prepositional phrases such as *au fond*, in the logical sense of 'fundamentally', 'at bottom'; *à fond*, meaning 'completely', as in the English colloquialism '[it suits me] down to the ground'. – Trans.]

14. [*Fond* in the original, in *L'Espace Littéraire* (Paris: Éditions Gallimard, 1955), 346. Maurice Blanchot, 'The two versions of the Imaginary', *The Space of Literature*, trans. Anne Smock (Lincoln, NB and London: University of Nebraska Press, 1982), 254. – Trans.]

15. [Immanuel Kant, *Critique of Pure Reason*, ed. Paul Guyer and Allen W. Wood (Cambridge: Cambridge University Press, 1999), 246. – Trans.]

16. ['emoved' may be now an obscure, obsolete term in English, but

it shares its meaning and its classical Latin root, *ēmovēre*, with Nancy's French term 'ému'(moved) and can be similarly hyphenated at the prefix 'e', a variant of the prefix 'ex' (out) that is characteristic of Nancy's writing ('exposition', 'ex-scription', etc.). – Trans.]

17. [In this passage, Nancy's use of the phrase, *aller au fond*, includes the directional sense, 'to go to the bottom', and the logical sense, 'to get to the bottom' (of a problem), as well as the figurative sense 'to sink', 'to founder', 'to go to ground'. – Trans.]

18. [Friedrich Nietzsche, *Nachgelassene Fragmente* (Berlin: de Gruyter, 1967), 49. 'We have art so as not to perish [*zugrunde gehen*] from the truth'. Literally, zugrunde gehen is 'to go to ground'. – Trans.)

19. Maurice Merleau-Ponty, 'On the Dream', *Institution and Passivity: Course Notes from the Collège de France (1954–1955)*, trans. Leonard Lawlor and Heath Massey (Evanston: Northwestern University Press, 2010), 209.

20. [My translation: '. . . la profondeur n'est encore que *l'apparence qui se dérobe'*, Maurice Blanchot, 'La question plus la plus profonde', *La Nouvelle Revue Francaise* (1961): 291. – Trans.]

21. ['A fleur de' – one of Nancy's favoured terms, literally, 'at the flower of', is a figurative term in French meaning just at the surface of, or just touching or brushing the surface. – Trans.]

22. [See Sigmund Freud, 'The Psychology of the Dream Processes', *The Interpretation of Dreams*, trans. James Strachey (New York: Basic Books, 1955), 528. Nancy follows standard French translations of Freud's original German word, *der Nabel*, as *l'ombilic* or 'the umbilicus'. – Trans.]

23. [Here, the term *s'enfoncer*, morphologically related to *fond*, means to sink into, to plunge, to cave in, to burrow down or embed (itself). – Trans.]

24. [*Figure maîtresse* in French; Nancy plays with the double meaning of this term, as both dominant or master figure (as the Oedipal father figure of Freud) and as the figure of the *maîtresse* or the Lady (as in Jacques Lacan's re-vision of Freud in 'On Courtly Love', *Book VII: The Ethics of Psychoanalysis*, ed. Jacques-Alain Miller (New York: Norton, 1997). – Trans.]

25. [In order to retain the morphological link between *le fond* (the bottom or base or ground) and *enfoncement* (to bury, embed), I have translated Nancy's term *enfoncement* here as fundal embedding, where fundus has the sense not only of the base or bottom of an organ but also base or bottom of the eye behind the lens. – Trans.]

26. [Nancy's term *fuite de fond*, literally, flight of ground, plays upon

the French term 'point de fuite', the vanishing point in painting.
– Trans.]

27. [*Boy in a Red Waistcoat* (1888–90). Meyer Schapiro, 'Cezanne as a watercolourist', *Modern Art: 19th and 20th century: Selected Papers* (New York: George Braziller, 1978), 45. – Trans.]

28. André Breton, *L'Amour fou*, (Paris: Gallimard, 1976), 240: (thanks to Clair Margat for the reference). [In the original, 'L'inquiétude métaphysique tombe sur le tableau par les plis de la draperie.' I have translated the French term *inquietude* as 'disquiet' in order to retain the sonorous qualities of Breton's original description. See also André Breton, *Amour Fou*, trans. Mary Anne Caws (Lincoln, NB: University of Nebraska Press, 1987), 106. – Trans.]

29. [See Jean-Luc Nancy, 'Painting in the Grotto', trans. Peggy Kamuf, *The Muses* (Stanford: Stanford University Press, 1996), 69–79. – Trans.]

30. Maurice Blanchot, *L'écriture du désastre* (Paris: Gallimard, 1980), 17, 27. [My translation of this citation by Blanchot follows the original in rendering *se taire* as 'to keep silent'. See also Maurice Blanchot, *The Writing of The Disaster*, trans. Ann Smock (Lincoln, NB: University of Nebraska Press, 1995), 13.]

5

On the Threshold:
Visual Culture, Invisible Nature

Adrienne Janus

'See the invisible, not beyond the visible, nor inside, nor outside, but *right at it, on the threshold . . .*'[1] Nancy makes his provocative imperative in an essay entitled 'On the Threshold' in relation to a painting by Carvaggio. In it, he calls attention to the invisible as the proverbial 'blind-spot' of visual culture, a blind-spot articulated most prominently in W. J. T. Mitchell's 'Critique of Visual Culture' as including the invisible, blindness, the unseen as well as other sensory modalities such as the tactile, the auditory and the haptic.[2] This imperative also raises the question of what modality of vision could conceivably see the invisible right at the threshold of the visible, and as its logical corollary, where this threshold is located, if not 'beyond the visible' in the realm of a transcendent spiritual principle, idea or signified, 'inside the visible' in the workings of a subjective consciousness (whether of the artist or spectator), or 'outside the visible' in the hidden traces of a larger material culture that the art work as an object may reveal.

In this chapter, I will explore two particular aspects of Nancy's conception of the image, and the modalities of vision corollary to it, by tracing the location of the threshold between the visible and the invisible as it moves in Nancy's writing between two different conceptual registers. The first might be called the 'macro' register of the Nancean body conceived as discontinuous sensual zones. Here, when vision as a modality of seeing visible forms reaches the limit point of intensity in relation to the image, it begins to resonate against the limits of other sensual zones, and is described by Nancy as a modality of listening or of touch, senses attendant to the invisible or the unseen. The second conceptual register is the 'micro' register of particles and waves, where, in the resonance of sense and the senses set in motion in relation to the image, Nancy's descriptions of images as visible forms dissolves into descriptions

of the invisible forces of physics, forces relating not only to the physics of light, but of sound and impact. Thus Nancy describes the light of the photographic image as the 'absolute velocity of appearing bodies, the sculpture of their mass'; sculpture as the art of 'mass as density and as gravity, as a measure of presence'; and video as the 'becoming-particulate' of the image, where 'light [is] converted into punctual signals [. . .] decomposed and recomposed into suspended and rustling waves'.[3] In addition to exploring these two conceptual registers through Nancy's works, such as 'The Image: Mimesis and Methexis', and a recent collaborative work with physicist Aurelien Barreau, called *What's these worlds coming to?*,[4] I will analyse how they come into play in two particular images. The first is a philosophical poetic image by Nancy, unearthed from an early unpublished journal and exposed in a recent exhibition *Trop*. The second is a video image from the work of contemporary artists John Wood and Paul Harrison. Throughout the course of this exploration, I will demonstrate that Nancy's descriptions in these two different conceptual registers are not only a rhetorical strategy in the philosophical project of deconstructing the ocularcentrism of Western metaphysics and of dislocating vision from its primacy in the sensual hierarchy. Just as Nancy's descriptions in these conceptual registers draw upon concepts from classical to modern science, from Aristotle to contemporary particle physics, they can also be set against current research in the sciences ranging from the physics of vibration and radiation in complex systems to visual psychophysics, and rearticulated in ways that make both philosophical and scientific sense. Thus, Nancy's imperative to see the invisible right at the threshold of the visible may also be indicating the thresholds that both separate and hold open a space between art and science, between 'visual culture' and 'visual nature'.

Nancy, in collaborative dialogues with practising artists such as Soun-Gui Kim and in recently published collaborative work with theoretical physicist, Aurelien Barreau, explores the location and dislocations of the threshold between culture and nature as of between art and science that have dominated Western thought. It is telling that Nancy does this, not by going back to Plato, for whom the sight of objects in the world was regulated by a vision of invisible forms of which all things in the world were merely visible copies, but to Aristotle. Aristotle conceived of the world and nature as realities in and of themselves accessible to human

intelligence through sensual perception and sensory experience in all its multiplicity, rather than through metaphysical 'visions'. It is in Aristotle's *Physics* (via Heidegger's reading of Aristotle in 'The Question Concerning Technology')[5] that Nancy finds the first location of art as that which marks the threshold between nature and culture, between *physis* as the principle of natural growth and *technē* as the techniques and technologies of human creation. In the classical period, says Nancy, 'Art is a word that was used to mean technique. "Art", in Latin "ars", was a translation from the Greek *technē* and, as Aristotle claims, *technē* is that which accomplishes ends where nature does not. Nature makes flowers grow, but nature does not make tables grow.'[6] For Aristotle, as indeed for Nancy, neither nature nor art is a copy of something beyond the world (a Platonic form or idea) or a reproduction of something in the world (an already existing thing in nature or culture). Rather, each flower, each work of art or image brings an original presence into the world through different means, but with no other end or necessity than to come into existence as the reality that it is (and Nancy's frequent use of floral expressions, such as *à fleur de* or 'at the flower[ing] surface of the image' to describe the image is not due to any presupposition of organicity, but due to the complexity and fragility of that reality as a surface that lightly brushes against the surface of our own existence).[7]

Thus, in the example Nancy offers, when Caravaggio or Corot paint a cluster of grapes, we do not see the visible (flawed) copy of the invisible Platonic Form 'Flower', or of a 'thing' as an object in nature, but the presentation of nature as a unifying principle of growth reproduced or re-presented by the artist's own technique of bringing the image to presence. Today, however, the penetration of technology into nature provokes mutations in both culture and nature, collapsing the distinction between culture and nature, as well as the Aristotelian distinction between the means of nature and those of technology. This is why, suggests Nancy in the dialogue with Soun-Gui Kim, no one today is going to paint a cluster of grapes. Instead, they might take a label from a bottle of wine and make a collage, or film it to present that which might be otherwise invisible: namely, the growing process of the technisation of nature that Nancy describes by the term 'ecotechnics'.

This technisation of nature dislocates the idea of nature as a unifying principle of growth and replaces it with the endless proliferation of new techniques and new technologies, which in turn

produces the endless proliferation of images, where 'everything must be made into an image, a sound, a rhythm, a monstration: bodies, products, places'.[8] This endless proliferation of techniques, technologies and images is however not 'unnatural', as 'technology too must be defined as one of nature's ends, since it is from nature that the animal that is capable of – or in need of – technology is born'.[9] Following Nancy's logic, one might say that it is from nature that the animal that is capable of – or in need of – art is born. This animal is born not as *homo sapiens* (as a species endowed with an essential 'human' nature) or as *homo faber* (man the maker bound by the dual logic of construction and deconstruction), but as *homo, animal designans, animal monstrans*. This is the human animal born of nature as drawn by no unifying, preconceived plan, principle or purpose, with no reference to an original or final construction, but whose need for the arts, technologies and sciences (s)he is capable of designing in turn penetrates both nature and culture, such that all existents are drawn together and dispersed in the ceaseless proliferation of 'profusions of species, forces, forms, tensions, intentions' whereby 'the possibility of the world – or indeed the multiplicity of worlds – renews itself'.[10]

This profusion and multiplicity of singularities is not regulated as the tension between order and chaos, construction and de(con)struction, but as the resonance between singularities that co-appear as a multiplicity of 'non-assembled assemblages'. This multiplicity is described by the logic of what Nancy, in his recent collaborative writings with the physicist Aurelien Barrau, calls 'struction': the 'non-coordinated simultaneity of things and existence, the contingence of their co-appartences'.[11] It is this mutual implication of nature and culture, of art and science, this logic of 'struction' that determines the two conceptual registers that Nancy's writing on the image oscillates between: the macro conceptual register of *homo, animal designans* as the 'non-assembled assemblages' of the body and the senses, a body that is itself a decentred, discontinuous multiplicity of sensual zones with no preconceived plan or unity as 'a body'; and the micro-conceptual register marking the penetration of technology into the otherwise invisible aspects of nature and the dispersion of these 'non-assembled assemblages' as forces, particles and waves.

Two images of 'non-assembled assemblages' invite us to see the invisible right at the threshold of the visible by moving between the macro register of bodies and the micro register of particles and

waves. This micro register touches upon images of the multiverse from the ancient to contemporary worlds. The first is a philosophical poetic image from a 1970 unpublished notebook by Nancy. The notebook was brought to light for a recent exhibition featuring Nancy's writing, paintings by François Martin, and music by Rodolphe Burger.[12] The second involves the particulate image of video works by artists Harrison and Wood, where audio-tactile modalities of vision are activated through their presentation of sculpted space in the play of spherical bodies – their own bodies, tennis balls, bubbles, floating spheres of light – whose 'mass as density and gravity' are converted into 'suspended and rustling waves'.[13]

In the passage taken from Nancy's early notebook, the philosopher meditates on the threshold experience offered by an image of what he calls 'the most primitive form' of vision at the threshold of the invisible, one that goes back to Pythagoras and Plato and runs through the middle ages and Renaissance: namely, the music of the spheres, an image of bodies in movement, where the spherical orbits of celestial bodies move in resonance with bodies on earth. Nancy's writing here suggests an oscillation between vision as a modality of listening and of touching, an example of perceptual switching between sensory zones that Nancy's writing on the image also invokes.

> The most primitive form of what was called the music of the spheres [is] a white music – barely a sound, barely a timbre, barely a cadence, and all the same a repeating beat, noise in formation [. . .] this insonorous, dampening matteness softly engenders, in its disappearance, a kind of vision. What kind of sight is this? But what then is seeing? [after a large blank space in the page] Would it not be a touch, as Descartes had it, but otherwise? Would it not be this ever-so light contact, this blossoming of things on the eyeballs, whose noise dies in whiteness (and don't images have something to do with this)? To see would be a manner of kissing the eye, in a white whisper, where a tiny irisation would tremble.[14]

Here, at the threshold point where the invisible rhythms and resonance of particles and waves in the music of the spheres disappears upon the whiteness of the eye, vision is engendered as a touch, the ever so light contact from which blossoms another delicate, ephemeral sensory presence or image. This touch is not

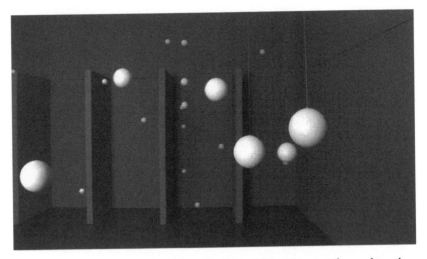

Figure 5.1 John Wood and Paul Harrison, *The only other point*, 2005 / 13′44″ / HDV / Courtesy the artists and Carroll/Fletcher Gallery, London.

that of a hand-oriented tactility that grasps and holds a totality (a concept or an object). It is neither the 'pure' sensory experience of a Cartesian world 'with its skin off' that Heidegger calls being present-at-hand or the contextually embedded ready-to-hand of being in the world.[15] It is rather the contact of two exterior parts of spherical surfaces lightly brushing each other at the most minimal points of contact and release: the spherical surface of lips brushing against the spherical surface of the eye. Or more precisely, to put Nancy's image in contact with the physiology of the human body, it would be the spacing of spheres in resonance: the sphere of the orbivularis oris muscles of the lips that contract and dilate to form a kiss around the aperture of the mouth; the sphere of the orbicularis oculi muscle that opens and closes the eyelids; and the sphere of the iris, a diaphragm whose contraction and dilation encircles the space of another sphere, the pupil which contracts and dilates in turn.

The image of the music of the spheres that Nancy develops here finds a complementary image in the videos of artists Harrison and Wood. In a sequence entitled *The Only Other Point*, the curvature of points of space is traced by the rhythmic choreography of spherical bodies (tennis balls, bubbles, orbs of light) that emerge and disappear as the camera pans left to right. In a rhythm that recalls the contraction and dilation of the muscular orbs of the

human eye from Nancy's image, or the rhythms of the saccadic movement of the eye as it tracks the movement of these spherical bodies, each scene or sequence of images opens and closes amidst the blackness of the flat, containing rectangle of the video screen. The first sequences trace the invisible force of gravity in the multiplicity of singular bodies that fall through space: tennis balls falling from a point off-camera onto drums whose resonance marks the dispersal of the force of impact of the balls' descending velocity, a force whose velocity is otherwise ungraspable and invisible; bubbles whose fragile transparency offers a vision of the light massiveness of their presence. Then, in an image that appears near the end of the sequence, these images of spheres in movement are decomposed and recomposed into a vision of the harmony of the spheres that absorbs and transfixes us in its resonant stillness: spherical white orbs suspended in resonant space, rotating almost imperceptibly as a register of the refraction of waves of force, the dispersal of air, of the resonance between them. If, as Nancy states, with video the image becomes particular or particulate, here, the particular 'I' of visual perception becomes absorbed in a vision that seems to oscillate between perception of the distinct parts of any one particular, rotating spherical body and the perception of the resonant whole of these bodies as non-assembled assemblages.

I will now turn to Nancy's essay 'The Image: Mimesis and Methexis' in order to further explore the conceptual registers subtending these images of 'non-assembled assemblages'. I will accomplish this by examining the macro conceptual register of the body as a discontinuous multiplicity of sensual zones, and the modalities of vision associated with it as a locus of the threshold between the visible and the invisible. Nancy's emphasis on the body as the threshold between visible and invisible sensations, and on the image as a site marking the threshold between art and science, is announced nicely in the two epigraphs that headline the essay. The first is from the scientist, cosmologist and natural historian Le Comte de Buffon's 1785 treatise *Natural History: Of Man*, which speaks of a vision of sensual excess: the 'increase of sensation' of opening one's eyes to a natural scene, where light, sky, earth, and water 'conveyed pleasures which exceed the powers of expression'.[16] The second epigraph is from the German art historian Hans Belting's recent book, *An Anthropology of Images: Picture, Medium, Body*, which speaks of vision as a threshold experience of the body, where 'We perceive the image as if it were

using our body as a host medium [. . .] through which we both give birth to inner images and receive images from the outside world.'[17] Nancy's interest in Buffon's citation is not because it locates the body as a threshold between visible sensations and the invisible idea of nature, but because it describes a modality of vision that reaches a threshold of sensual intensity. Similarly, Nancy's interest in Belting's conception of the body as a threshold between (presumably) invisible 'inner images' and visible 'outer images' does not have to do with the body conceived as an incubating medium for the internal consciousness of a subject who captures external images by sight and 'completes' its representation in psychic interiority of the imagination or mind (a problematic theory not only for Nancy and Belting but also, as we shall see, for scientists in the field of visual psychophysics). Nor, in receiving images from the outside, is the body that which is imprinted by the invisible trace of cultural inscriptions. Rather, for Nancy, the body – whether the body associated with the human self or the 'body' of an image – is not one and is not 'a body' but 'a range of intensities where each zone becomes a discontinuous whole from the others, without there being a totality of any part'. Or, rendered in terms of the logic of 'struction', the body is a singular multiplicity formed by the co-appearance of body and image as a 'non assembled assemblage' that 'ceaselessly remodels and replays the sharing out of erogenous or eidogenous zones'[18] of the senses and of sense. If this 'imaginal' body is a locus of sensual intensity whose force of erogenous tensions and eidogenous intentions gives birth to imaginal forms, it also at the same time gives birth to new forms of the self, a self that is no longer a self of visual subjectivity fixed to its objective point [of view] but 'is exposed, pushed outside and returning to itself, [. . .] no longer *punctum caecum* but *corpus sensitivus*'.[19] The self, in other words, is no longer the subject of visual perception whose field of vision in perceiving any objective form contains a blind spot, but a sensory-sensitive body whose excitation in the zone of the visual reaches the threshold point of excitation and sets into resonance other sensual zones or modalities in the range of the invisible – primarily listening and touch.

Indeed, in 'The Image: Mimesis and Methexis', Nancy counters the presumed 'silence' of images with descriptions of images whose surfaces rustle and murmur in resonance with the movements of the self as 'corpus sensitivus' and with the 'fundamental noise' of their groundless ground. It is in light of this that Nancy describes

the modality of vision associated with the body as a corpus sensitivus not as a modality of sight but of listening, where we 'see' the invisible right at the threshold of the visible.

> Differently to the sight of an object, the seizing [la saisie] of the image – or indeed the imagination understood as a faculty for seizing and producing images – would represent a vision operating as a mode of listening: a vision that would experience in sight [la vue] (la *veduta*, le *Bild*, le *tableau*) the movement of its rising in me and its return towards me. Experiencing its resonance in this way the image would form the sonority of a vision, and the art of the image a music of sight.[20]

With a vision that operates as a modality of listening, we are no longer dealing merely with bodies, no matter how sensitive, but with the 'invisible' space that opens up as a site of resonance between 'visible' bodies, a site of resonance which ceaselessly gives birth to new imaginal forms and imaginal bodies as singular pluralities that co-appear in the simultaneous vibration of their movement in resonance.

I would like to put a bit of pressure on Nancy's movement from the body conceived as 'corpus sensitivus' to this opening or spacing between 'imaginal' bodies conceived as a site of resonance where singular pluralities co-appear. This is not only because it is a movement that allows Nancy to escape accusations of hypostasizing a form of body-centric presence. Nor is it only because Nancy insists on this conception of resonance in describing art and the art of image-making as that which ceaselessly gives birth, in the mixing of force and form, to new imaginal bodies, when he declares, for example, that 'What is named by the very indistinct term "art" is nothing but this resonance of resonances, this refraction of refractions between zones of emotion.'[21] It is also because Nancy's conception of resonance here, and of sight as a modality of listening, has interesting points of convergence with science. This brings us to the second conceptual register, that of particles and waves. One point of convergence would be with a fascinating, but incorrect, scientific theory that still held at the turn of the twentieth century: that just as sound waves are propagated in air, impact waves in water, the propagation and refraction of light waves through space also required a medium, the invisible (and non-existent or imaginary) medium of ether. Other, perhaps more productive points of convergence can also be located in the

concept of resonance as understood by current research in the physics of vibration and acoustics as well as visual psychophysics. These points of convergence suggest that aspects of being-with and co-appearance that have been seen as philosophically and logically problematic in Nancy's ontology and aesthetics have some basis in 'real' (or at least scientifically verifiable) experience of the world.

The first philosophical or logical problem that might be resolved by setting Nancy's conception of resonance against studies in the physics of sound, radiation and vibration in complex systems has to do with Nancy's ontology of co-appearance as 'mediation without a mediator', as Nancy describes it in *Being Singular Plural*.[22] Namely, how can we 'know' (perceive, sense) the limits or boundaries of singular existents as that which always comes into appearance simultaneously with other existents without that co-appearance being constituted by an inter-subjectivity that is formed by the mediation of a self by the other, or, for that matter, by an encounter with the self as other as mediated by the image? First, it must be noted that resonance, in physics, as in Nancy's use of the term, does not have to do with intersubjective sympathetic affective vibrations transmitted through the medium of the body or of language, a conception of resonance that runs from Rousseau's affective communion to Lacan's psychoanalytic conception of 'intersubjective resonances' between analysand and analyst, to the sensory intercommunication of Merleau-Ponty's sympathetic vibrations between self and world associated particularly with synaesthesia.[23] Rather, resonance, as defined by scientific studies of vibration in complex systems, is the particular phenomena of wave propagation and reflection at the limits or boundaries of those systems. Resonance is not then a phenomenon of free vibration, but, 'as a large amplitude response to excitation', is a 'phenomenon associated with *forced* vibration, generated by some input'.[24] Or, in Nancy's terms, the resonance of the image is not the free vibration or circulation of sense and the senses in the world, but is also generated by some input: by the force of the artist's desire to bring forms to the fore out of the inform, with an inaugural gesture of painting, drawing, photography, etc., that accompanies but then exceeds any artistic intention; by the force of our desire to enter into relation with the image that moves us in tension towards it and incessantly withdraws. Most significantly, in the physics of complex systems we encounter no logical problem with 'mediation without a mediator' and no recourse to inter-subjectivity to explain how the limits or boundaries of any singular

element or part of a system is constituted if these limits or bounda-
ries necessarily co-appear in relation to other singularities. In a
description of the elements of a complex system (whether sound,
light, impact or other frequency waves) that highlights subjectivity
as merely a conceptual default habit and linguistic convenience,
the 'elements of complex systems only "know" about boundaries
because of the phenomena of wave propagation and reflection'.[25]
Or in Nancean terms, it is only through resonance – the reflection
of frequency waves at boundaries – that we 'know' (sense, perceive,
hear, touch, see, etc.) the edges, boundaries, and limits of forms of
images, of ourselves, of the world in the first place. Insofar as reso-
nance also involves the large-amplitude excitation of the bounda-
ries against which these waves or forces are reflected, furthermore,
in the physics of complex systems resonance can 'lead to structural
failure or other undesirable consequences'. Obviously, in Nancy's
poststructuralist philosophy, structural instability is to be desired,
and resonance always also destabilises, blurs the boundaries of any
form, moving them in resonance towards a dissolution that opens
again incessantly to the emergence of new forms, to new 'imaginal'
bodies.

When brought back into relation with visual perception, Nancy's
conception of resonance as one of being moved not before but *in*
resonance with the image, where the boundaries of any form are
necessarily blurred or destabilised, raises the question of how it
is then that our perceptual experience of images, and of Nancy's
descriptions of particular images in his writing, attains such a
high-level of intensity and acuity, rather than merely dissolving
into the experience of semi-visible blur. If, as Nancy has it, the
'consistence' of the image is not constituted by the contrast or
'contours of figure and ground', but in the resonance of forms
that offers 'a polyvalence of impression that blurs figures' and
'dissolves the unity of substantial ground', how then do we 'see'
so clearly and intensely the images Nancy evokes?[26] For example,
in our encounter with Cézanne's 'Young man with skull' in 'The
Image: Mimesis and Methexis', Nancy brings to the fore both the
distinct forms or 'figures' of the foreground – the 'visibly drawn
ear' of the young man, the coloured textures of his waistcoat of
'coarse wool of midnight blue', the 'hard lines of the skull' – as
well as of the 'background' of 'the softened, faded mauves, the
pale-green of the ground', highlighting the line moving between
the two 'as though tied together by tracks of white'.

This brings us to the second point of convergence between Nancy's conception of resonance and studies in visual psycho-physics of stochastic resonance as 'seeing' the visible at the threshold of the invisible. These studies demonstrate a counter-intuitive property of sensory thresholds within human and animal visual systems relating to images with low-level contrast between 'figure' and 'ground' or weak or blurry edges that normally fall near the threshold of visibility (are almost invisible). When a stochastic force (random wave frequencies across the spectrum) is introduced across the visual field (that is, along a diagonal between figure/ ground) some of its frequencies resonate at the same frequencies as the visual signal, amplifying, rather than decreasing, the ability to perceive distinct forms.[27] Rather than rendering visible forms invisible in a mushy visual fusion of figure and ground, perception spontaneously switches between two opposed poles or two possible perceptions, where, using Nancean terms, perception oscillates between the poles of the ground rising to the surface, and forms sinking back into ground.

Having explored Nancy's conception of vision as a modality of 'listening' or of sensory resonance in both the 'macro register' of the body and the 'micro' register of particles and waves, we have not exhausted the modalities of 'seeing right at the threshold between the visible and invisible' offered by Nancy's conception of 'imaginal' bodies as discontinuous zones of sensual intensity. An aspect of Nancy's writing that has garnered far more attention than this conception of resonance and vision as a modality of listening is, of course, Nancy's conception of vision as akin to a modality of touch, a tactility that does not grasp and hold images as objective totalities, but registers across the distance of exterior space, a proximate contact between zones of surface exteriorities: between the surface of the eye or the skin and parts of the surface of an image or the world. Nancy's conception has interesting points of convergence with studies in visual psychophysics, particularly those that also turn to tactile analogies to question the idea that we overcome defects in the engineering of our visual system (the blind spot, the smearing of saccadic eye-movements) through an internal representation or 'iconic' mental picture that completes and fixes our necessarily partial and defective views of the exterior world. In a line of argument that echoes Nancy's oft-repeated critique of the history of representation in Western culture, visual psychophysicist O'Regan states that this notion

of the world as picture is an illusory impression formed by our 'cultural heritage of graphical representation (maps, drawings, paintings, photographs, diagrams, film and video) which biases us into thinking that our representations of reality have a similar iconic quality'. Similarly to Nancy's conception of our sense of the world as spatial exteriorities, O'Regan claims that 'we need make no internal representation, replica or "icon" of the outside world, because it is continuously available "out there"'.[28] If the outside world is continuously available as an exteriority, the question of 'Why do we not notice optical aberrations or gaps [relating to the blind-spot] [or] the smear and displacement caused by eye movements [saccadic rhythms]?' is easily transferred to the analogous question: why, when we hold a bottle, do we not feel holes in the bottle where the spaces are between our fingers? A tactile impression of smoothness and wholeness is provided by registering the sequences of changes in sensation by 'sampling' – by moving our fingers over the bottle – and we are aware of the idea of the whole bottle but only ever feel part of it at any one time. Similarly, in visual perception, we can only attend to a part of an exterior presence at any one time by 'sampling', 'probing' (or in Nancean terms 'touching) the exterior surfaces of our environment through changes in eye movement, attention, body position and other perceptual senses (haptic, tactile, motion, etc.). From these 'probes', we assemble a 'schema' of spatial exteriority, a kind of 'non-assembled assemblage' of parts. For O'Regan, then, the question of 'Why the visual world seem[s] to offer us the impression of such a rich, full presence?' is a non-question: 'Like the concept of "ether" in physics at the beginning of the century, these questions evaporate if we abandon the idea that "seeing" involves passively contemplating an internal representation of the world that has metric properties like a photograph or scale model.' 'The richness and presence of visual perception are actually an illusion', an illusion, O'Regan conjectures, that is equally available to the congenitally blind whose relation to the world is primarily (audio)tactile.

To dispel this illusion of fullness of presence of the 'whole' that Nancy's body-centred ontology of the human animal might offer, Nancy not only oscillates between vision as a modality of listening-touching to reach the threshold of the invisible, but also decentres these sensory modalities with another move towards a micro-conceptual register of the physics of 'invisible' particles and waves.[29] In this movement between two conceptual registers, we

encounter the threshold not only between the visible and the invisible, but also the threshold between art and science, between metaphysics and physics, where the idea of a 'world-view' that grasps the world as a totality gives way to a multiplicity of images and a multiplicity of worlds. As the philosopher Nancy and physicist Barreau announce in their collaborative work: 'even the idea of "world" (one, an ensemble) no longer applies either to investigations in physics or to metaphysical interrogations; "pluriverses" or "multiverses" are the order of the day for physicists while "multiplicity" and "multitude" traverse sociologies as much as ontologies', a multiplicity that does not consist merely in multiplying, as in 'multiculurality', but in the fortuitous, non-coordinated simultaneity of non-assembled assemblages of bodies, spheres, and particles in resonance.[30]

Notes

1. Jean-Luc Nancy, 'On the Threshold', in *The Muses*, trans. Peggy Kamuf (Stanford: Stanford University Press, 1996).

2. W. J. T. Mitchell, 'Showing Seeing: A Critique of Visual Culture', *The Journal of Visual Culture* 1, no. 2 (2002): 165–81.

3. Jean-Luc Nancy, *Multiple Arts: The Muses II* (Stanford: Stanford University Press, 2006), 171, 180. Jean-Luc Nancy, *The Ground of the Image*, trans. J. Fort (New York: Fordham University Press, 2005), 74.

4. Audrelien Barrau and Jean-Luc Nancy, *Dans quels mondes vivons-nous?* (Paris: Galilee, 2011); *What's these worlds coming to?*, trans. Travis Holloway, and Flor Méchain (New York: Fordham University Press, 2014).

5. See: Martin Heidegger, 'The question concerning technology', in *The question concerning technology and other essays*, trans. William Lovitt (New York: Harper & Row, 1977).

6. Jean-Luc Nancy, *Presentation and Disappearance: Dialogue with Soun-Gui Kim*, in this volume. Aristotle, *Physics* II, 198a25, 199a31.

7. Nancy's frequent use of the phrase 'à fleur de l'image', a figurative expression meaning 'just at the surface of the image', but whose literal translation is 'at the flower of the image', has prompted discussions of Nancy's conception of the image as a flower or 'the touch of a flower.' See James Elkins and Maja Naef, eds, *What is an image?* (University Park: Pennsylvania State University Press, 2011).

8. Barrau and Nancy, *Dans quel Mondes*, 83.

9. Ibid.

10. Ibid., 19, 95.

11. Ibid., 90.

12. From Nancy's unpublished notebook, 'Le Philosophe Boiteux' (1970), excerpts of which were exhibited for the exposition: Rodolphe Burger, Isabelle Décarie, Louise Déry, Jean-Luc Nancy, Georges Leroux and Ginette Michaud, Trop. Jean-Luc Nancy (Montréal: Galerie de l'UQAM, 2006), exhibition.

13. Nancy, Multiple Arts, 180. Nancy, The Ground of the Image, 74.

14. Cited in: Ginette Michaud, Cosa volante: le désir des arts dans la pensée de Jean-Luc Nancy: avec trois entretiens de Jean-Luc Nancy (Paris: Hermann, 2013), 221 [my translation].

15. Martin Heidegger, Being and Time, trans. Macquarrie and Robinson (Oxford: Basil Blackwell, 1962), 132.

16. Georges Louis Leclerc de Buffon, Natural history: general and particular (1785), trans. William Smellie (Edinburgh: William Creech, 1785), 50.

17. Hans Belting, An Anthropology of Images: Picture, Medium, Body, trans. Thomas Dunlap (Princeton: Princeton University Press, 2011), 19.

18. Nancy, 'The Image: Mimesis and Methexis', in this volume.

19. Ibid.

20. Ibid.

21. Ibid.

22. For further discussion of the philosophical problems with Nancy's conception of mediation without a mediator in Being Singular Plural, see Simon Critchley, 'With Being With?: Notes on Jean-Luc Nancy's Re-writing of Being and Time, in Ethics, Politics, Subjectivity: Essays on Derrida, Levinas and Contemporary French Thought (London: Verso, 1999).

23. Jacques Lacan, 'The Resonances of interpretation and the time of the subject in psychoanalytic technique', in Écrits, trans. Alan Sheridan (New York: Norton, 1977) and Friedrich A. Kittler, 'The World of the Symbolic, the World of the Machine', in Literature, Media Information Systems, ed. John Johnston (Amsterdam: GB Arts International, 1977), 140. See: Maurice Merleau Ponty, The Phenomenology of Perception, trans. Colin Smith (New York: Routledge, 1962).

24. Frank J. Fahy, Sound and Structural Vibration: Radiation, Transmission and Response (Boston: Academic Press, 2012), 28–38.

25. Ibid.

26. Nancy, 'The Image: Mimesis and Methexis'.

27. On the role of stochastic resonance in enhancing the ability to attend to visual forms with weak signals or visual forms with low contrast, 'weak' edges, particularly in a 'noisy' visual environment (environments common to contemporary visual art), see Kurt Wiesenfeld and Frank Moss, 'Stochastic resonance and the benefits of noise,' *Nature* 373 (1995): 33–6.

28. Kevin O'Regan, 'Solving the Real Mysteries of Visual Perception', *Canadian Journal of Psychology* 46, no. 3 (1992): 461–88.

29. On Nancy's move between conceptual registers in relation to an 'erotology of touch', a 'hyper-micrology' of theoretical physics, and a deconstructive logico-semantic register of 'difference-without-positive-terms', see: Geoffery Bennington, 'In Rhythm: A Response to Jean-Luc Nancy', *SubStance* 40, no. 3 (2011): 18–19.

30. Nancy and Barreau, *Dans quels mondes vivons-nous?/What's these worlds coming to?*: 13–14. [my translation].

6

Pornosophy: Jean-Luc Nancy and the Pornographic Image

Peter Banki

What happens when a philosopher gets a hard-on? Generally speaking, this is not a subject philosophers often discuss. Moreover, the slang, some might even say obscene expression 'to get a hard-on' does not properly belong to the idiom of academic research. In place of 'hard-on', or the only slightly less offensive 'erection', one should probably say something like 'tumescence of the penis', presuming for the moment that a hard-on must refer to a penis, which in turn must be part of a male body identifiable as such. Nothing could be less certain. In any case, the boldness and directness of the idiom of 'getting a hard-on' should probably be avoided, since its place is rather in pornography or maybe the bedroom. And yet, in apparently complying with such a powerful taboo, one must be able to ask if an opportunity is thereby lost. 'Male' philosophers such as Georges Bataille, the Marquis de Sade, Friedrich Schlegel and, closer to our time, feminists such as Hélène Cixous and Luce Irigaray have not only reflected on sexuality, they have sought to bear witness to ways in which sexual arousal and desire touch their philosophical thoughts and writing. For this mode of sexualised reflection, Avital Ronell has proposed the term 'pornosophy'. She introduces it as follows:

> Closer to the mores of contemporary writers, Friedrich Schlegel to this day takes beatings from philosophical overlords who continue to press charges against the philosophical pornography machine, the *pornosophy*, his novel *Lucinde* indulges. As Paul de Man once drove home, the scandal of Schlegel consists in the crossover of genres, the wonton staging of incompatible codes, and the ensuing contaminations of reciprocally alien formalities, rather than in the build up of any specific or accreditable content. These writers, including, of course, the formidable Marquis de Sade, have tried to take philosophy to bed.[1]

Has anyone in modern philosophy ever attempted to elaborate an ethics or politics of the hard-on? Enduring debates about what is called the gender gap in philosophy departments throughout the world,[2] sexual harassment,[3] not to mention the endless vexations and jokes about the virile comportment of philosophers, and philosophy itself, that have been circulating in the backrooms of the discipline since I don't know when – all of this would support an argument that such an ethics or politics merits at least to be considered. In *The Post-Card* Jacques Derrida was not afraid to see that behind Socrates' back, under his right leg, Plato had 'an interminable disproportionate erection'.[4] This image, which Derrida claimed to have discovered one day on a post-card in the gift shop of the Bodleian library in Oxford, is from a drawing by Matthew Paris (1217–59), which appeared in a thirteenth century manuscript containing a series of fortunetelling tracts. Derrida went on to announce that 'this couple . . . these old nuts (*ces vieux fous*), these rascals on horse back (*galopins à cheval*) . . . this is us, in any event *a priori*, (they arrive upon us) (*c'est nous de toute façon,* a priori, (*ils arrivent sur nous*)'.[5] In all probability Gilles Deleuze was on a similar wavelength when in a published letter he spoke memorably about conceiving the history of philosophy 'as a kind of ass-fuck (*enculage*), or, what amounts to the same thing, an immaculate conception'.[6] Taking from behind the older philosophers who apparently came before him, Deleuze imagined himself in a virile position that replicates that of Plato in *The Post-Card*. The image of intergenerational and, one must confess, white male coupling, or to use a subcultural term, barebacking,[7] is from the point of view of Western philosophy scarcely one image among others. Both Derrida and Deleuze seem to agree; it belongs almost intrinsically to philosophy's procedures of transmission, be they conscious or unconscious. Could one dream of or imagine different procedures of philosophical transmission?[8] How might one begin to think the hard-on's finitude?

Naked erection: 'A spurt of paint in our eye'

Finitude, it goes without saying, is one of the major motifs of the thought of Jean-Luc Nancy, who inherited it in a certain way from Martin Heidegger. 'We are infinitely finite', Nancy writes, 'infinitely exposed to our existence as a nonessence, infinitely exposed to the otherness of our own being.'[9] Although he never,

to my knowledge, posed the question of finitude in terms of the hard-on, Nancy is one of the few philosophers to take the erect penis into consideration. He has also written on 'The Birth of the Breasts', as well as the *baiser* (which in French means both kissing and fucking) in a book called 'The "There is" of the Sexual Relation' (*L'Il y a du Rapport Sexuel*).[10] Further, he has written of the opening of the *baiser* onto 'the bite and the taste of blood' and 'the unbearable tearing apart of orgasm' in a remarkable reading of a film by Claire Denis called *Trouble Every Day*.[11] For reasons that will become clearer below, I'm not sure, however, if he would ever accept that his thought be described as 'pornosophy'. I would even go so far as to suggest that it is possible to read in Nancy's writings a certain aversion to porn, linked, as is so often the case, to a denigration and stigmatisation of sex work.

Nancy's discussion of the erect penis can be found in the context of a study of the nude in Western painting and photography, which bears the elegantly inventive title *Nus Sommes [La Peau des Images]* (2006). The English translation of the title, *Being Nude [The Skin of Images]*, sadly loses the sense of nudity as an existential mode of our exposure to one another, our being-with: another Heideggerian motif that Nancy has emphasised and in many ways, dare I say, expanded.[12] The study of the nude is undertaken as part of a collective writing project with Federico Ferrari, who was one of Nancy's students.

Now surprisingly, Nancy and Ferrari insist on maintaining a clear distinction between the nude and pornography, even while they are compelled to acknowledge that in the nude there is always some vacillation between the two:

> [T]he nude is never only shown; it also shows its monstration. There is no stripped nude that isn't stripping (stripping itself: and being stripped by whoever sees it). In this sense, there's always an imperceptible vacillation between the nude and porno. Not that the difference isn't clear: but it trembles, and this is perhaps also the trembling of modesty.[13]

Modesty for Nancy and Ferrari is a decisive value; it allows the imperceptible vacillation between nude and porn to be held in check. For once an erect penis enters on the scene, the nude they claim goes beyond nudity and becomes unambiguously pornographic, because all reserve of modesty has been lost:

Of all human nudity – and there's no other kind of nudity – the penis is the only part that reveals more than, or something other than, nudity . . . Nudity here lacks any reserve of modesty. The skin is not the luminous transparence of the body; it is only an organ and an additional limb. In truth, the body is left behind. We are before another presence, singular, independent – hanging out. Either the penis falls, almost shapeless and crumpled, an awkward pendulum, or it's erect, swollen, huge, powerfully in action, with meaning and presence only in ejaculation. [T]he erect penis can't be painted (or photographed) without being pornographic, that is to say, without revealing a *methexis* without a *mimesis,* a contact, a contagion that dissolves the representation. The penis is the joker of the naked – but an uncompromising joker (*Joker*), forever too improper really to be put into play (*à jamais impropre à entrer véritablement dans le jeu*).[14]

What exactly is so threatening about the sight of a penis, especially an erect one? From where comes the necessity to put the penis into a separate archive called pornography and thereby immunise the archives of Western art and philosophy? As counter examples to Nancy and Ferrari's argument, one could, of course, name the work of artists such as Robert Mapplethorpe, who do not seek to conceal the penis in their nudes. Moreover, anyone who has ever set foot into a Tantra, Taoist sexuality or kink/BDSM[15] workshop might also query Nancy and Ferrari's reading of the erect penis as having 'meaning and presence only in ejaculation'. But this will not help to read what for them – and perhaps also for a dominant tradition of Western art and philosophy – appears to be singularly threatening.

Nancy is willing to acknowledge that, without exception, all images have an erotic component that is proper to them, due to the *methexis*, the force of desire and participation, which envelops and propels the aesthetic form. 'Each *eidos*', he writes, 'is an *eros*: each form marries a force that moves it.'[16] In the same essay, 'The Image: Mimesis and Methexis', Nancy adds: 'No *mimesis* occurs without *methexis* – or else be merely copy, reproduction – that is the principle. Reciprocally, no doubt, no *methexis* without implicating *mimesis*, that is to say precisely production (not reproduction) in a form of the force communicated in participation.'[17] Like an unmarried bachelor, the single erect penis, however, would no longer be erotic, but a force without modesty or reserve – a contagion so powerful that it dissolves the apparent stability of the aesthetic form and can therefore no longer be taken seriously. As

pornography, it would be masquerading as the thing itself of sex, which cannot be represented:

> But the penis offers to us a blind and obscene orbit, a sort of *comic* menace . . . a spurt of paint in our eye, which is nothing but Polyphemus's furious spasm and the painting of desire, which cannot be represented.[18] The sun, death, and sex: we cannot look straight at them because they do not have a face. They are each an access to the absolute, the infinite, real impossibility, and the intimate obscurity of the image.[19]

When it comes to porn, the writing strategy goes beyond, as Adrienne Janus suggests in the introduction to this volume, 'rubbing up against a little wet paint' to reach a blinding limit.[20] The comic image of a penis spurting paint into the eye of the viewer should not conceal the political implications of Nancy and Ferrari's argument, which are quite serious. Unlike the nude and by extension Western art, pornography is negatively characterised as being on the side of prostitution, removal of freedom and abuse. This becomes explicit in their reading of a photograph by Julien Daniel, entitled 'Peep Show':

> According to its etymology, pornography is a piece of writing, a document, story, or description concerning prostitution. The Woman who is prostituted, *porné* (or the prostituted man, *pornos*), is transported to be sold. The verb *pernumi* belonged to the language of exportation, especially the export of slaves. Porn is first of all displacement, transfer: exile, expropriation, deportation [. . ..] The skin of the nude imposes itself on the gaze, touching and penetrating it, denuding the gaze in its turn, while, in pornography, the skin provokes the eye to function *as a mechanical viewer* (emphasis mine) a prism that disperses the spectrum of getting off. One is the nude of truth, of its infinite coming into presence, and the other is the nude of definite and definitive access to truth, showing all its faces at once. [. . .] ['Peep Show'] is caught in the trap of representing the unrepresentable. That's why it's poor. It braves this poverty, as the reverse side of nudity, the other face of the spasm, sublime and miserable . . . [Porn] tries to use and wear out what can't be used or worn out . . . [It] is worn out from the start, worn out in advance as a fantasy of use (which must therefore also be about abuse: exportation, exhibition and the extortion of excitation, putting the trance up for sale . . .).[21]

Despite the philosophical terminology, this characterisation participates in a very old and conservative stereotype of sex work, which, whenever it is rehearsed in the media or by lawmakers, works to stigmatise and denigrate the bodies of those of who do sex work, who – dare I say – have always been mostly women and/or members of sexual, gender and/or racial minorities. It is surprising and disappointing that a philosopher of Nancy's stature would have countersigned it. It is quite unjust to accuse pornography of provoking the eye to function as a mechanical viewer. Mechanical functioning is not restricted to viewing pornography, but is a consequence of a structure at work at the very origin of all viewing, reading and marking practices, including those of art and philosophy. I am referring to the structure of repeatability or 'iterability' in excess of presence, whose far-reaching consequences Derrida analysed, for example, in 'Signature Event Context'.[22] Mechanical functioning does not arrive in a second moment to corrode an originally free, spontaneous or self-present intentional gaze. It is only with the help of mechanical repeatability that the eye (or any other organ for that matter, including the penis) can function at all.[23] And if so, it is not legitimate to oppose the nude and pornography on two sides of an indivisible line, where one would be proper and the other improper: the nude as singularly human, modest, unusable, uneconomical, 'infinite coming to presence'; and porn as mechanically corrosive, immodest, abusive, tainted by commerce, the masquerade of 'definitive access to truth, showing all faces at once'.

What would be *un regard juste* with regard to pornography and the hard-on? How might art and philosophy give greater hospitality to that which apparently threatens to undermine its authority? These questions have, I would argue, some urgency, since today pornography is produced and disseminated more readily than ever before. As porn scholar, Tim Dean, has pointed out: 'Now anyone with a phone and Internet access may become a pornographer ... what distinguishes the new image technologies from their predecessors is the ease of reproducibility, which lends every mobile-phone photo unprecedented potential for viral circulation.'[24] He adds: 'obscenity always threatens to undermine authority (whether of an individual or an institution)'.[25] He gives the example of a New York congressman, Anthony Weiner, whose inadvertent circulation, via Twitter, of a picture of his penis shattered his hitherto successful political career. On the basis of Dean's

inference, I would risk the following hypothesis: neither art nor philosophy can welcome what is called pornography into their archives without losing some of their authority or, at the very least, having their authority put into question.

But why is authority, especially institutional, dare I say, phallic authority, so allergic to porn? In all probability this allergy will never completely go away, despite the increasing difficulty of segregating pornography from public view. Perhaps one answer is because a hard-on is unjustifiable; it cannot be accounted for or defended in the public realm. It is in default with regard to 'ethics', if ethics implies the capacity to render an account, an explanation, give sufficient reason for what is and/or happens: the *Principium reddendae rationis*. That the 'sexual relation' happens *a priori* in excess of the Leibnizian principle of reason ('*nihil est sine ratione*') is *also* what Nancy suggests, when reading Lacan's famous provocation '*Il n'y a pas de rapport sexuel*':

> There is no report, no account to be given, no result or product or accomplishment – *achievement* in English – of the sexual relation, and it is precisely according to this measure that there is, indeed, 'sexual relation'.[26]

If one were to write an ethics or politics of the hard-on, it would have to take into account this limit of ethics where there is no report, no account to be given, no result or product or accomplishment. Ronell makes the point more even starkly when, in the course of an interview with me, she asked about 'the purely unjustifiable in the practices and grammars of sexuality':

> You can't justify, 'This is the way it is' or 'it's not', because you don't have a grasp of it [. . ..] You could say, 'No, there's no positive value to this'. [But] that we're not allowed to do, we're not yet allowed to say, 'There's no legitimacy to what I want, this is just how I get off'. I can't tell you it's positive, as a matter of fact, I'm not sure it is.[27]

If it is impermissible, as I believe, simply to abandon responsibility and ethics with regard to the 'sexual relation', then the question becomes: How to give a report for that which 'there is no report, no account to be given'? Such could be the ethical or political task of pornography today, or, if you like, pornosophy. As a matter of urgency, such pornosophy could inquire into the links (if any)

between what Nancy, via Kant, identifies as the virility of the drive of reason and the 'modesty', which demands that a hard-on must always be taken out of serious consideration:

> This is why the *Trieb* is also the thrust internal to reason that Kant designates as the movement of reason toward the 'unconditioned' (or the 'undetermined', *das Unbestimmte*). Kant is the first to attempt to give this drive its due, namely, a due exceeding the order of the 'understanding' and knowledge of an object, a due that is regulated by nothing other than an opening to the infinite.[28]

> 'Being', understood as a verb, *to be*, means 'to thrust or push' (or 'to impel', 'to throw', and even 'to shake', 'to excite'). Being, to be, is drive [*pulsion*] and beating [*pulsation*] of the being in general. The drive of reason is its desire for the thing itself.[29]

Earlier in the same chapter of *Adoration: Deconstruction of Christianity II*, entitled 'Mysteries and Virtues', Nancy writes:

> The word virtue bears within it, not only in its Latin etymology – *virtus*, virile quality [. . .] We must say that virtue is above all *drive*.[30]

In a footnote accompanying the phrase 'virile quality', Nancy adds:

> Let the issue of machismo not be raised here. With or without Freud, *we know* that virility is no more the reserve of boys than tenderness is that of girls.[31]

Through the detour of Latin etymology, Nancy conjures the virility of the drive of reason, while at the same time raising 'the issue of machismo' in a footnote. Intriguingly, Nancy raises 'the issue of machismo' by dismissing it. The apparent effect of his reading is that the value of virility is justified. Virility would belong intrinsically to reason – to philosophy itself, one might go so far as to suggest – as an essential characteristic of the drive from which it comes. And yet, there remains a question, or at least, the phantom of a question, which is implied in the rhetoric of 'Let the issue of machismo not be raised here.' This is presumably a feminine or feminist question concerning the drive's male specificity, or more precisely, its macho excess. Significantly, when it comes to the

word 'virility', Nancy does not rely, as he so often does, on ety-
mology. According to the Oxford English Dictionary, virility, like
the French *virile*, is derived from the Latin *vir* meaning man, hero.

I agree, of course, with Nancy's claim that virility (like machismo)
is no more the specific reserve of 'boys' any more than tenderness
is that of 'girls'. It is not dependent on the supposed biological
possession of a penis. But all the same I wonder about his appeal
to self-evidence: 'we know'. Who exactly 'with or without Freud'
is the 'we' who 'knows'? Somewhat ironically, Nancy employs
this rather macho rhetorical style to justify (not) raising 'the issue
of machismo' in relation to the value of virility: not only that of
the drive of reason, but that of the drive as such. For Nancy, the
drive, while virile, would still be modest; it would not be tainted
by machismo. For Nancy, and indeed not only for him, it is that
macho excess, the manly cockiness or pride, which is not virtuous
and generally speaking out of the question. The issue should not
even be raised. Rather it must be denied, disavowed or hidden, like
pornography, or as pornography: a place where you put what you
really do (not) want to look at. The question remains, however,
if there isn't always some machismo at stake in the virile drive,
especially, in the philosopher's drive, which in size is the biggest
one of all, according to Derrida, who speaks of the place of the
philosopher's desire and ambition as that of a 'modesty haunted
by the devil'.[32]

Derrida's virility or modesty, which he avows to be haunted by
the devil, is inseparable from an experience of impotence. With
regard to both the impotence and the machismo of the philosophi-
cal drive, I consider Derrida to be much more honest than Nancy,
who does not seem to want to know about either. Later, with the
concepts of the im-possible and the aporia, Derrida will place the
experience of impotence at the very heart of his thought. That is
to say, as the *sine qua non* of invention, forgiveness, hospitality,
reading, and so on. This impotence would include notably the
incapacity to imagine the figure of the philosopher as anything
other than masculine. While the purpose of Nancy's 'we know'
is to shut down a phantom debate about machismo, it could also
encourage one to inquire into the complexity and subtlety of sex/
gender dynamics with regard to virility as an often disavowed,
but key Western philosophical value.[33] Inasmuch as the drive
of reason can be said to be in excess of the Leibnizian principle
of reason, virility would belong, in Nancy's terms, to the same

domain as that of the 'sexual relation', for which 'there is no report, no account to be given'.

Inasmuch as pornography, on the other hand, has the audacity to report, to archive, and moreover, to make of sex a marketable product, it is within Nancy's terms without justification. It is an improper contagion of the 'sexual relation' for which properly there is 'no report, no account to be given'. For Nancy and Ferrari, sex – or rather, love – should not be pornographic: 'the pleasure of love is devoid of fantasy: it's your body and mine now; this is not a scene'.[34] In a rather austere and Christian way, Nancy opposes love and pornography. In a later text on sexual exclamations, written to be included in the French *Dictionary of Pornography*, he reiterates:

> If pornography consists in remaining attached to the fantasy of exhibi-
> tion (and to the exclamation as overexhibition), love (or whatever we
> want to call it), by contrast, leaves fantasy behind and withdraws from
> the cry into murmur and silence.[35]

But why do love and pornography have to be opposed, as if they could only be enemies of one another? Why can't pornography also be a space of 'love' and 'thought': an archive or event where one bears witness to the fantasy of exhibition and to the murmur and the silence? As if to pre-empt such questions, Nancy goes so far as to interpret sexual exclamations, among which he includes, (depending on the tone), 'I love you', as 'in themselves already in lived reality an inchoate form of pornography'.[36] They 'double vision on the plane of language'. Noting the abundance of such exclamations in literature, he adds that 'this inchoate form of pornography' may also be considered 'a sort of poetry *in nuce*'.[37]

Feminist porn and the deconstruction of Christianity

If pornography and poetry are commensurate with one another at least *in nuce*, this opens a perspective onto how Nancy's thinking of the image might communicate with the work of those today that seek to reimagine the art of erotic film-making. In particular, I'm thinking of the contemporary movement of 'feminist pornog-raphy', interest in which has grown considerably over the last decade, as indeed has the scholarly interest in porn more gener-ally within the Anglophone world.[38] In his essay on the cinema of

Abbas Kiarostami entitled 'The Evidence of Film' (2001), Nancy links cinematic image-making with the motifs of justice, education and respect. If an image, he argues, is made with care, with regard for what is looked at, then the real will also be cared for.[39] It is worth recalling that, for Nancy, the real is not the attribute of a thing (*res*) understood as a realised presence, but corresponds to its non-realised 'coming to presence', which is in excess of any representation, vision or world view. A rightful and just look (*regard juste*) is 'respectful of the real it beholds'. Looking 'amounts to thinking the real, putting oneself to the test of a meaning (*sens*) one cannot master'.[40]

In this concluding section, I would like to bring Nancy's argument into communication with the work of Sensate Films: a feminist erotic media company. The 'slow porn' of Sensate Films articulates an ethics of slowing down the production of erotic images and the experience of their creation 'to pay greater attention to what in mainstream pornography is often missed: the quality of a breath, for example, or the words in a whisper'.[41] It is porn that also makes a claim to being art. Unlike the films of Abbas Kiarostami and other art film directors, it is not a cinema of the '*auteur*', which almost irresistibly would be interpreted as the origin or 'subject' of the look (*le regard*). Sensate's two producers, Aven Frey and Gala Vanting, acknowledge the people who appear in their work not only as actors, but as co-creators, who give input and even direction on the creation of the images in which they appear. This albeit marginal yet important work would seek not only to create new addressees of pornography, but to stir and shake up the erotic gaze itself, to make it more inclusive, creative, more accurate and just.

> We believe that … erotic media have great potential to reflect and question our values, to educate us, to speak truths personal and political, and to expand our capacity for emotion – including but absolutely not limited to desire.[42]

The larger feminist pornography movement to which Sensate Films belongs is part of an so-called 'third-wave' feminism, which arose in opposition to the 'second-wave' anti-pornography feminism, with which it has an ongoing debate. Led by figures such as Andrea Dworkin and Catherine MacKinnon, this 'second wave' reached its zenith during the 1970s and early 1980s; it saw in

pornography a key agent of female oppression. It should be noted, however, that even during this period many feminists recognised the great importance of giving attention to women's sexuality as a key site of resistance to the phallocentrism of Western thought. This is especially true, for example, of the work of Luce Irigaray and Hélène Cixous.[43] In line with the recognition that today production and access to pornography is unprecedented, this new younger generation of professed 'sex positive' feminists (many of whom also publicly identify as sex workers) seek to provide alternatives to mainstream porn, but in so doing also question what porn is and does, as well as the social, political and economic restraints imposed on it. Within this incredibly diverse genre, I'd like to focus on two short films by Sensate, which portray the submission of a woman to one or several men. The first, *Taken*, is the narrative of an abduction fantasy, both written and performed by a young woman, Viva, in which she plays the central role of the one abducted. The other, *Amber*, is the documentation of a pre-negotiated BDSM/edgeplay[44] scene between a young woman and a considerably older man, which includes impact play, knife play, strangling and breath-play.

I choose these two films in part because they explore 'the purely unjustifiable' from a certain feminist point of view. They attempt to account for the possibility of being deeply turned on by submission to male authority, which is portrayed as being self-serving, macho, violent, as well as physically and psychologically sadistic. What could make these two films feminist? There is the consensual aspect, certainly, which is strongly emphasised; but there is also the dimension of agency and empowerment. *Taken* is Viva's own fantasy, in which she dictates everything that happens. The film does not show a woman being abducted by a man, but a woman who has a fantasy of abduction. You see only her face. The man to whom the fantasy is addressed never appears. The film shows and tells us something of who the woman is who has this fantasy: her face, her age, her accent, the tattoo on her left shoulder, the sound of her voice when she is truly excited, her narrative and poetic pornography:

Take, took, taken, you took, but I gave, didn't I, I gave way [. . .] I never know where you are taking me and how long or what you'll do with me, whether I'll have release or frustration, whether we'll be together or whether you'll give me to others, whether I'll be humili-

ated, cherished or hurt or pleasured, but this beginning, my abduction never changes, and before the ritual of taking is complete, you have to ask me, you always ask me, your voice harsh, loud in my ear, do you want this, and my answer as always is yes.[45]

As the supposed 'author' of the piece, Viva appears in the film also as one who lives on after the fantasy to which she bears witness. This 'breaking of the fourth wall' is a common device of feminist porn, which often uses performers who already have an off-screen sexual relationship and often also includes interviews with them before or after the scene to give the viewer a context for the work to be read.

In *Amber*, the question of empowerment and agency is more complex. It is a very emotional piece, where one of the two protagonists, Gala Vanting, weeps while she is being flogged, her hands tied to two poles, naked. Following the film in the attached interview, she comments:

A big part of this film is footage of me crying. From a very surface user perspective, I'm in pain or I'm experiencing something negative. And so for someone who is totally unseasoned to this type of play or these types of ecstatic experiences, this looks not good, unsettling, whatever. They identify with the female character who is crying. They think: bad. For me, that's just as much of a release as an orgasm or as a scream. It's about taking that full spectrum of experience and concentrating it into an expression of some kind so that it can leave my body. Throughout the whole film, you see things coming into my body, you see impact, or energy or your will or whatever and I find it beautiful and delicious that it welds in this way, and that it releases in this way.[46]

The title of the film, *Amber*, refers to a word in the couple's safe wording system. By saying this word (among others, which remain unspoken) Gala, who is in the submissive role, can exert a minimum a level of agency in a situation where her possibilities for agency are starkly reduced. By saying this word, which she does twice, she is able at least to pause the relentless flogging, take stock and weep. On her use of the word 'amber' Gala comments to her partner, Frank Ly, the film's other protagonist:

Another key point you touched on was your confidence that I can take care of myself . . . every time I say 'amber', I just look so smug, like

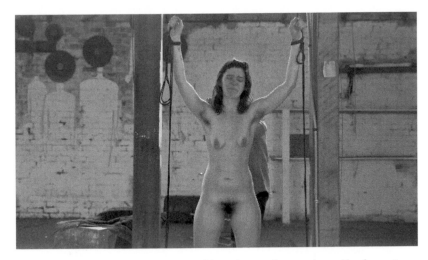

Figure 6.1 *Amber* is a film about the push-pull of erotic edgeplay and the curious brutality of love. Directed and performed by Gala Vanting and Frank Ly.
© sensate films 2012.

> I've done my thing, and I've taken care of myself, that creates this real solidity for me which then dissolves and drops out into further experience of that state of transcendence, or ecstasy, or whatever you want to call it.[47]

Gala speaks about that which would seem to give her a last vestige of agency also with a certain ironic detachment: 'I just look so smug.' On the one hand, she admits that saying 'amber' creates 'a real solidity for her', but, on the other hand, this solidity dissolves, as if for her it were ultimately a question of giving up entirely, letting go, sinking further and deeper into 'whatever you want to call it'. At that moment, could you say that the film is still feminist? It is for me to judge, but it is clear that the film still seeks to be, in Nancy's terms, a rightful and just look (*un regard juste*) with regard to the real. This is especially so because of the care taken to place what the viewer sees into a context, which it turns out, is a Christian one (even if atheist). Significantly, Gala's partner, Frank Ly, who during the film is apparently in the dominant role, administering the pain, controlling the action, admits: 'the relationship I had with you is exemplified in the act of yielding *both of us* to that relationship, not knowing actually what it is'

(emphasis mine). On the topic of BDSM more generally, Frank Ly adds:

> The use of pain in human existence has been there for thousands of years ... [and] the use of pain in a conscious ritualistic way [...] is not new. I find it fascinating that the moral inquisition of BDSM as something that is right or wrong comes from a Judaic-Christian thought about what is morally right, how we should be treating each other as human beings. And yet, we know very well that Christianity, the Christian history of the church is masochistic and sadistic, both at once. I'm not judging that. I'm just bringing attention to it and inherently I think within the human experience there is a need and a desire to push those edges. And it is exemplified over and over again. If you give it a context, an intelligent context of service to each other, then it is far from harmful. Whereas if it is not given that, it will seek expression and it will be harmful. It's something that's happening in the cloisters, literally.[48]

In this passage, Frank attempts to provide an argument for 'an intelligent context of service to each other', which would make what would otherwise be harmful 'far from harmful' – the need and desire, which would be intrinsic to the human experience, 'to push those edges'. As a BDSM practitioner myself, I am strongly tempted to agree. The philosopher in me, however, (who I am not sure is masculine) feels compelled to question the self-certainty with which he proposes a thesis about the nature of 'the human experience' and especially, the reassurance that his argument would offer that when practiced under certain conditions 'pushing those edges' will be 'far from harmful'. How can you be so sure? This assurance seems to me irreconcilable with what Frank admits earlier – that neither he nor Gala know exactly what their relationship is. Intrinsic to the yielding to 'the relationship' in which their relationship 'is exemplified' is *not knowing*. This 'not knowing' can be read in Bataille's sense as non-knowledge (*non-savoir*). In the film, Gala enthusiastically agrees with this point. In fact, when Frank says it, it seems to turn her on. If one takes their admission seriously – that neither the one nor the other knows what 'the relationship' is and/or what happens between them, then one cannot be assured that what they are doing is 'far from harmful'. Ronell makes a similar point in response to another BDSM practitioner:

Your subject is still choosing violation and containing it, and still saying it's positive, it's healthy, but what if you didn't know what the fuck it was? Nor whether it is really pleasurable or unpleasurable? But all that is suspended in a very risky, dangerous way that, however, is part of something like destructive *jouissance* or the 'essence' let's say provisionally of desire, which is to say maybe the utterance 'hurt me' for some. But if you then have to round it up and say, 'don't worry folks', this is actually positive, then I think you've been coerced.[49]

The reference to Judaic-Christian thought, and especially to the bloody history of the Catholic Church and the Inquisition, is essential to Frank Ly's argument. By pointing to the church's hypocrisy, he believes he can at least question what the Judaic-Christian heritage says about 'what is morally right, how we should be treating one another'. How far can this questioning go? What Nancy calls – following Derrida and Heidegger – the (self-)deconstruction of Christianity, is not a dismissal of the moral injunctions and laws of the Judaic-Christian heritage on the basis of what we believe 'we know' of its history. One could say almost the contrary. This (self-)deconstruction will have 'opened up a space to let us see something which was always present in [Christianity] but unseen and unseeable until now'.[50] Among those things that perhaps remain from Christianity, Nancy includes faith, as distinguished from religious assurance, and 'the famous Christian love'.[51] This love, which Nancy recognises as impossible, 'the top of absurdity', is the injunction to love everybody, even your worst enemy.

I believe it is possible to read in *Amber* and in the work of feminist pornography more generally an inheritance of what Nancy calls 'the (self-)deconstruction of Christianity'. In all likelihood without being aware of it, feminist pornography seeks to be faithful, pornographically faithful,[52] to this famous Christian love, for example, through its ethics of inclusivity, harm reduction, equality, human dignity, 'safer sex', its rigorous rejection of rigid definitions of sex and gender roles, and so on. Yet, the unjustifiable remains unjustifiable, without which, (dare I say) porn would not be porn and sex would not be sex. From the yielding to not-knowing, porn, sex and, (dare I say), 'love' hold their enduring interest and draw. What would happen to academic philosophy if it were not so threatened by this?[53]

Notes

1. Avital Ronell, 'Introduction: The Stealth Pulse of Philosophy', in *Blind Date: Sex and Philosophy*, by Anne Dufourmantelle, trans. Catherine Porter (Champaign: University of Illinois Press, 2007), xvi. See also Paul de Man, 'The Concept of Irony', in *Aesthetic Ideology* (Minneapolis: University of Minnesota Press, 1996), 168–9.

2. Molly Paxton, Carrie Figdor and Valerie Tiberius, 'Quantifying the Gender Gap: An Empirical Study of the Underrepresentation of Women in Philosophy', *Hypatia* 27, no. 4 (2012): 949–57.

3. Jennifer Saul, 'Philosophy has a sexual harassment problem: Recent allegations against Colin McGinn are just the tip of the discipline's iceberg', *Salon.com*, Thursday, August 15, 2013, accessed 30 July 2015, http://www.salon.com/2013/08/15/philosophy_has_a_sexual_harassment_problem.

4. Jacques, Derrida, *The Post-Card: From Socrates to Freud and Beyond*, trans. Alan Bass (Chicago: Chicago University Press, 1987), 18.

5. This is a slightly modified translation. For Kant, the term a priori indicates from first premises, independent of experience. By employing this term, Derrida suggests that we do not simply have a choice about the arrival of this couple on horseback upon us. It happens whether we are aware of it or not, whether we like it or not. But hasn't Derrida also taught us to ask: who is 'us'? Jacques Derrida, *Margins of Philosophy*, trans. Alan Bass (Chicago: Chicago University Press, 1972).

6. Gilles Deleuze, 'Lettre à un critique sévère', In *Pourparlers 1972–1990* (Paris: Editions de Minuit, 1990), 15.

7. Tim Dean, *Unlimited Intimacy: Reflections on the Subculture of Barebacking* (Chicago: University of Chicago Press, 2009).

8. Derrida, *The Post-Card*, 18, 48.

9. Jean-Luc Nancy, *The Birth to Presence*, trans. Brian Holmes et al. (Stanford: Stanford University Press, 1993), 155.

10. Jean-Luc Nancy, *Corpus II: Writings on Sexuality*, trans. Anne O'Byrne (New York: Fordham University Press, 2013).

11. Jean-Luc Nancy, 'Icon of Fury: Claire Denis's *Trouble Every Day*', *Film-Philosophy* 12, no. 1 (2008a), 1–2, accessed 30 July 2015, http://www.film-philosophy.com/2008v12n1/nancy.pdf.

12. Compare this with: Jean-Luc Nancy, *Being Singular Plural*, trans. Robert Richardson and Anne O'Byrne (Stanford: Stanford University Press, 2000).

13. Jean-Luc Nancy and Federico Ferrari, *Being Nude: The Skin of Images*, trans. Anne O'Byrne and Carlie Anglemlire (New York: Fordham University Press, 2014), 98.

14. Nancy and Ferrari, *Being Nude*, 51–2.

15. BDSM is the abbreviation for: Bondage and Discipline, Dominance and Submission, Sadism and Masochism.

16. Jean-Luc Nancy, 'The Image: Mimesis and Methexis', in this volume.

17. Ibid.

18. Nancy and Ferrari, *Being Nude*, 53.

19. Nancy and Ferrari, *Being Nude*, 71.

20. Adrienne Janus, 'Introduction', in this volume. Nancy, *Birth to Presence*, 351.

21. Nancy and Ferrari, *Being Nude*, 97–9.

22. Derrida, *Margins*, 309–30.

23. Is this not what Nancy also says in *L'intrus*? 'I have – Who? – this "I" is precisely the question, the old question: what is this enunciating subject? Always foreign to the subject of its own utterance; necessarily intruding upon it, yet ineluctably its motor, shifter, or heart – I, therefore, received the heart of another, now nearly ten years ago . . ."I" always finds itself caught in the battlements and gaps of technical possibilities.' Jean-Luc Nancy, 'L'intrus', trans. Susan Hanson, *The New Centennial Review* 2, no. 3 (2002): 1–3.

24. Tim Dean, 'Introduction: Pornography, Technology, Archive', in *Porn Archives*, ed. Tim Dean et al. (Durham: Duke University Press, 2014), 6.

25. Dean, 'Introduction', 5.

26. Nancy, *Corpus II*, 98.

27. Peter Banki, 'Sex/Philosophy: Interview with Avital Ronell', Interview at the *Sex/ Philosophy Symposium*, University of Western Sydney, Sydney, April 2013, accessed 8 August 2015, https://vimeo.com/65452472.

28. Jean-Luc, Nancy, *Adoration: The Deconstruction of Christianity II* (New York: Fordham University Press, 2012), 48.

29. Nancy, *Adoration*, 49.

30. Nancy, *Adoration*, 47–8.

31. Nancy, *Adoration*, 110. Emphasis mine.

32. Jacques Derrida, "Dialanguages," in *Points: Interviews 1974–1994* ed. Elizabeth Weber, trans. Peggy Kamuf & Others (Stanford: Stanford University Press, 1995). p. 140.

33. In *On Touching – Jean-Luc Nancy*, Derrida speaks of his embarrassment concerning the privilege of 'virility' (Derrida's scare quotes) implied in Nancy's use of the terms 'generosity' and 'fraternity in abandonment', which play an important role in the concluding argument of Jean-Luc Nancy, *The Experience of Freedom*, trans. Bridget McDonald (Stanford: Stanford University Press, 1993). Jacques Derrida, *On Touching – Jean-Luc Nancy*, trans. Christine Irizarry (Stanford: Stanford University Press, 2005), 22–3. In a footnote of *Being Singular Plural*, Nancy acknowledges Derrida's critique and adds: 'I have reversed my position again and again on the possibility of looking into whether fraternity is necessarily generic or congenital . . .' Nancy, *Being Singular Plural*, 198ns28.

34. Nancy and Ferrari, *Being Nude*, 99.

35. Nancy, *Corpus II*, 106.

36. Nancy, *Corpus II*, 105.

37. Nancy, *Corpus II*, 105.

38. Not only have there been a number of recent studies and scholarly anthologies – Dean, 'Introduction' and Tristan Taormino et al., *The Feminist Porn Book: the Politics of Producing Pleasure* (New York: The Feminist Press at CUNY, 2013) – but also the establishment in 2014 of an internationally peer reviewed journal, *Porn Studies*, published by Taylor and Francis.

39. Jean-Luc Nancy, *The Evidence of Film, Abbas Kiarostami* (Brussels: Yves Gevaert, 2001), 18.

40. Nancy, *Evidence of Film*, 38. Translation modified. It can be argued that Nancy's realism is irreducible to any conventional theory of realism, logic of mimesis or faith in indexicality. Derrida, *On Touching*, 46. See also: Laura McMahon, 'Post-deconstructive realism? Nancy's cinema of contact', *New Review of Film and Television Studies* 8, no. 1 (2010): 73–93.

41. Aven Frey and Gala Vanting, Sensate Films, http://www.sensate-films.com, accessed 11 August 2015.

42. Frey and Vanting.

43. Luce Irigaray, *Speculum of the other woman*, trans. Gillian C. Gill (Ithaca, NY: Cornell University Press, 1985). Hélène Cixous, 'The Laugh of the Medusa', trans. Keith Cohen and Paula Cohen, *Signs* 1, no. 4 (1976): 875–93.

44. Play on the edge of safety or sanity.

45. Aven Frey and Gala Vanting. *Taken*. Film. Directed by Aven Frey and Gala Vanting. 2013. Sensate Films, 2013.

46. Aven Frey and Gala Vanting. *Amber*. Film. Directed by Aven Frey and Gala Vanting. 2013. Sensate Films, 2013.

47. Frey and Vanting, *Amber*.

48. Frey and Vanting, *Amber*.

49. Banki, 'Sex/Philosophy.'

50. Jean-Luc Nancy, *Dis-Enclosure: The Deconstruction of Christianity*, trans. Bettina Bergo et al. (New York: Fordham University Press, 2008), 36. Jean-Luc Nancy et al., 'Love and Community: a round-table discussion with Jean-luc Nancy, Avital Ronell and Wolfgang Schirmacher', Seminar at The European Graduate School, August 2001.

51. Nancy et al., 'Love and Community.'

52. This essay is in dialogue with John Paul Ricco's re-reading of certain motifs of Nancy's thought, notably in John Paul Ricco, *The Decision Between Us: Art and Ethics in the Time of Scenes* (Chicago: Chicago University Press, 2014) and in the recently published 'Pornographic Faith: The Two Sources of Naked Sense at the Limits of Belief and Humiliation', lecture at Reed College, Portland, Oregon, 25 March 2014.

53. *Last night I had a dream that a lion was walking beside me in a field and I was so paralyzed by fear that I could not walk any further. Maybe the lion was Jean-Luc. I woke up trembling and my partner reassured me. But before I woke up I had the thought that no matter how much brilliance and sophistication and richness goes through my mind, it is of no value next to the incredible force beside me and this moment when I could be devoured, when I am probably about to be devoured, as I can longer move forward to safety in the form of a house on the other side of the field. And there is no one who will appear with a gun to scare the lion away, presuming that a gun could scare it away or...make it disappear. It is as if everything, my life, my body were frozen in that moment. The instant of my death? I never got to find out what then happened because I woke or was woken up. Afterward, I got a strong hard-on, as I often do in the morning and through the night.*

Presentation and Disappearance / Présentation et Disparition

Dialogue between Soun-Gui Kim and Jean-Luc Nancy (video-conference).
For the International Biennale, Gwuangjiu, Korea, 28 March 2002
Translated by Adrienne Janus

Originally published by Slought, with the Artsonje Center and the Institut français of South Korea. Edited by Jean-Michel Rabaté and Aaron Levy, Trans. Fiona Moreno and Tchoi Mi-Kyung, in collaboration with Soun-Gui Kim (for the English-Korean translation). This new translation aims not to correct the work done by the translators of the Slought edition, but to render Jean-Luc Nancy's French in a way that coheres with the other translations and chapters in this volume as a whole.

S-G. K: Various aspects seem to characterise the current landscape of art. What we commonly call post-modernism as well as contemporary art already seems distant. This is certainly not unrelated to the movement of globalisation. For several years now, artists, participants in the art world, curators and organisers have been exploring new experiences. The characteristics of this new landscape are numerous. First, the diversity of the arts and the practice of a pluralist aesthetics, the pronounced tendency to explore inter-cultural and cosmopolitan experience; the dissolution and the mixing of expressions, genres, and languages as well as the de-hierarchisation of the so-called 'major' and 'minor' or 'high' and 'low' arts. This interest in experience and experimentation has as its consequence the disappearance of the object. More precisely, what is significant is the disappearance of the aesthetic object and of the image. All this can be observed here, at the Gwangju Biennale, where the major preoccupation of the event seems to be articulated around the question of presentation itself. In other words, the absence of content seems to constitute the content of

art today. I would like to ask you the following question: where does art now find itself? Where is art located? Is what we call art to be found precisely in this very movement of the disappearance of presentation? That's my first question.

J-L. N: Thank you. I'd like to say to you, to the people here today, and to those who will be coming in the next two months to visit the Gwanju Biennale, that I am very pleased to be able to speak with you. I'll try to respond right away to your question. I think that art has never known where it is. In a certain way, this isn't a new question. Perhaps during a certain period, at least in the West, one knew where to locate art, knew that art occupied a space that was not that of the sciences, not that of philosophy, and not that of religion. But this period of art's localisation was rather short. One can say that in the West, it was from the fourteenth century to the twentieth century. 600 years. That's not a long time! Before, one could say that there was no clear distinction between art, religion and politics. Nor, to a certain extent, between art and knowledge. So, I'd say that, without a doubt, in a context like that of Korea, in a Far-Eastern context, in general, just as for example in an African context, the very question of the idea of art is posed again in other terms, if indeed it is posed! I don't know the Korean tradition. I'd like to ask you right away: is there an ancient, traditional, word, in Korean, that designates 'art'?

S-G. K: It can be translated using the term *yé*, 'art'. But in the past the term *yé* didn't include visual art. It's only around, let's say, the fourth century BC, that painting and calligraphy, which would become the major modes of artistic expression, assumed an important place. The invention of tools that we know of today date from this era, tools like the brush, ink, and paper.

J-L. N: Yes, but here you're referring to the definition of a specific practice, of a technique, with its instruments, its means of production. The question is rather that of ends, of purpose. In the Western tradition, one can use the term 'art' – art as a word that was used to mean technique. 'Art', in Latin *ars*, was a translation from the Greek *technē*. *Ars* is exactly the Greek word *technē*. It's only quite late in the West, at the end of the seventeenth century, that the word 'art' was used to indicate what was at first called the 'Fine Arts' or 'Beaux-Arts', that is to say the arts of beauty,

the techniques, the arts and crafts consecrated to the beautiful. So this question of art in the West is a very modern question, one that appears when the beautiful becomes an autonomous category. The beautiful and then the sublime.

To return to your question, today the fact that art no longer has a clear identity, the fact that no one really knows any more what the beautiful is, what the forms of the beautiful are, or the norms of those forms, or even, as you said, the fact that we no longer really know what arts are 'major' or 'minor', 'high' or 'low', the fact that the images that we are, the two of us, at this moment, can indeed be very well presented in an exposition as equal to the images that have been purposefully produced as works of art, all this, it seems to me, represents nothing other than a radicalisation of the question of art – a question that appeared as soon as there was art. As soon as a technique of beauty has been 'autonomised' – rendered autonomous – (in general, let's stick with the term 'beauty', and so not speak of the sublime), the question of beauty as such is raised. What is beauty? If beauty is not a correspondence with an order of the given world, if beauty is distinct from the agreeable (the big distinction that Kant makes, Kant who is fundamentally the inventor of a philosophy of art), if beauty is not the glory of God – a god of truth – then beauty quite simply has no location, has no place. One could go on to add, for example: if beauty is no longer the desirable. Then, if beauty is neither truth, nor the desirable, nor the agreeable, what is it?

In all countries, in all regions of the world, there have been long periods of norms, canons, rules of the beautiful, which could be rules linked to representation. Let's take the history of Western painting, where one might say that it's about representation, for example, the representation of people: to represent people, one might represent them as bodies, bodies which themselves correspond to a certain ideal of beauty. It's true that, today, as you say, in the era of globalisation, it seems that there no longer is an ideal of beauty; nor is there any longer an ideal of representation, and art is no longer given the mission of transmitting a message of truth. One could say that today, art, once again, is without the 'desirable', without 'truth' and without the 'agreeable', and is also detached from scientific truth.

I would like to say first of all that this movement is not all that recent. It's only from the end of the nineteenth century that Western art started to undo its own forms and rules. And at that

moment it encountered the forms and the rules of the rest of the
world. In Europe, this was quite noticeable with the discovery
of the art that was called *l'art negre*. You know very well how
important African sculpture was for Picasso. Then, later in the
twentieth century, the discovery of a certain number of Japanese
and Chinese arts – perhaps the most striking for Western prac-
tices was the discovery of No and Buto. However, all this, in fact,
accompanied the movement of globalisation, that is to say the
movement that lead to the economy becoming a global market,
and thereby the radicalisation of the question of art, even a kind of
move towards the disappearance of art itself. Not really only the
disappearance of the objects of art, but also a kind of disappear-
ance of art itself. Many times, since Hegel, one has asked, 'is art
finished'? When it's said that Hegel claimed that art was finished,
a certain error is committed, a certain false sense of (understand-
ing) Hegel's thought, but it is very significant that now for over
a century, we still haven't stopped asking 'Is art finished?', 'Is art
dead?', 'Is it lost?', 'Where has it gone?' I think this means that
underlying the question of the beautiful, there is the question of
form (I take 'form' in its most general sense: visual, auditory, ges-
tural). There is the question of the form that sense can take. When
we are in the world, we are always in a minimum of sense; even if
we don't know very well what the ultimate sense is, there is sense
at least in the fact that we communicate with one another, that
we are in a world where communication has attained an intensity,
a quantity – for which a video-conference between Gwangju and
Strasbourg is an example. But at the same time, we don't know
under what form sense, the circulation of sense in our world, can
be embodied. It's no longer in the form of religion, it's no longer
in the form of politics; and we often have the impression that there
is only one form of this general circulation, that of the economy.
It's for this that more and more art also appears to be positioned
against the economy, completely opposed to the economy, and at
the same time completely tied to its developments, to this technical
or technological interaction. What we are doing right now repre-
sents a great amount of technical interaction, and also a great deal
of money. It is an economic phenomenon. Our communication,
on the occasion of a biennale of art, is an economic phenomenon.
Here, underlying the question of art, is the question: how to invent
a form for this sense that circulates like a sort of deranged sense,
that goes round in circles, and indeed no longer has any privileged

object – no object, no hierarchy, of the arts, etc. Would you like to say something?

S-G. K: Yes, about sense and the absence of content. Numerous participants in contemporary art, critics and artists, say that the very fact of posing the question of sense is precisely a non-sense. This would mean that contemporary art doesn't allow us to pose the question of sense, because the absence of content is precisely the content of contemporary art.

J-L. N: Yes, and I'll go on using the terms you employ. The absence of content ... Yes, this absence is the content, because what you call the absence of content, is the absence of a (defined) object, of matter, in what should take place as the presentation of (a) sense. But this is not a pure absence. This absence designates the latent presence of (and at the same time releases and disturbs) a sense searching for itself. And the absence of content indeed leads back to the form. It is for this, I think, that in contemporary art extraordinary importance is given to the gesture of presentation. For example, to take the case in which we both find ourselves: the frame; how to cut out an image. One could say that this question of framing, of cutting out and furthermore, of the gesture of presentation: 'Where is it that one presents?', 'What is the room you are in?' (framed by the installation of an exposition); the question of the cost of the museum, 'What is a museum?' – it's not only a place of conservation, it's a place of presentation; but also, 'What is a performance?' – it's a mode of presentation in action and of ephemeral presentation. All this doesn't mean simply that a pure absence is the true content, but rather that the content is itself first of all a question of presentation.

S-G. K: Exactly. That truly characterises the current situation. Recently I visited the Palais de Tokyo [the museum of contemporary art in Paris] and was struck by the organisation of the exposition, arranged as the process of a movement of activity and of life: a mobile space, where the artist, the curator or restorer, the archivist and the public, participate at the same time in this event of art and of life. That reminded me of the traditional Eastern conception of art, where the idea of true beauty cannot be dissociated from nature and from life, nature and life being moreover synonyms.

J-L. N: Nature and life were also reference points for Western art in the form of the idea of the representation of nature. This never meant copying objects as they were, but the representation of something like a natural or living power to make exist, to bring to life, to bring to presence. And the artist was the one who reproduced the gesture of bringing to presence. Indeed only in the contemporary world – and this touches upon all our traditions at the same time – we have a heightened conscious that there is no nature, that there is no longer any nature and no longer any life; everywhere, in nature and in life, there is technology. Medicine, modern biology, bio-genetics, all the possibilities of technological intervention in the very processes of life, in human life, in animal life, in vegetable life, so in nature in general – this shows us more and more that we cannot take as our point of reference something like a unity, a unifying principle of nature or life. So I think that the absence of content which you spoke about has to do with this, and that the question of art today is how to present the absence of [unifying] principles. When Caravaggio, or much later Corot, painted a cluster of grapes, there was a certain rapport between the idea of nature and that cluster of grapes. Today, no one is going to paint a cluster of grapes because precisely it is the idea of nature behind the cluster of grapes that is problematic. On the other hand, someone will perhaps take a label from a bottle of wine and stick it on something, or film it, and with that make a presentation of what? The presentation of the growing process of the technicisation of nature.

So, what I would like here to draw attention to is (as I mentioned earlier) that technique is art. Therefore, in a certain way, art today confronts the question: what does it mean to represent technique (which also means 'to represent itself for itself') for art? Art today presents at the same time its own disappearance and, in this disappearance, it asks again the entire question, 'What is art?', that is to say also 'What is technique?', and also to say 'What is coming in place of nature?' This is after all the definition of technique for Aristotle, since Aristotle said: *technē* is that which accomplishes ends where nature does not. Nature makes flowers grow, but nature does not make tables grow.

S-G. K: Yes, nature is life itself. Now nature is found in the skyscrapers of Seoul. Didn't John Cage say about silence (as I mentioned in my earlier dialogue with Derrida), that according to him,

silence is 'Sixth Avenue, in New York', where he lived. Silence, that is to say, nature, noise, sound, music, or the environment, therefore life itself. Derrida said: 'silence is the place of the encounter, silence shares in it'.

J-L. N: Yes, but even so, silence is completely ambiguous, because silence withdraws from the noise of the street, and it is also that which opens to let all noise enter. I would say that if silence is the place of the encounter, the encounter itself is double. The encounter is in the withdrawal [*le retrait*]. There would be no encounter if there were not first of all a separation. That is, silence as withdrawal. In the same way there would be no image if there were not first of all the cutting out of an empty space in which the image takes place. On the other hand, silence is the opening of space, or the frame in which things and people can come and encounter each other. I'd just like to emphasise that. It is this duality – the emptiness of silence, or the emptiness of the frame of the image – this emptiness is at the same time a withdrawal and an opening for something to present itself.

S-G. K: I could translate the term 'silence' in terms of 'chaos' in the sense given in the tradition of oriental philosophy. Following your expression, I could say, chaos, like withdrawal, is the beginning as the opening of multiplicity. You said 'the beginning as opening and as re-tracing' [retrait]. However, chaos is not conceivable in terms of re-tracing or of re-apparition. Nature leaves no trace, neither of its penumbra, nor of its silhouette; it is nothing other than the process of transformation that allows each moment of our life to actualise. I'd like you to tell us more about this idea of withdrawal [*retrait*].

J-L. N: Withdrawal [*le retrait*] it is at once a retreat, a stepping back, a spacing [*écart*]. I pull back from a situation, but at the same time, in pulling back, I trace, I retrace, this is also what withdrawal means; in pulling back I retrace. What do I retrace? My own place in space. It is perhaps this that the artist does. The artist makes an image or a piece of music; as an artist, as a person, she pulls back, but in pulling back, I would say, she cuts out her own spiritual silhouette, which becomes the space and the form of the image, of the melody, of the choreography. That is withdrawal. Withdrawal is a pulsing [*battement*], not a

unilateral act. It is because of this that art has pulled (itself) back from its place ... as we were saying earlier: 'art had a place', or 'one believed that it had a place', 'one knew what art was', and art retreated, drew back; but in drawing back it draws an indistinct form, a form that each new attempt at art retraces, which is the form, the silhouette of the question of a presentation ... a presentation of sense and one can also say of encounter ... it's the same thing.

S-G. K Indeed, there is no re-tracing. There is no re-apparition.

J-L. N: No, it's not a re-apparition! There is no 're'. The 're' of withdrawal does not mean repetition; it means presentation.

S-G. K: Presentation, yes, but is there not a movement of return? In other words, there are two movements: the withdrawal and the beginning, and between the two, the spacing [*l'écart*].

J-L. N: Yes, I see, I think that I could also say the same thing. But I find it more interesting to split, to double, to share out, rather than to posit a unity. Positing a unity suggests closure.

S-G. K: There is no unity without the question of difference. Chaos is the absolute potentiality and virtuality of difference, thus, of multiplicity. What I mean by 'unity' is not homogeneity. For me, only where there is difference can true unity be found; harmony is only possible with multiplicity.

J-L. N: Yes, but that's why I wouldn't say 'chaos'. One can't really say 'chaos' at this point. Because in saying 'chaos', one gives it identity, cohesion and then it isn't chaos any longer. We should speak in other terms. We should say 'what we call chaos'. And precisely the fact that unity is already in itself undone, multiplied, that is what I call recreate. There is no unity that doesn't proceed from its own withdrawal.

S-G. K: We should say something other than chaos. The article is masculine [in French, le chaos]. But chaos is the state of confusion of sky and earth, in other words the union of two differences, it is the origin of millions of things and beings. According to the legend from high antiquity, chaos was three, composed of three 'ones':

One, one, one. From this, chaos would mean the beginning of multiplicity and the process of opening.

J-L. N: The sky and the earth. This is the major form of the initial division of creation which goes back to before the monotheist traditions of the West. It begins with the major Babylonian cosmologies. Creation is always the division of the sky and of the earth. So the Western form of the question was the form of the creator-god. The god as creator is the god who divides, separates, separates the sky and the earth. If this god is a unity that withdraws in itself, as is the case in all the major monotheisms, then the god is not one, present somewhere; the god is itself in the withdrawal, the spacing of sky and earth. At this point, I would say that perhaps god is the occidental name for oriental chaos.

S-G. K: So it shouldn't be said that god created the sky and earth, because he is not the initiator. . .

J-L. N: No, to create doesn't mean to produce. To create is the opposite of produce. God isn't the initiator either. It's that which is difficult. He is not the producer, not the maker, not the initiator, but rather is the name 'god', in Latin 'dies', 'deus'; the name of the day insofar as the day distinguishes itself from night – the name of separation.

S-G. K: Yes, that's closer. However, in modernity in the East, the term 'create' is often used in art.

J-L. N: We make counter-sensical[1] use of the word 'creation' as well in the West, all the time. If the word 'creation' – a word which by the way was taken up again in the tradition of art in the nineteenth century, when the artist was considered to be a creator – means a kind of magic fabrication out of nothing, it's an absurd concept. If, on the contrary, 'creation' means something altogether different, if it means that nothingness itself opens itself as a world, it's entirely foreign to production. This doesn't assume a producer before the production. However, that is the sense given to creation *ex nihilo*, creation out of nothingness, as it has been understood by all the major theologies and above all by the major monotheistic mystics.

S-G. K: At that point then we shouldn't use the term 'creation'. We should start with the verb 'to appear'. . .

J-L. N: Yes, yes, of course, exactly! But 'to create' in Latin does not at all mean 'to fabricate' or 'to make', it means 'to grow'.

S-G. K: I had a second question. It's significant to note that for a while now in contemporary art there appears to have been a loss of interest in painting, while photography has made a powerful entrance on scene and has taken the place of painting. We know that painting occupied a major place in Western art. It was the same in the East. What's singular about photography is the 'non-image'. With photography, the image disappears. So we can say that the 'non-image' replaces the image. How do you explain this phenomenon?

J-L. N: I think that photography proceeds from a movement that's more or less the inverse of painting. In painting, light and visibility are brought onto a surface, with brushes, colours, pencils. With photography, you let light strike a surface, when it's on photographic film, and with digital photography, you let light be transformed into numerical signals. The two gestures are, I think, profoundly different. Painting was first of all an active gesture, photography is a passive gesture. This gesture highlights two passivities: the passivity of the photographer, a passivity in which the photographer must find their own activity; the photographer's own gestures become creative in the capacity of receiving what is there, at the right moment, or in choosing from amongst their photos one which will correspond to a certain sensibility. On the other hand, the facility[2] of the photographer corresponds to the facility of the subject, because the subject photographed is taken from the place where it is, in a certain way pulled away from its place, to pass into the image. When photography was first invented, some people believed that taking a photo took something away from the person photographed. Balzac was quite scared of photography, because he believed that each photograph took a piece of the self away from him, so he needed to make the right calculations – a little bit of photography, but not too much, or else it would diminish the substance of his person! I think that this anecdote shows that photography relates to a kind of fundamental absence. Between the passivity of the subject photo-

graphed in the sense of an object, and the passivity of the subject as photographer or artist, something is produced which is no doubt quite exemplary for art today: this is the encounter of the technological apparatus and light. I find this even more striking in digital photography. When you have a digital camera, and you see an image on your little monitor, you bring it into focus, that immobilises the image and already the photo that you're taking is a fraction of a second behind the subject that's before you. There's no longer even the same direct communication, where via the lens an impression is made on the film. That's why I think photography has taken on such importance, because it is in some way a presentation of this conjunction between technology and what used to be called nature – or perhaps chaos, if you like – at any rate it is, once again, light.

We could return to the question of the diversity of the arts that you raised at the beginning of your first question. Is that OK with you? I think you were right to call the diversity of the arts a diversity that is today at once mixed – scrambled, chaotic – between performance, video, performances with video and music, without there even being any idea of a 'total art'. I think this is quite important, because it touches upon a question that has confounded the theory of art for three centuries in the West: namely, the question of the classification of the arts. The classification of the arts assumed first of all a unique motivating conception for art, and then that there are many arts without there ever being an answer as to why there are many arts, except by saying that each art related to a sense: the sense of sight, the sense of hearing, but after this there's a problem because with taste, touch, and smell, they either don't relate to any art or they only relate to minor arts. So every classification and every hierarchy of the arts has always been done in a way that is violent and reductive towards the arts. Most of the time moreover, poetry was put at the summit, and when poetry is at the top, this means that language comes back into it and thus the imposition of signification, of what the meaning is. And then on the contrary today the question of the plurality of the arts is posed in a much more evident way, as a question which can't be answered by hierarchy, or by a unifying principle, and consequently, this shows that diversity is constitutive of art, and that art is a singular name that should never be pronounced in the singular. We should always say 'the arts'. There's a beautiful sentence of Benjamin's about the Muses (there were nine muses)

that goes, more or less, 'the plural of the Muses is the true name of what one calls in the singular, but wrongly, art.'[3]

What does this mean? It means also that the Muses have no other existence, no consistence, apart from one in relation to the others. They all touch upon each other, all the arts touch one another: painting touches music and music touches dance, etc. But at the same time with this touch, there is never confusion, never a collective overlapping. I can never transform an image into a sound, but at the same time an image is always also a hearing of something and sound is always a seeing of something. So, I would say, the diversity of the arts poses the question of a circulation of sense, a circulation that however transmits no identifiable signification. If I say 'a sound is red', I'm using an obvious metaphor, or if I say 'a screaming red' (*une rouge gueule*, as we say in French), it's a metaphor, and at the same time we understand this metaphor quite well, it's a correspondence of intensity, of force, of violence. But at the same time a correspondence by way of total heterogeneity. Because there's never been a red that has let out a scream!

S-G. K: That's where I see the difference too. In the East, we have the tradition of the ideogram, the pictogram. The Korean language, invented in the fifteenth century, is formed from alphabetic signs. But before that point we often used Chinese ideograms transcribed phonetically into Korean. So, at the outset, we emerged from the tradition of the ideogram for which image and language were not separate. According to legend, the King Hi-Ho invented the ideogram by observing the trace of a bird's flight: watching the bird's flight in the sky and observing the bird's tracks on the earth. That is the origin of both calligraphy and painting. A Chinese poet, Su Dong Po, looking at a tableau by Wang Wei, said that 'painting is the image of writing; poetry is the writing of the image'. So there appeared, from the origin, an indissociable relation between language and image. Understanding that, we can understand the fundamental difference between the Western art tradition and that of the East.

J-L. N: Of course, I can follow you further in this sense, by saying that in the West which is entirely alphabetic, the ideogram is a kind of ideal, a dream, I would even say a fantasy, first of all with the form of the hieroglyph, the Egyptian hieroglyphs. The first ideograms that we knew of, at least from the inside, from what was

anterior to the Western tradition but still very close to it, we called them hieroglyphs, that is to say 'sacred writing', 'sacred engravings' ('hiero' means 'sacred'). In the West we are still obsessed by the possibility of a sacred writing, that is to say a writing that is absolute, immediately representing the thing. For example, the poet Apollinaire made calligrammes. There were lots during that period: the first half of the twentieth century had a wealth of what was called 'concrete poetry', using letters and words in representational forms. Apollinaire wrote a poem in the form of a flower, of a horse, etc. Let me point out that 'calligramme' is a word that means 'beautiful writing', it's the Greek word for it. Callipyge, which means 'of the beautiful buttocks'. It's an adjective that's often used to describe certain Greek Venuses – one says 'the Venus callipyge' or the 'Callypigian Venus'. So 'calligramme' is beautiful writing.

I would be curious to know what a calligramme is called in Korean, in Chinese. Is there also the idea of beauty? Because the idea of beauty, in a certain way, has nothing to do with representation, with the pictogram; the pictogram and the calligramme are in principle two different things. In the West we also have calligraphy. In the past, one learned to trace beautiful letters using certain forms, for example, 'à l'anglaise' – in the English style. But precisely the fact that there was a troubling proximity in regards to the meaning of calligraphy and picto-ideography, let's say simply pictography, which demonstrates that for us the idea of beauty is directly linked to the idea of a pictorial representation, and that, moreover, when we say calligraphy, we suggest that normal writing isn't beautiful. And at that point it's called cacography!

S-G. K: There isn't really such a word for calligraphy. For example, the art of calligraphy is called 'so-do' in Korean and 'su-tao' in Chinese. In the term 'so', the image appears of a hand holding a brush. In other words, the art of tracing, of drawing. In the term 'hua' the idea of a field of rice appears. Tchuang Yuan-Won said that painting was like a field of rice – a space whose limits are marked by water. Water is precisely the synonym for 'emptiness', according to Daoists. In other words, painting is the field composed by the void, by emptiness.[4] The true idea of beauty appears by way of terms such as 'supreme simplicity', 'plainness', 'formlessness', or vitality – aesthetic notions which are directly attached to the idea of emptiness, chaos and nature, in the sense that I

discussed earlier. On the other hand, there is another term, 'whua', in which the idea of beauty appears, but beauty in the decorative sense, of 'the useful', 'the agreeable', 'the finished'. These are terms which suggest an idea of beauty linked to everyday life and to use, a characteristic of 'popular', 'minor' or 'low' art. These terms are often used in the pejorative sense. Here, it's precisely interesting to see how, in contemporary art, this idea of the decorative seems to take an important place. And from this comes a change in its signification.

J-L. N: This very question of the relation between beauty and decoration is the question of the relation between the beautiful and the agreeable that I spoke about in regards to Kant. A last point. I'd like to return to what you said in citing someone in your tradition: 'poetry is the writing of the image; painting is the image of writing'. What's important in my understanding of it is that there are two and that when it is said that one is the reflection of the other, there is a restitution in some way of the other, and at the same time there is an absolute difference. There is the total non-communication between word and image. If not, we couldn't say that 'the image is the language of . . .' 'language is the image of . . .' I am very attentive to this spacing [écart], because if one were to say 'the image is language in painting and the image is painting in language', in a certain way, everything is flattened out, mashed together. We forget, if I can just say, that an image never says anything and a word, even a pictogram, never shows anything the moment it becomes a word.

S-G. K: On the other hand, a word, as an act of language and gesture, does show something.

J-L. N: The difference is there at that moment, in your tradition, between writing and voice. If I say 'tao', I show nothing; if I write 'tao', I show something (I don't know what, because I don't know how to write 'tao').

S-G. K: Precisely, 'to show' as an act of language and as a 'form of life'.

J-L. N: Of course, in speaking I also show something. I don't only signify something. But then, I show not by speech, but with the

voice, that is to say, by intonation, by timbre, and also by what linguists call 'pragmatics', that is to say my aspect, the look on my face, my gestures. We Westerners often find that Easterners don't express much when they speak. We say: 'they are reserved'. There, you're laughing, I'm making you laugh by saying that normally for us you seem impassive. In the West, the Italians speak much more with their hands than the French, who themselves speak much more with their hands than the Germans, the Danes or the Swedes. All that, then, of course, is a 'monstration' that takes place, but which is below or beyond the meaning of the words, and the sense of the sentences pronounced. This touches on a matter or a material that can become material for art. It's sonorous material or the material of a face, of the skin, of a gesture, even of a dance.

Notes

1. [Counter-sense is a term used by Husserl (*Widersinn*) to indicate a term that contains an internal contradiction. – Trans.]

2. [Nancy uses the term *facilité* in French (cognate to 'facility' in English), playing on the etymological roots of the term in the Latin *facere*, 'to do' or 'to make', and *facilis*, 'easy to do' or 'to make'. – Trans.]

3. Nancy is recalling here some sections of Benjamin's writing on Goethe's *Elective Affinities*, of which the most relevant passages are: '[. . .] the ideal of the philosophical problem can be represented only as a multiplicity (just as the ideal of pure content in art is to be found in the plurality of the Muses). Therefore, the unity of philosophy can in principle only be explored in a plurality of multiplicity of [virtual] questions. This multiplicity lies immured in the multiplicity of true works of art [. . .]'. Walter Benjamin, 'Theory of Criticism', *Selected Writings, 1913-1926, Vol. I*, trans., ed. Marcus Paul Bullock, Michael William Jennings, Howard Eiland (Harvard University Press, 1996), 179, 218.

4. [A different version of part of this passage appears in the English translation that Soun-Gui Kim collaborated on. It reads: 'The true idea of beauty appears as a synonym, and at the same time is always accompanied by a notion of truth. It is not 'the truth', but 'the true', as in 'veritable', 'authentic', as in Tao – 'life', 'way', 'path', 'nature', in the sense I discussed earlier. There must be such notions for art to appear. Calligraphy, therefore, has a direct relationship with art, hence with the Way, with the Tao, but never anything to do with beauty in the ornamental sense.' – Trans.]

8

Writing in the Place of the Animal
Phillip Warnell

> Outlandish are the bodies: they are made of the outside, of the extra-
> neitas that forms the outsider's outsidiness. The outside always seems
> to come after the inside, like a medium, an element in which the inside
> world pre-exists, detached, closed onto itself. But this enclosing, this
> enfolding inside can only take place through the detachment unfolding
> the outside.[1]

Mourning the loss of the animal body, having colonised their
world, our savagery was met with reticence, silence from our part-
ners in form who showed up, remained and faded. The finitude
of annihilation leaves us now searching for authors accounting
for the place of the animal, waiting on those who can enliven
speech, lending voice and character, prompts for re-animating
lost species. This is radiated animality, witnessed in cinema's
projected electric world and encountered in the aqua-vivarium's
scrutiny of specimens. Jean-Luc Nancy's notion of bodily secrecy,
dissected decompositions 'deployed in world secret',[2] are accord-
ingly rewritten as newly composed collaborations in bodily form,
textual revelations on how creation causes embodiment according
to variants brimming with combinations on originary code. These
ex nihilo creations are bristling with sudden momentum, möbius
ribbon linking a 'spasm of the nihil'[3] to the 'spec with no dimen-
sions'.[4] The genesis of nothing pre-empts the growth of an arma-
ture, an enclosure for an otherwise eternally disembodied spirit.
In turn, this exudes exotic ramifications spawning bewildering,
endless displays of potential form, species variation and cross-
species mutation.

If writing in the place of the animal includes first contact with
the other side, this chapter seeks a negotiating position whereby
robust creaturely conveyances are also sought, extending gestures

of generative co-proposition, gazes returned. The terms of such engagement do not require *a priori* knowledge, privileging an emergent framework for operations without need of any shared intentionality, a human-animal and animal-animal accord advancing a perceptual, semio-spheric endgame where residues still meet, each organism co-signing a contract, humanity seeking a form of closure.

To explore reciprocity, avoiding traps of complacency, let's take an initial look at matters where transmissions, flow and exchange between species ended their worldly co-occupancy. Firstly in the heinous, unfortunate direction of the laboratory or abattoir, the former a sectioned bio-medical space where creatures, held under scrutiny, are withdrawn and objectified, kept in mortifying conditions. This de-contextualised limbo is an emblem for the extremity of our violence towards all species (including humanity), a death-space where sentenced animals are objectified as experimental machines, testing limits, auditing responses and limiting longevity. This is pure violence whatever the benefits, traversing the domain of our encounters with other organisms, their forcedness, reduced to industrialised foodstuff – humanity ingests animality per se, consuming its own exteriority – extending to their use as expendable, trained forces, harnessing an ability to act in the place of the master. One has only to think of the still resonant cold war spirit of soviet space dogs, all of whom were strays – apparently more willing – plugged into proto-rocket technology, an innocent's exploration of unknown capsules and g-forces working on the body, first at altitude and eventually in circuiting satellites, heating and spinning, lost and found in earth orbit. The extent of sacrifice and coercion in pioneering the spirit of military and medical surrogates is a touching, emotive example of how other species perpetually push human boundaries by proxy. The processing, rendering, torture and suffering of creatures can perhaps be most horrifyingly felt in the intimate, compelling strangeness and docu-brutality of Georges Franju's post-war film on the abattoir *Le Sang des Bêtes*.[5]

Turning our attention askance towards a more abstracted, less barbaric convergence of cross-species collaborations in form and protocol sees the less tested double-figure of a palimpsest, a trans-figurative merger between monarch and beast. This strange translucent inter-subjectivity can be felt and heard through deviancy and lawlessness, commonality of criminal incursion, a ruler of kingdom and unnamed animal, one within the other: archetypal,

metamorphosed and co-dependent. Somewhere akin to those baroque, schematic, excessively formal drawings of Charles Le Brun – whose figurative juxtapositions not only depicted human-animal resemblance, but also prompted Darwin's work on wonder – lies the resemblance between sovereign, the one who sets the law, their foregoing status above the law and the de-territorialised beast representing the cryptic puzzle of nature, endlessly roaming beneath those laws. This unnamed animal forever transgresses territory in opposition to the privileging of power, market and property. Together, the duo produce signs of permeable relations and co-ontology, animal magnetism carried within surges of animality. Monarch and beast share mutuality in the final phase of their metamorphosis, *'predators sovereign by their allure alone'*,[6] whereby beauty and the beast become beauty as the beast, witnessed in the revelatory moment and eternal seduction of death, forever echoed in the proclamation of regal demise and simultaneous rights of succession . . . *the king is dead, long live the king*!

High-rise animality: The big dipper

Humanity inextricably operates under the sign of the animal in motion, which is written in the shifting constellations of the night sky. Literally encircled by a network of projected, metaphysical animality, this configuration suggests a celestial set of animate-coordinates, a zodiac of oriental or occidental persuasion, mystical, mythological and playful signs for the anniversary of our bodies, their purported characteristics and even, why not, our futurity. The Mexican magical realist poets agreed on this principle, of ancient meeting points between logic and myth, as Octavio Paz exquisitely poeticises in *Brotherhood*.[7] As Nancy suggests, art is inherently cosmological, producing a singular monadic and nomadic spacing, spanning the world.[8] Celestial bodies are eternally unfixed, remaining constantly so. We are written in them. The domain of cosmology retains an air of predictability, Ptolemy's *Almagest* (AD 150)[9] the earliest surviving closed cosmological treatise on the vertiginous nature of endlessly elliptical movement. In astronomical terms, nothing is ever stationary, the trajectories of animated paths defining the inspired nature of bodies. Not a single atom of matter is in absolute repose, perpetual motion measured by the telescopic, optical process of parallax viewing. Paradoxically, however, we are reconsidering the tenets

of a myriad infinite universe, the writings of Peter Sloterdijk[10] and others, returning us to consider this previous closed state, of encounters with external, cellular forms with limits, an outer shell, the parcelling of climate control, breathing spaces and shared orbs, vast globes and other worldly zones.

Isn't the temporality we produce whilst inhabiting and entrenched within a body inevitably also drawn from bestiality, residing within whichever of its untamed guises: be it unconscious, symbolic, genetic, bare life or bio-political. Striking a vivid if lackadaisical pose, the anthropological machine[11] prefers to be viewed apart from its zoology, giving rise to endlessly overworked, desperately recycled stories, soulless encounters, high-moral representations longed for by the overworked forces of homogeneity, both in linguistic and other public spheres. The need for high subjectivity defines cultural clamour, placed at the service of poor narrative, an empty and predictable zone, stifling in its production of anthropocentrism.

Conversely, 'writing in the place of' conjures an urgency supported by a plethora of interconnected theoretical and literary stances, intense speculations on exchanges of inter-bodily, spatial and temporal imperatives, from rhizomic inter-species notions of animal becomings, to the agency of animism itself, as extended in classical mythology. These cellular reconfigurations have long told tales of transfiguration, embracing the qualities of love, contact, archetype and even, as Deleuze and Guattari would have it, molecular reapportionment.[12] Animal-to-animal relationships are syntheses, bordering on the symbiotic: the hunter and the hunted, possessed and possessor, sacred and interlocutor, predator and scavenger, shaman and sacrificed, master and beast, each beholden by the other. So where do the limits of this potential reside? Is there a primordial bond between human and other species? Or is this link a work in progress, a retro-projected form and proto-understanding of an as yet unidentified coexistence, approaching the lost imperatives of predetermination, our nature in mutuality.

Surges of animality and poetic interventions mediating human-animal relations need further theorising. These inter-constitutive facets of an extended stretching of corporeality comprise intimate distances. They propose a radically altered concept of metaphysics, interdependency and coexistence, as imperative as ways of feeling or imagining oneself in the place of the stranger, as Lisa Cartwright observes.[13] Further linked to this concept, Agamben

deliberates on the (non) borders of separation and proximity between animal and man, developing a succession of ideas departing from the tenets of *Dasein*.[14]

The inaugural gestures of representation were a calling, humanity inscribing after the animal (organisms colonising certain of our inscriptions, world-forming their own micro-palimpsest), these renderings an apology for the violence of its sacrifice and prompt by which humanity prospered.[15] Indeed, Bataille suggests the performance of gesturing towards the animal as one whereby 'the actual doing embodied the entire intention'.[16] In the cave of repeat renderings, a tableau is formed across the curvature of undulating planes and cavernous surfaces, a subterranean study of pigmented herd and multiple animal mass, at Lascaux numbering some nine hundred animal bodies almost entirely devoid of the human figure. What needs further consideration, however, is the question of whether it is gesturing that raised, shifted and altered consciousness, or whether it is rather the discovery and realisation of animal form, which initiated monumental shifts in human perception. Children ever remind us of this perceptual transformation, mesmerised by their formative attempts at primary figuration; of circular, bulbous form and line-denoting limb, coloured bodies, conditioning awareness through their imaginings of endless configurations and protrusions.

As catalysts for perceptual re-attunement, drawing, performance and poetry are reminiscent of how writing and trace resonate in all directions simultaneously, forming an elliptical, non-linear, time-honoured sense, for example in Persian culture, whereby one doesn't simply read, one *does* Hafez. In an after-dinner act, randomly opening the ancient poet's canon, selecting and scrutinising a given verse, the opened volume confirms one's participation in a metaphysical act, placing the participant at risk within elements of chance missives, fated notes and preordained discoveries. It opens the possibility of a moment of revelation embedded in the suspended *ghazals*; an epic snapshot of poetic analysis, a *divan* written for eternity, a fortune and future told in the act of writing.

Constellations of subterranean stars, dot-to-dot configurations of celestial critters and pigmented animal figures in motion ritualise and exorcise poetic animality, bearing witness to a return of previous time, an opening of temporality and placelessness. Violated and venerated, we mourn the eternal animal, their presence always already lost to us. The darkened spaces of cave, séance and cinema

induce incantations, phantasmatic encounters in written, pictorial and projected form. These shamanic advents for the spirits of repressed animality are implicit in the production of animal form and performing figuration. Drawing on the death of other species felt through embodied affect, we internalise their body, soul and time. Such planetary and bodilyness can paradoxically be sensed in the uncanny ability of other creatures to act therapeutically, the enigma of a cat 'intimate with the impossible'[17] coupled with the cradle of humanity, Hafez's poetry with the constituents of being.

Nancy's writings present further facets of inscribed intuitions relative to corporeality, an initial magnet towards his corpus. The inherently collective experience of de-natured bodies, new commonalities and reconfiguration of the bodily assemblage for Nancy involved heart transplantation, first performed in 1990 and later repeated. His thrice-hearted writings before and since that date, particularly L'Intrus,[18] a philosophical diary on his experience published ten years later, disclose a certain coincidental force of thought, anticipating and thinking further on his own (forthcoming) experience in prescient manner. His body and text channel uncertainty, the precarious condition of our temporary encasement in bodily enclosure, born into a world of 'strangeness unpreceded by any familiarity'.[19] Along with recent bio-medically driven innovations: of transfusions, harvests and organ re-assignation comes the Nancean ability to relate the extreme, permeated circumstances of transplantation by textual intervention, borne out in unprecedented, post-operative, post-traumatic prose.

Here, philosopher is recipient and conveyor of both graft and gift, his body the essential material of his own musings, a becoming text afforded by radical, surgical incision and operation, an unlikely, anonymous assemblage of intra-organic partners. As Nancy points out in L'Intrus, the continuation of our bodies is subject to the limits and interventions of medical technology, its capabilities of the day. The recent advent of immunology radically shifts the scope and territory of bodies, their trans-capacity, calling into question the very moment of mortality. A harvested organ commences resurrection whilst still set within its originary host relative to a controlled, incremental staging and episodic three-part death of its initial user. Temporarily disembodied organs contradict Artaud's higher spirit of contradiction, whereby organs denote 'marks of a judgment, permanently etched within us'[20] abstracting their extractedness in a bizarre, technologically assisted

conversion of death, as formulated by Lesley Sharp.[21] Comprising the accident and associated resuscitation by emergency services, this is followed by an eventual declaration of brain death, which in turn culminates in a controlled physical shutting down, as life-support machinery is turned off. Extraordinarily, during the third of these stages, the beyond repair host is essentially functioning as an organic incubator, prior to the re-assignation and harvesting of their organs for use elsewhere. In a race against time, organs take on life-like value, exposing the death-drive, gift-oriented economy and de-gendered venture. Introducing an elsewhere into the nowhere and no one of a body, the value of an organ transporter takes its place alongside that other long-established surrogate, the Canopic vessel utilised as a sacred storage place for organic extractions as eternally fetishised objects of worship, veneration or curiosity. Although given without cost, attention becomes the payment for such a gift, the tremendous scrutiny required for a graft to remain unrejected. The drawbridge of the second-life guest-host and recipient of donated material is permanently lowered, their immune system open, in constant dialogue with technology.

In 'Strange Foreign Bodies',[22] a text written to accompany the film *Outlandish*,[23] Nancy meditates on the foreign body, its intrusion, intimate distance and 'outsidiness'. The film offers a further visual counterpart to his on-screen delivery of the text in the form of an octopus, that most inside-out of creatures, suspended in a raised aquarium, constructed on the deck of a fishing boat journeying on the Mediterranean Sea:

> One's own body – we say to differentiate it from a foreign body: but what kind of ownership does the one owning have? It isn't an attribute of my substance, it isn't a possession of my right, though I can identify it as such in certain respects. It is my own in the sense that it is me rather than in the sense that it is mine. If it were mine in the sense of an attribute or a possession, I could take advantage of it to the point of annihilating it. Annihilating myself then, I would show that it is me and not mine. It is myself, yes, *ego extraneus*. Myself outside, myself out, as out of me, myself as division into an inside and an outside, the inside sunk into itself to the point of obscure concentration, opaque and bottomless, in which the spirit is torn between an abstract I 'that needs to accompany all my representations', as Kant demands, a logical and grammatical subject without substance, and an uttered 'I',

an ego wide open in two lips curved around the funnel of air thrust into sounds by throat, palate and tongue, according to the airwaves demanded by the unique biology of my tongue. Inside turned onto itself, extravawide, exogastrulated, exclaimed, expressed and thrown – not 'outside' but 'as outside'.[24]

In the almost photographic encounter with aquatic life a sea-going aquarium provides, projected moving stillness is screened. In *Outlandish*, a part-animal part-landscape precisely frames perpetually recycled encounters and extended instances. These unconsolidated spaces are where memories and instincts are best forgotten. Frozen, miniaturised, translated life-worlds (of specimens that can reside in such artifice) remain in suspension and evolutionary limbo, instincts on hold, hovering somewhere between play, death and the image. This unembedded, cubed world is configured within a slow, glass skin, standing free-form as a sculptural entity, set eternally at the brink of its own collapse.

False bodies: the *pseudomorph*

What embodied strangeness, the emotional octopus, a creature whose nature is in torsion and rotation, a lithe body formed as if turned out on a lathe, crafted during a giddying, whirling experience of micro-incubation. A watery magician, mimic and writer, the exquisitely cared for, protected origin of this creature is mesmerically documented in Jean Painleve's part-scientific, lyrical *The Love Life of the Octopus*.[25] The ink of the cephalopod literalises an answer in our search for an author (and species of sculptor), its ink sac iris responsible for the dispersal of sepia production, squirting an extended ability to disappear into a puff of inky escapism. However, if we fully wish to appreciate its pre-figurative bio-scriptures, we must see beyond inky technique to the more impressive, even astounding ability to produce false bodies, or *pseusomorphs*. These ejaculated forms are projected forth, demonstrating the complexity and breadth of the squid's relationship to its outside, of contraries and extremes: producing on the one hand temporary camouflage and behavioural mimicry, a process of becoming the other, whilst on the other hand capable of an ability to deliver temporary replica foreign bodies. Casting a complement of extra hands comparable in size with their source, these projections are dense with mucus, maintaining an external

inchoate in liquid for longer than dissipating clouds. The creature produces several of these ectoplasmic decoys, blanching its own colour in correspondence with the group, escaping in the ensuing hall of mirrors and kaleidoscopic multiples, the temporary creation providing disguise and cover. This is a nifty solution for the one on the run, the dummies mistaken by potential predators for a jet-propelled escapee, the cephalopod itself.

Even as we speak of captive animals, let's be reminded that the (second) largest of all molluscs, the shimmering gold giant *architeuthis*, has never once been captured let alone kept alive in the displaced circumstances of a parlour ocean. Its extraordinary mass, shyness and complexity were first filmed only recently[26], the creature endlessly evading first contact with our prolific, pathologically driven culture of captive, live specimen observation, the classification and appropriation of other species by forced, land-bound proximity. A reminder that the ocean's deep is essentially of another order, this aquatic monster has lethal weaponry in serrated circular suckers and parrot-like beaked form, dinner plate-sized eyes peering, nightmarishly worthy of its mythologised sea monster cousin, the *Kraken*.[27]

Writing in mourning for the animal and the eternal voice of the dead . . . for it is the animal that knows how to die. And when the human-animal dies, it dies just like any other species. The sensation of mortality and precarious genre of the philosopher's body as filmic material is insisted on by Deleuze in his exposition of why A is for Animal, not Adam. This indexical film[28] sees the philosopher, ravaged by illness, performing his own proto-animality in full flow, encompassing perceptions and excessive keratin growth. Famously extended, his fingernails resist sensitivity, loathe frottage and disclose animal to animal tendencies, captured on film in full anticipation of the eventual taking of his own life, knowing how and when to have taken place. His agreement to make A-Z included a proviso that it wasn't released before his death, positioning the lexicon into a futurity without a present, outing the death drive, and longing for eternity.

In the slippage between the images of a film projection, which occupy as much screen time as a film itself reside the felt, magnetic, electric animal and possibility of a shared unconscious, conjuring the magical beginnings of electric images in cinema and their origins in projected phantasmagoria. Safaa Fathy's film *d'Ailleurs Derrida*[29] sees film-maker and philosopher develop a number

of negotiating positions on the medium, feeling their way into that precarious genre, the uneasy philosopher on film, or rather, the body and word of the philosopher as film. As with Deleuze, Nancy and others, displaced time, speech act and discomfort are experienced of Derrida as interlocutor for the film's narrative, his overwhelming sense of forcedness into film as matter nourishing the discourse of cinema as the preparation of a text: selected, edited and signed by the film-maker as author. A visit to the aquarium prompts his apprehension at being made to perform as captive intellectual and material specimen, in keeping with cinema's adoption of animal puissance as a measure for the motorisation of the moving image, still a crucial element in the formation of a cinematic image. Derrida's glowering concern is palpable, inscription before a lens the epitome of his definition of cinema as the 'art of ghosts'.[30] Impossible identity mixes autobiography with phantom witness and absenteeism, forced into the necessities and apparitions of film-making's dis-temporality: its uncanny curiosities, endless procedures and limitations. Philosopher and spectator are reminded of time as unfelt between species, sensing the untranslatable aspects of an unshared experience with those of another order. Philosophers, authors, species and co-occupants all sense this uncertainty, or at least the unwished for certainty of their assimilation, succumbing to the silver screen's inevitable little death,[31] its phantom figures, lenses and apparatus of camera or aquarium.

Premised on a felid named *Ming*, his relationship to Antoine Yates and *Al* (alligator), *Ming of Harlem*,[32] also made in collaboration with Nancy, explores the depths of high-rise co-habitation. Together a prodigious tiger, dangerous alligator and human, three disparate and nominally conflicting protagonists, shared the confines of a fifth-floor social housing apartment in Harlem. This ended in 2003 when Ming bit Yates, hospitalising him. That they had formed a secret world and successfully sheltered (or at least survived) in this environment for several years provoked collective outpourings of disbelief and amazement in the neighbourhood. It culminated in a rescue operation of the now lonesome predatory duo, a situation the New York police department termed an 'animal condition'. However, during an extended, digressional mid-film sequence a re-attunement of the viewer occurs, articulating a radically different experience of spectatorship and accompanying shift in perception. The threesome's cohabitation and interdependency offer potential for correspondence between the

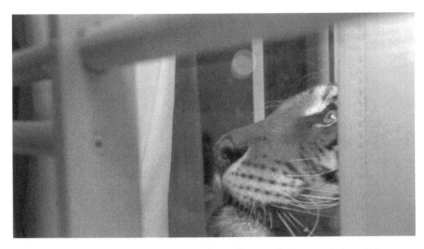

Figure 8.1 *Ming of Harlem* film still © Big Other Films, 2014.

film's intentions, protagonists, methods and text. Nancy's poem written for the film begins as follows:

Oh Tiger oh Alligator
one another neither friend nor foes
cruel indifferent sovereigns meeting by chance
not through hunting or the whim of men
zoo or domestic fantasy
fantastical fantasy face-to-face in ignorance
pure cruel innocents
sawing jaws bony frame violent game
long indolent torpor
skin-deep sleep
and sudden awakening
as if called by a bugle
a signal an alarm
a cry a scent a rustle a breeze
an insect or snake
pulse of prey or threat
pulsing death oh indifferent death
sacrifice without idol[33]

Non-human and human animals are defined by territory, an inextricable relationship to architecture, geometry and co-ordinates

within which they produce a kind of temporality permeated by corporeality, a 'border' and 'order', as Nancy suggests.[34] It is in this sense animals are not in the world, they are the world, territory both the property of the animal and one of its properties. The bowerbird is an exemplar of notional ideas concerning permutations by which the constituents of being correlate with dwelling, synthesising in both bodily and projected forms of animality, encompassing the house and grounds of the body. The full-crested variation of the bird wears its display integral to its body, a resplendent feathered red crest, whereas the plain, uncrested bird produces an alternative, magnificently crafted architectural bower on the forest floor. This marvel is replete with colours, textures and sensory attractors, one of the wonders of the animal world. As an externally produced equivalent to embodied display, the bower's architecture is in a sense just as bodily as the body, not an outside but *as* outside, touched, felt and constructed through an astonishing number of aesthetically inclined constituent choices and complex variations. The crested and bower producing bird are variants on the oddity, abode and display of bodilyness, reaching towards representation, revealing how spatial and bodily discontinuity works, whereby difference and sameness melt into the identical. In forming this elaboration the uncrested bird isn't necessarily competing, as nature documentary commentaries insist, it is completing, in the sense that it produces and configures its own spatial exteriority. Its inside is produced as an outer form of completion, whilst its territory integrates an externally sensed fold of the bird's requirements for 'outsidiness', as Nancy suggests, each conditioned by the other.

The forced discontinuities of *Ming of Harlem*'s film set landed like a model of the wherever placed within an existing UK zoo tiger enclosure, carrying its own potential for boundary and narrative setting explored and written by the tiger in the place of the film-makers.[35] As integral to the film as the camera, director or protagonist, *Ming's* set was ethically and strategically deployed. *Tales of the Unexpected* commences with opening a trap door, the daily routine by which zoo big cats gain access to exterior enclosures from sleeping quarters. Contrary to the conventions of the film industry, where animals mysteriously appear on studio sets from improbable origins, this 'ferociously luxurious' creature stayed at home, musing on our construction from within spraying distance. Entering repeatedly during a two-day shoot, Ming

stepped into a residence that, apart from a replica window, did not, however, depict Yates' apartment. Yet once inserted into the film's montage it takes its place, hovering somewhere between archive, territorial zone and life-world translation. Huge, striped steps taken through a trap door into the vestige of an unfamiliar Manhattan domain saw familiar visual and olfactory stimulants remain, but a radically changed proto-world encountered, utterly usurping the known; a projection of exterior terrain as interior footprint, slice of Harlem fifth floor and cinematic wild inside.

no altar no ritual
sacrifice to ravenous life
to the living gods of fertile devourings
to the gods of older worlds
tiger the vengeful god alligator the wrathful
knowing neither vengeance nor anger
oh such impeccable savagery save barbarity
save war peace dilemma
powers identical to themselves
even not the same
living outside their names
outside the languages that name them
these names that roar and gape
these sharp-toothed names
hot-throated maws
claws and craws
scales and stripes
all these animal words
they have not learned
nor understood or swallowed nor devoured or digested
them in their names not in them their names
names which flutter outside flags torches ideas images
nothing to eat nothing to scratch nothing to bulge
but growling snapping biting
forms of fierceness called by name
Tiger Alligator
more than your truthful names
following your hunger
following what suits your ways
unconcerned with proper splendours
sumptuous coat scaly leather undreamt-of luxuries

massive luxuriance radiating
figures of an old mystery
of living profusion
a mystery of origins in the prolific profusion of geneses
of genes of generations
of crossings of selections of mutations
of trials of errors of successes
in families species and varieties
through to rare specimens the great loners
lords of forests and rivers
born just for this lordly dominion[36]

Nancy described the set as a 'cracking egg',[37] resonating with Antoine Yates' philosophical description of high-rise living, a 'crack to escape', lost somewhere between 'ground thing' and 'up there'. He also reminds us how creatures of huge difference in eventual size emanate from eggs that are, in the main, of similar scale. Not so with a wild tiger, whose outside is defined by an extended territory of hundreds of kilometres, repeat forays and perpetual need for predation integral to its survival and psycho-geography alike. This is a poignant reminder that the confines of social housing offer but an abject compromised counter-stimulation for such a prodigious creature.

Ming's magnetic enlivening of the film set was achieved not only through territorialising it but becoming it, effortlessly imbuing and moistening it with an inspirational, impossible sense of identity. Felid, alligator and space dialogue in an open zone of temporality and fusion, where the 'scales and stripes' meet the 'stars and stripes', not in a shot-by-shot montage, but rather, as Raymond Bellour[38] has suggested, where animal and cinema coalesce in the notional possibility of a sign-by-sign progression.

Tiger Alligator
sovereign by your allure alone
by your stretches by your leaps
by your sated sleep by your starts
by your fury your courage your glory
which our tongues
try to form in roughened rhymes
gnashing scratching roaring
rumbling repetitions

hoarse tongued torsions
tongue behind words
in your mouth which roars and which weeps
groans moans howls
cries from your tear-filled throat
your throat tigrator your throat
but no less mine no less
deep in which these names you do not know make signs
which celebrate you which honour you
rituals prayers
rhythms of adoration
from throat to belly and into the lungs
heart liver nerves and tendons
spread the shiny splinters of your names
Tiger Gator
their savage invocations
which make of you in me the gods
the ancient the fearsome
intimate with the impossible[39]

If the animal is a 'being on the lookout'[40] it emits signs, operating in the absence of the present, always already moving towards that lost presence from where the sign derives. If it is a signature, the pure event of writing a trace produced by its own erasure,[41] it inscribes its way through the erasure of the film's points of reference, their removal through the turning of filmic-pages, room-by-room, gesture after gesture, step by step, writing in the place of the film-maker, precisely the apartment as a protagonist coupled with the sleek movement of the tiger, essentially flowing through the dwelling. An unexpected mnemonic twist supplements the film's scenario, stand-in tiger Rajiv's personal memories of being raised in the built environment providing an explicit echo of Yates' raising of Ming. Reared in a house as a circus big cat and celebrity cat at corporate events informed Rajiv's inclinations on set, spraying and urinating in corridor, bathroom, front door and den, but never in the living room area. His familiarity and sensory limits resonate with déjà vu in the perplexing thought of a house-trained predator, recalling the steps of endless generations of 'forms of fierceness' placed into geometric zones, environments of hand rearing, tiger training and strange proximity between animal keeper and celebrated specimen. Handlers, trainers and spectators

all in pursuit of a precarious, impossible desire: the taming of wild animals and timeless ambition to walk alongside them, sensing false mastery over them, seeking their unobtainable trust.

Philosophical zoophilia

Yates' dream-like incursions towards Edenic fulfilment enter an unconscious zone of electric-animal dominance, chiming with celebrated Tiger Trainer Mabel Stark's sixty-year career. *Ming of Harlem* commences with archive footage of Mabel in action. Famously, she could work seventeen Tigers simultaneously, teaching a Tiger to tightrope walk on two parallel ropes. Her autobiography *Hold That Tiger*[42] elaborates on the demands and fascination of her creaturely co-operations, most especially two tigers of the same name with whom she built a special rapport, culminating in an ability to perform a particularly exotic, if discreet act of zoophilia.

The film's own probings form an exchange between species, storeys and tales, where episodes of imagining, personal and social history, residence, model-making and façade meet. Here Nancy's dual-character the Tigrator emerges, a creature of cinematic, poetic, hypnotic and mythic proportions, along with his later multi-charactered, multi-attributed *cinématogriffiques* and *cinégatorgriffiques*.[43] Where dwelling and waiting occur in thinking space and family residence, co-naming necessarily intersects with the sites of cinematic and terms of philosophy. Animal proximity, touch, captivation, belonging and nothing are sensed and felt, being inevitably traversed by nothing. An irreconcilable dilemma defines an eternal struggle between man and animal or man as animal. Agamben confirms this in a range of assertions, concluding that *Dasein*, the epitomy of the human, is simply an animal that has learned to become bored, awakened from its own captivation to its own captivation. And whilst the constitution of a world has been set in opposition to a supposed animal environment, this misshapen *weltarm*[44] has long been exposed, confirming a view that animals have a world in their stimulatory constitution and territorial requirements.

It is, however, in the realisation of the *corpus* itself that we find an unspoken, yet fully developed authorial answer, amounting to contact with and even knowledge of the unknown.[45] The liveness and variation of animality is the articulation of sense

and worldly stipulation in the endgame of enlivened creatures, displaced worlds. The constant reformulation of biological life necessitates a certain reattunement towards the animalisation of the human and humanisation of the animal, 'bending' instincts, as Antoine Yates describes it. Nancy reminds us that high-rise living and climate control equally diminish our sense of space, the loss of ground, height and absence of co-ordinates at altitude resulting in disequilibrium extending in all directions. At odds with the apart of apartment, intoxicated with vertiginous disorientation, confronted by Ming and Al in-situ as simply living beings, Nancy suggests that what remains of their essential, coalescent menace of the two species is 'savagery save savagery'.

Thinking on the animal is produced without knowledge, establishing being by means of poetic insight and bodily substance, set amidst the otherworldly requirement that the first man named all the animals on the fifth day (but not on the fifth floor). How profound was the chasm formed in that gesture of naming, where representation and writing opened a fissure between human-animal and other species. However, the split-imperatives of *Tigrator* cut a figure and motif whereby we can sense the false integration and microcosm of dangerous roommates. In forging newness of hybridity and neologism, Nancy exits the language of proper terms, entering world forming via word forming, inextricably bridging species attributes', 'scales, stars and stripes'. The combination of pennant, space and being form a mutant poetics, establishing being-with and threatening further transgression. In a bizarrely somatic, realised unreality of limbs, letters and names – from 'Liger' to 'Zonkey' – chemistry extends to cross-species versions of birds, reptiles, cats, ruminants and insects. It opens up the somewhat taboo question of forbidden love, the secret need to withdraw from society to comply with a calling towards an exotic, otherworldly and perverse bond of companionship, placed at its sexualised extremity. The shock of witnessing seal and penguin copulation eventually gives way to a more palatable sense in which unexpected transmogrification is a material pre-requisite for evolutionary development.

If in the making of a film and in writing in general there is an impossible search for an identity, it suggests a compelling, if somewhat ill fated attempt at a self-audit, written in the paradoxical sense of listening to oneself, yet hearing another. This permeates all production, resounding and coursing through it, channelling

as integral to it, stretching its limits. Not that all production is autobiographical, far from it. Rather, that the impossibility of self-auditing and certainty of a relationship to the unknown permeates writing and film, shaping, informing, erasing and measuring it. If listening to oneself be non-semantic, neither is it intuitive, revealing only that externality goes all the way. This operates in the same way that psychoanalysis provides, as Jacques Alain-Miller puts it,[46] an opportunity to tap into and dialogue with one's unconscious, a methodological analysis resulting in its relative depletion, accompanied by the lessening of its surges through interstices into the real. Coupled with ourselves, sensing both guest and host, hearing blood coursing as would the ocean amplified by a conch held to one's ear, spells out *ego extraneus*.[47] In witnessing ourselves as 'myself out' in a multiple-form-name encounter with the weight and intensity of dimensionality, we contend with unending non-relations, the voracious and precarious conditions of infinitesimal division, creaturely abode and secrecy of an outrageous wild inside.

Notes

1. Jean-Luc Nancy, 'Strange Foreign Bodies', in *Outlandish: Strange Foreign Bodies*, Phillip Warnell and Jean-Luc Nancy (London: Phillip Warnell, 2010) 19.

2. Ibid., 22.

3. Ibid.

4. Ibid. Nancy is referring to Augustine's *De quantitate animae* 1.2; 5.9, AD 354.

5. Georges Franju, *Le Sang des Bêtes*, film, directed by Georges Franju (1949, France; USA: Criterion Collection, 2004), DVD.

6. Jean-Luc Nancy, 'Oh the animals of language', © Big Other Films, 2014.

7. Octavio Paz, 'Brotherhood: Homage to Claudius Ptolemy', in *The collected poems of Octavio Paz, 1957–1987*, ed. Eliot Weinberger, trans. Eliot Weinberger and Elizabeth Bishop (New York: New Directions, 1987), 508.

8. Jean-Luc Nancy, 'The Technique of the Present' (lecture, Nouveau Musée, 1997).

9. Ptolemy's *Almagest*, trans. G. J. Toomer (Princeton: Princeton University Press, 1998).

10. Peter Sloterdijk, *Globes: Spheres Volume II: Macrospherology*, trans. Wieland Hoban (Cambridge, MA: MIT Press, 2014).

11. Giorgio Agamben, *The Open: Man and Animal*, trans. Kevin Attell (Stanford: Stanford University Press, 2004), 33–8.
12. Gilles Deleuze and Félix Guattari, *A Thousand Plateaus: Capitalism and Schizophrenia*, trans. Brian Massumi (London: Bloomsbury Academic, 2013).
13. Lisa Cartwright, *Moral Spectatorship: technologies of voice and affect in postwar representations of the child* (Durham, NC: North Carolina Press, 2008).
14. Agamben, *The Open*, 16, 67–8.
15. Jean-Luc Nancy, *The Muses*, (Stanford: Stanford University Press, 1996) 69–80.
16. Georges Bataille, *Lascaux, Or the Birth of Art: Prehistoric Painting*, trans. Austryn Wainhouse (Geneva: Skira, 1955), 129.
17. Jean-Luc Nancy, 'Oh the animals of language', © Big Other Films, 2014.
18. Jean-Luc Nancy, *L'Intrus* (Paris: Galilée, 2000).
19. '*Le monde est l'étrangeté que n'a précédée aucune familiarité*'. Nancy, 'Strange Foreign Bodies', 19.
20. Antonin Artaud, *To Have done with the Judgement of God*, trans. Clayton Eshleman and Norman Glass (Los Angeles: Black Sparrow Press, 1975).
21. Lesley Sharp, *Strange Harvest: Organ Transplants, De-natured Bodies and the Transformed Self* (Berkeley: University of California Press, 2006).
22. Nancy, 'Strange Foreign Bodies', 17–23.
23. Phillip Warnell, *Outlandish: Strange Foreign Bodies*, film, directed by Phillip Warnell (2009, London, The Wellcome Trust).
24. Nancy, 'Strange Foreign Bodies', 20–1.
25. Jean Painlevé, *The Love Life of the Octopus*, film, directed by Jean Painlevé (1965, USA: Criterion Collection, 2009).
26. Mark Shrope, 'Giant squid filmed in its natural environment', *Nature: International weekly journal of science*, last modified 14 January 2013, http://www.nature.com/news/giant-squid-filmed-in-its-natural-environment-1.12202.
27. An enormous mythical sea monster said to appear off the coast of Norway.
28. Claire Parnet, *Gilles Deleuze from A–Z*, film (Los Angeles and London: MIT Press, 2012) DVD.
29. Saafa Fathy, *d'Ailleurs Derrida*, film, directed by Saafa Fathy (1999, Paris: Editions Montparnasse, 2008) DVD.

30. Ken McMullen, *Ghost Dance*, film, directed by Ken McMullen, (1983, UK: Mediabox, 2006) DVD.

31. In the etymology of the word 'film', traced through pellicule to pellicola.

32. Phillip Warnell, *Ming of Harlem: Twenty One Storeys in the Air*, film, directed by Phillip Warnell (2014).

33. Jean-Luc Nancy, 'Oh the animals of language', © Big Other Films, 2014.

34. Nancy, 'Strange Foreign Bodies'.

35. Ming of Harlem was partly filmed in a tiger enclosure constructed at the Isle of Wight Zoo, UK.

36. Jean-Luc Nancy, 'Oh the animals of language' © Big Other Films, 2014.

37. Jean-Luc Nancy, 'notes on animal' (unpublished, 2015).

38. Raymond Bellour (lecture, Whitechapel Art Gallery).

39. Jean-Luc Nancy, 'Oh the animals of language' © Big Other Films, 2014.

40. As described by Deleuze in *A is for Animal* in Parnet, *Gilles Deleuze from A-Z*.

41. Giorgio Agamben, *The Signature of All Things: on Method* (New York: Zone Books, 2009), 79.

42. Mabel Stark, *Hold That Tiger* (Caldwell: Caxton Printers, 1938).

43. From a short unpublished poem by Jean-Luc Nancy, 2015.

44. Martin Heidegger, *The Fundamental Concepts of Metaphysics*, trans. William McNeill and Nicholas Walker (Bloomington: Indiana University Press, 1995).

45. Maurice Blanchot, *The Infinite Conversation*, trans. Susan Hanson (Minneapolis: University of Minnesota Press, 1993).

46. Jacques Alain-Miller, 'Rally of the Impossible Professions' (lecture, 2008).

47. Nancy, 'Strange Foreign Bodies', 21.

9

Together at the Limit:
Jean-Luc Nancy, Art and Community

Lorna Collins

This chapter draws from the aesthetic theory of Jean-Luc Nancy and his work on community to think about how an artwork exposes limit and how, as a result of this, it engenders a sense of community. I begin by juxtaposing Nancy with Sophie Calle's 2007 installation *Couldn't Capture Death*. Calle's artwork seems to present purely the human limit, by revolving around a documentary-like video recording of Calle's mother's death. This work prompts a sense of Nancy's *Inoperative Community*. It does so because when we enter this installation we co-appear with its object – being-with the ungraspable last moments of this dying lady. This experience exposes our syncopating finitude. It engages Nancy's *The Inoperative Community*, by defining a sense of community as the communication and sharing of our finitude.[1]

I question what it means to argue that an artwork produces a sense of limit and community. Drawing from one of my own installation artworks, *Flashback*, I use Nancy's aesthetic and communitarian corpus as a muse to inspire both the creating and comprehending of an immersive installation that uses the senses of smell and touch to evoke an agent of making sense at the limit. This limit is not so much about dying as touching the threshold of a rebirthing process. When people enter my installation, they dwell within and experience this process. Composing and comprising such a dwelling, the installation (temporarily) houses a community.

Nancy helps me understand this as the work of my artwork. Here we share our finitude (and its eternal return of *renaissance*). To solidify this thesis, and connect my work with that of Calle's, I conclude by constructing a plane of 'transimmanence'. This plane is Nancean. It draws across ('trans') and beyond the power of sensory immanence gained from viewing and making art. This

plane locates and houses a logically inoperative but productively aesthetic sense of community. Here we (the community who assemble here) can initiate a touching journey of trying to make sense at the limit brought forward during the aesthetic experience.

Sophie Calle

Sophie Calle's *Couldn't Capture Death* is an installation artwork that was shown at the Venice Biennale in 2007. It was part of the main international exhibition at this event, which was curated by Robert Storr. Calle's installation featured a video of the last moments of her mother's life. In one of the two rooms was a DVD player showing on continual loop the indeterminate moment that she died. This moment is impossible to capture. The context of this work is integral here – the work was created in response to the tragic coincidence of Calle learning of her commission to represent France at the Biennale (with another work, which was in the French pavilion) and also of the terminal illness of her mother, Monique, who only had a few months left to live. One of Monique's last wishes was that she could have gone to Venice to see her daughter showing her work here. As Calle wrote on the wall in the first room of this installation: 'Here she is.' The film in the installation continued to play, on continuous loop, around this indeterminate time of Monique's death. It seemed to show me, purely, the threshold of existence, holding this moment, which is impossible to capture in eternal repetition (that the event of its encounter, my encounter, by then had become). Time seemed suspended around the moment where passage of life turned to the 'pas au-delà', as in Maurice Blanchot's *The Step Not Beyond*.[2]

This artwork provided a certain showing and sharing at the moment of Monique's finitude. In this way, the installation at the Biennale presented a Nancean sense of community. We do not share her death; we witness something we cannot and must not share, and in such exposure is built a vestige of life and love, which provides a sense of community.

What does it mean to say there is a sense of community shared here? To investigate this I shall now look at how what Nancy says about community, and how the 'compearance' and 'transimmanence', which define the sense disseminated by Calle's work, engender what Nancy would call an *Inoperative Community*.

Nancy on community, finitude and art

In Nancy, community is the being ex-tatic of being itself: '*Community, or the being-extatic of Being itself*'.[3] This means that community is a being outside of itself, being is seen in terms of a conglomeration of others, a coming together (which means, also, being at a distance) of singularities. Community is the ex-tasy of singular beings, or intersubjectivity. The meeting point for the event of their encounter – *our encounter* – is a shared non-relation to death:

> A community is the presentation to its members of their mortal truth [. . .]. It is the presentation of the finitude and the irredeemable excess that make up finite being: its death, but also its birth, and only the community can present me my birth, and along with it the impossibility of my reliving it, as well as the impossibility of my crossing over into my death.[4]

We are together exposed to the fact that we cannot appropriate this finitude. We cannot share it. It is shared, and it shares us out; but it is not ours to share. We all die, and we all have no relation to our imminence towards death; by exposing and sharing this ineluctable fact we live together as a community. Sharing means the communication between singularities, which then defines community. Exposition and communication – or showing and sharing – provide a sense of our finitude and interrelation, that is, our being. We can immediately see how important and constitutive art is in defining and providing community.

It would seem paradoxical to argue that an *œuvre d'art* provides agency that defines 'la communauté désoeuvrée', but the exposition and communication that constitute the latter are provided and shared, opened by the artwork. This is what Nancy is referring to when he talks about the 'désoeuvrement des oeuvres'.[5] The immanence of an artwork, in terms of creating, exposing and encountering this artwork, then opens an interface, which can counteract and redistribute the identitarian pure immanence, a different kind of immanence that governs the communal fusion, predetermining sense in a totalitarian society. This political agency is the active potential and drive of art.

To define community, Nancy takes the term *désoeuvrée* from Blanchot, who defines 'désoeuvrement' as the agency or move-

ment which precedes, conditions and then negates the literary œuvre; it is an 'unworked', 'inoperative', or destabilised exposure to singularities.[6] With *désœuvrée*, Nancy wants to disrupt a totalitarian sense of community that prescribes and determines identity, industry and politics in terms of a pure essence, or with static, teleological ideals on the basis of the collective appropriation of death as project. By documenting the 'insaisissable' moment of Monique's death, any sense of community that this work provides has to avoid being seen as a collective appropriation of death, or a communal appropriation of finitude, because this is how Nancy defines totalitarianism. Nancy's vision of an 'inoperative' community would say that what we share, when we encounter this artwork, is an exposure to the inaccessibility of death.

Nancy says that the essence of community is as something lost or broken because he is trying to disrupt a pure and undivided social identity, which is fascism. The revelation of our being-together, or of being-with, is through our finitude, which crystallises a community from and in terms of the death of its members, that is, the loss of impossibility of their innocence or immanence. For Nancy this sharing of being-towards-death exceeds the resources of a metaphysics of the subject's 'I am'. This is because if the 'I' cannot say that it is dead, if 'I' disappears effectively in its death, then the 'I' is a different thing than a subject. 'I' is not an 'am', nor is it a subject. Nancy is trying to determine an ontology with community, which he does by using the key, Heideggerian term 'being-with' or 'mitsein'. This is vital because it opens the subject to what is not 'I'; the subject is with others, it opens itself to a community, which exceeds the metaphysical resources of the subject.

In terms of the community not being an œuvre, or *désoeuvrée*, the point is to ensure that the community does not make an œuvre of death. Community is this impossibility, the impossibility of making an œuvre of death. Community is revealed in the death of the other, by the other and for the other. This is not a communion which fuses the (multitude of singularities of) me into a grand Me, or into a superior We. Being-with is the community of the others towards our finitude. A true community of mortal beings or death as community is impossible.

When Nancy writes about community, immanence is considered in terms of communal fusion, or fascist society; it operates the suicide of the logic of community, which this society governs. It makes an œuvre of death; rather than sharing, communicating

and being-with one another towards death, the immanence of communal fusion makes an object of death, inducing it. Nancy's *communauté désoeuvrée* means to disrupt and break up the static and destructive logic that determinates community in terms of immanence or communal fusion. What is interesting to me is to think about what Nancy calls trans-immanence, which is involved during the aesthetic encounter, and how the immanence of the artwork can articulate and then disrupt the static and destructive logic that determines community in terms of immanence or communal fusion. How can immanence be used to articulate, communicate and disrupt immanence? Where is our being, our finitude, and the community? How can the immanence of an œuvre, or the exposition of an artwork, engender not a totalitarian fusion, but a sense of the inoperative community?

In Nancy, finitude exists as communication: it appears and presents or exposes itself. Because we exist as being-with, a conglomeration of others, finitude co-appears, or compears (*com-paraît*). Finite being always presents itself together, hence severally: we are, in common. But we have no being-in-common. Before all else there is a question of communication in this sharing and compearance – com-parution – of finitude.

La comparution ('compearance') is a neologism Nancy brings forward in his work with Jean-Christophe Bailly.[7] Nancy uses this term to indicate how we exist as being-in-common, and how we come together in the world. Compearance is a sense of the community of existence, thinking of communism not as a politics, but as ontology, in terms of sharing. The term has a legal origin, meaning being summoned to appear before court, where appearance is always with others. The 'co', which denotes 'with' and in particular, 'with others' is the key to Nancy's use of this term, and it shows the strong influence of Heidegger's notion of '*Mitsein*', or Being-with, in *Being and Time*. When we compear we co-appear.

Nancy says that compearance is originary. It is the appearance of the between – you and I (between us) where this 'and' is sharing, and exposition: 'you (are/and/is) (entirely other than I)'/('toi [(es) t] [tout autre que] moi. [. . .] *toi partage moi*'); or again, more simply: '*you shares me*'/('*toi partage moi*').[8]

In Nancy, community exists of 'Sharing Voices'.[9] He defines community in terms of singular events of communication; we can use this to define the artwork, or the art's work. In Calle's work – in any artwork – there is communication, between Calle, the work

itself (as a monument of sensation, as a trace of Calle's mother), and those who encounter it. We continue this communication in these reflections here. Nancy says that articulation, dialogue, or 'Sharing Voices', which is also the being articulated of parole itself (or its being-written), defines literature. He says that literature opens a community of articulation, and not of organisation, but a community, which situates itself beyond the sphere of material production, the *communauté disoeuvrée*. Nancy talks about the articulation of our finitude and the way it expresses and shares the end of man – neither the goal nor achievement of man, but the limit. He says that this is man bared of immanence and transcendence, seen in terms of his limit: the singular exposing and sharing of his necessary non-relation to death, to others, to his being-in-common. This is what literature is for. Ian James writes about how literature provides a sense of community for Nancy. He says that 'literature is where the sharing of human voices and community occurs; it is where the new and the different can be affirmed'.[10] Nancy extends his definition of literature to include:

> [. . .] a painting, in a dance, and in the exercise of thought), then what 'literature' will have to designate is this being itself . . . in itself. In other words, it would designate that singular ontological quality that *gives* being *in* common [. . .] It is 'literature' that does the sharing. (Nancy 1991: 64)[11]

So we can take Nancy on literature to talk about art per se, and in particular, the sense of community shared in Calle's artwork.

In Nancy, 'partage' (or 'sharing') – in terms of communication, being-with and distribution – is the sense of our finitude, our limit, and it defines our community by its particular singularities' articulation and communication. Nancy talks about this in *The Experience of Freedom*, where our definitive being-in-common is constituted by sharing: '"to be" (to exist) is to share. This is relation [. . .] existence delivered to the incommensurability of being-in-common'.[12]

Nancy and Calle

We can use this sense of sharing to develop Nancy's idea of 'co-appearing' with the different dimensions, situation and particular event of Calle's installation. We watch Calle's mother dying in

the future anterior, that is, only because she has already died; it is actually impossible to see it really happen. That limit remains. However, the installation, whilst including a film of this happening, is itself another particular event (the Venice Biennale 2007), in which it seems as though spectators encountering the work are as much a part of the artwork as both the film and Monique's death. We are invited to enter the space and 'comparaissons' beside the bedside of a dying lady. We aren't actually by her bedside, just as we can't actually see the moment of her death. But because of the way that Calle has made this installation, with the architectural format of two rooms and the low bench beside the film, the artwork seems to almost become a kind of (temporary) dwelling, and there is a real sense of 'partage' as spectators draw with it.

By attending to this work we do not seek to share finitude, make a project of death and appropriate what is beyond appropriation. We don't make an object of meaning by assembling through mourning when we enter this work. What we share is, partly, the imperative not to make such exposure the object of a collective project. That would connote a totalising immanence and a collective exposure to death, which is what conditions fascism. Nancy says that community determined by a totalitarian ideal imposes a sense that becomes a machine of death, through its fusing and oppression of identity and politics.

By contrast, the inoperative community breaks up this kind of fusion and dislocates its war machine so that beings exist as finite singularities in terms of the events of their encounter and interaction. This disruptive motion realigns the war machine so it can provide the economy of a creative line of flight. It is the exposition and *mise en scène* of interacting singularities, in their dislocated and heterogeneous non-alliance, which defines a disjunctive sense of community.

We can think of this kind of community at play in the exposition of Calle's artwork, in terms of the spacing and *mise en scène* of the installation, the singular events of individuals encountering the work at the Venice Biennale. Thence, I argue, an 'œuvre d'art' (or *Couldn't Capture Death*) can provide agency that defines 'La communauté désoeuvrée'. The exposition and communication that constitute the latter are provided, shared and opened by this artwork. We can see this disseminated in Calle.

When Nancy writes about community, immanence is considered in terms of communal fusion, or fascist society; it operates

the suicide of the logic of community, which this society governs. It makes an *œuvre* of death; rather than sharing, communicating and being-with one another towards death, the immanence of communal fusion makes an object of death, inducing it. Nancy's inoperative community intends to disrupt and break up the static and destructive logic that determinates community in terms of immanence or communal fusion.

We can think about Nancy's 'transimmanence', which is involved during the aesthetic encounter and how the immanence of the artwork can articulate and then disrupt the static and destructive logic that determines community in terms of immanence or communal fusion. In this way, we can use the immanence of the artwork to articulate, communicate and disrupt the immanence of communal fusion and create a sense of the inoperative community.

Community can be read from Calle's work because the sense it shares with us is not a binding, gathering or closing community of immanence. We encounter this work not only in terms of historical singular encounters at the event of its exposition at the Venice Biennale of 2007, but also our encounters with it continue here and now through this exscription.[13] The sense dispersed by this work bears an intimate relation to finitude; a monument of memories, love and care in relation to someone's passing out of time. Not being able to see this passing out of time, we are still touched by the event of its occurrence, so the work expresses something fundamentally true and ungraspable about being. This is what we share.

The transimmanence and compearance that define Calle's work provide a centrifugal movement of dispersal, rather than a centripetal movement of gathering. Its exposition is an outward moving force, which is about dispersal, distance and singular plurality, rather than proximity, gathering or enclosure. This is an ontology of excess which is ungraspable and open. These ideas are Nancean; with them Nancy wants to think of being and sense, the spacing of our being-together-in-the world, as different from the central motif of gathering that makes Heidegger's work in *Being and Time* connote a fascistic immanence that falls to a project of death and the logic of subjectivity.

Therefore, I am arguing that by looking through Calle, the immanence of an œuvre, or the exposition of this artwork, engenders a sense of the inoperative community. But who or what is this community? Does it apply to only the (privileged) few who

Figure 9.1 Lorna Collins, 2014, still from *Flashback* (4.24mins 8mm film and VHS video transferred to DVD, and mixed media installation).

encounter this artwork? Who else? What does the artwork, any artwork, provide or mean for a community?

How can I think further about the artwork in relation to finitude and death? This artwork gave me a sublime sense where I felt I knew something, or witnessed something, that was very true to how we are as human beings. It was about life and death and limit and love and time and loss and grief. This artwork expresses fundamental issues of life and death, and shows how creating an artwork can provide a means of facing and living through these issues, which will then open a sense of community. I want to think about what an artwork is or does for a community.

Flashback

Calle's work and process of making it inspired me to make my own installation artwork, *Flashback*. By creating and exhibiting

this piece, I used Nancy's aesthetic and communitarian corpus as a muse to inspire both the creating and comprehending of an immersive installation that uses the senses of smell and touch to evoke an agent of making sense at the limit.

Flashback is about the physicality and ungraspability of memory, which has roots in something very material and tactile. I project a narrative of sounds and images in the exhibition space, as flashes of data that stimulate and form the content of sudden, involuntary recollections. *Flashback* is an impossible attempt to grasp hold of these recollections in order to secure and place the history and meaning of my life.

I respond to a limit-experience of having total amnesia as a result of a chronic head injury, after falling off a horse. I lost all memories of my previous life. I reached the apex of my absolute limit. But now, 14 years later, I suddenly experience flashbacks of vivid memories, stimulated by my return to the horses, after so many broken years apart from them. The physicality of my re-found bond with the horses triggers memory involuntarily. I begin again.

The exhibition space thence becomes a space for the *décollage* of flashing memories that reshape and nourish my mind. Analogue filmic images and sounds flicker in narrated succession. These audio and visual flashbacks are objective fragments of gorgeous memories about a blissful youth, with the horses on a farm in the countryside.

Walking into the installation, the viewer perceives my attempt to grasp hold of these sudden recollections, and my effort to try to ensure that they are not lost again. The ultimate impossibility of this procedure (given the transience of life and/as time) is evident in a similar way to the 'impossibility of capturing' (or *Couldn't Capture Death*) made explicit in Calle's work. Though Calle deals with her mother's death, whilst I am dealing with my own rebirth after serious trauma, both cases speak of reaching a limit and making art in response to it. The consequent art then engenders and communicates both a sense of our finitude and invites the viewer to share in this moment. Such sharing and communication is, through Nancy, the definition of a community, and also, I am arguing, the work of art.

To some extent, both Calle's piece and my own are autobiographical. My work speaks about regaining personal memories and it tells a life story. The objects in the installation and the film

represent indexical pieces of what French artist Boltanski calls 'small memory' – or 'little things' that define the fragility and fini-tude (which is what Nancy would call the limit) of an individual's existence.[14] In my own case, the objects and film in *Flashback* provide a 'small memory', which is autobiographical, since they harbor memories and solidify my own history. *Flashback* also speaks about memory (and what conditions it) for itself.

The work then also becomes a Boltanskian piece of 'large memory', because it says and embodies something intrinsic to a larger sense of what memory is per se, in terms of its involuntary and physical activation. In this way, *Flashback* speaks about our finitude. But it nuances the consequent sense of our humanity by showing how life can rebound and flourish after touching this ineffable moment that is impossible to capture. I lost everything. It returns.

This renaissance is profound and particular to my own history, but it is also something that happens to everyone. We all begin again. Our lives consist of what Nietzsche called the 'eternal return'. It is not the being that returns, as Deleuze (on Nietzsche) says, it is the returning that is the being.

In *Flashback* and *Couldn't Capture Death*, time becomes shaken up, or what Nancy would call 'syncopated'. Nancy posits the rhythmic notion of the 'syncope' in his *The discourse of the syncope: Logodaedalus* as a deconstructive tool to shake up the foundations of metaphysical discourse.[15] For Nancy, any philo-sophical discourse that proposes to ground thought in a founda-tional notion of self-identity (such as the Cogito) simultaneously demonstrates its own withdrawal from that ground within the way it presents it, through language. Presented in metaphysical discourse, thought can never confirm that it is grounded, since there is an ineluctable gap between the event or instant of the Cogito and its representation in language. Nancy describes this dynamic of presentation and withdrawal in terms of its 'synco-pated' beat, or paradoxical rhythm, and uses it to demonstrate an inherent groundlessness of thought.

Syncopation is a useful idea to help me think about what I can draw from an artwork, whilst it also provides a deconstructive utility to shake up the lineation of limit, or the line of our finitude. The syncopating rhythm resonant in Calle's work seems to decon-struct or shake up Nancy's account of the threshold, and bring on a paradoxical logic of limit in tune with Blanchot's writing about

the eternal return and the impossibility of situating 'the line of demarcation'.[16] As Calle's work shows us, being exposed to the limit (in its future anterior) seems to bring on an experience of limitlessness, in terms of our inability to grasp its moment.

The syncopating rhythm evident in my work *Flashback* is evident in the shaking up of time and my history, the pulsing movement of returning and renaissance, which defines the stimulus offered to viewers. Both works, Calle's and my own, enable the viewer to think about temporality in terms of one's imminence but necessary distance towards our absolute limit, through the transimmanence of the artwork.

Furthermore, thinking about both works as time-dependent, site-specific events, their process of creation, and public installation (in terms of the final works' making, *mise en scène* and consequent encounter) actually provides a sense and fundamental residue (syncopating with the necessary absence of the mother who has died and my memories which disappeared after my head injury). Such residue or excess is autonomous from and transcends such contingencies and retains a presence that delivers the need for this work and its very efficacy. This is shown when the viewer is stimulated and responds to either/each work.

In the case of the works being discussed in this chapter, stimulation concerns limit. This limit and the being of returning that defines our existence, as it is perceived and (almost) touched in *Flashback*, is not so much about dying as touching the threshold of a rebirthing process. When people enter my installation, they dwell within and experience this process. Composing and comprising such a dwelling, the installation (temporarily) houses a community. Nancy helps me understand this as the work of my artwork. Here we share our finitude (and its eternal return of renaissance).

How was this stimulated in *Flashback?* Positioned in the corner of the exhibition, the piece was out of most viewers' way, and not very many walked in. However, all those who did, immediately noticed and commented on the pungent aroma. This was intentional. One could smell horses. This smell often stimulated memories of viewers' childhoods, and their own histories with horses or in the countryside. The piece was thus evocative and – to this, small, extra-sensory extent – powerful. Several people verbalised their fascination by the evident narrative that lay behind the work. Some people were amazed and then they found the art even more effective.

Empathy soaks the installation. People are drawn by the smell. They stay and remember. We connect memories, which bring viewers together, and in this way the work erects and sustains a communitarian present. Here I recall that Nancy defines community as 'Sharing Voices'. Nancy sees community as singular events of communication, as I showed through Calle. This is the self-evident work which operates in *Flashback*.

Thinking about the work as community is not without controversy. To some degree, the work threatens to celebrate the authentic, auric, uniqueness of what Walter Benjamin calls a 'traditional' work of art, since it engages with historic and biographical elements that potentially correspond to a hierarchical higher-class politics. This is seen in the idyllic pony club antics shown on the film, which contains footage of me riding ponies as a child. Although the work uses a medium of reproduction film, it seems to celebrate the sphere of tradition and calls for continuity of its presentation and appreciation. Benjamin is critical of this kind of art in his essay 'The Work of Art in the Age of Mechanical Reproduction'.[17] But *Flashback* can be read another way, beyond the farmyard and the stables, into a more immersive, sensuous, physical experience. This has aura and is authentic, but it is neither exclusive, traditional nor tied to any political statement.

Wanting to avoid the political onus some viewers perceive in this piece, I made a set of prints from the film in the installation. I did this to slow down the narrative and capture single frames. These prints enable the viewer to appreciate the painterly pixels and analogue effects that were found and also created on the film. This process and the final prints that were made speak about memory, since they show how an image can dissolve, resolve itself, appear and disintegrate into pixels. These pixels are strangely beguiling but appealing to the senses. The image they form is beautiful because it is sometimes hard to see what is there. Impossible to grasp, and yet frozen in time. This is the purpose and meaning of my aesthetic opus: to freeze memories in time, so they are never lost again.

The sense of community, or limit, or returning (which I use to redefine our finitude) remains in this set of prints, by illustrating fractions of those moments that I lost, but re-found, and relive. These moments may still be impossible to capture, but their indexical trace hits me, pricks me. There is that unsignifiable punctum

which touches something fundamental and fleeting about life and death (Barthes 1981).[18]

The sense of finitude and community given

Both Calle's work and my own help me understand the limit-line between art and the world. This line is our finitude. I am arguing that art shakes up (syncopates) this line, and that our limit is the eternal return of rebirth. From this viewpoint, Nancy's article '*The Art of Making a World*' helps me understand how art can help us reach and make sense of the world that situates our presence and our finitude (that is to say, our impending absence).[19] Nancy's understanding of the world considers it as a sum of reality, what there is, and the there or the placing point of what there is, in terms of how it is expressed and interpreted. In this case the reality of the world depends upon thought and art to express and interpret it. Here sharing and communication are vital factors in the reality of the world, and the community therein.

To begin with, the artwork 'makes us feel'.[20] Thence art and thought help us speak about the world: 'thought and art constitute two faces of a relationship to the truth, which necessarily has two parts [. . .] Truth is the world'.[21] The artwork is then fundamentally transformative. It does not just describe a situation in the world, but it actually creates and makes up this world. Art has agency. We see this agency in art's capacity to provide a community for those who engage with it, whilst it also provides a method of contacting, expressing, and moving from our finitude. These matters are contained within and spill over the thoughts, feelings, connections and responses that the work inspires and collects from those who witness its occurrence.

The agency seen in *Couldn't Capture Death* and *Flashback* consists of their aptitude to provide a *praxis*, where Calle's work helped her deal with her mother's death, whilst my work gave me the agency to rebuild my life. Art stimulates proactive feelings and thoughts. We (Calle and I, amongst others) feel, and we use art to think, to react, to share, to connect. Barbara Stafford's transdisciplinary work on the neuroscience of the aesthetic experience helps me understand this process. Stafford describes what happens during such an experience by arguing that we think in images: 'thought is an image (since the different sensory modalities also generate "images") that incites us to re-perform (in the manner of

mirror neurons) what we perceive. We can only know that we are having thought when we bring some specific event "inside", but do something with it outside.'[22]

Nancy describes thought in a similarly proactive fashion in *The Sense of the World*.[23] Here Nancy thinks of thought as a 'praxis', which is situated in the world and reacting to it, processing information on the world, where what we think does not represent or signify this world. It is at the limit on the edges of representation, and there motored by the excess of sense. The excess of sense is the movement of our being towards the world, and the passage of our presence here.

Nancy says that thought has agency (or praxis) in terms of the world. This also applies to the similar agency that art has in and on the world. This agency concerns the potential that art has to build a community and to express or approach our finitude, which then defines a logically inoperative and productively aesthetic community.

Conclusion

This agency that defines art evolves from its capacity to, as I have shown from Nancy, operate as agents of communication and sharing. Thinking about art as praxis connects to the way the art in this chapter has provided a Nancean sense of community, which is built from such communication and sharing. What is communicated and shared is our finitude; the limit of who we are. We cannot touch or share this limit. But we sense, communicate and share its inoperative impossibility. This connects us – as viewers, as individuals, as a community. Whilst we sense the art, whether Calle's or my own, we dwell in a place of immanence (in the sensations stimulated by this experience) which bridges across and beyond its sense and parameters. The excess of such 'transimmanence' then rebounds from the artwork's parameters, since its sense is one that recoils from finitude and exists as an eternal return, where being is becoming and returning, incessantly, again.

Notes

1. Nancy's *The Inoperative Community* is called *La Communauté désoeuvrée* in French. The original French title remains important in this essay, since the concept of being 'désoeuvrée' is hard to trans-

late accurately, and I want to retain the link with an 'œuvre' (or an artwork) and the role that this has in the formation of a community. Thus, in this chapter community will be described as both 'inoperative' and 'désoeuvrée'.

2. 'The Step Not Beyond' is a reference to Blanchot and the impossibility of the subject knowing their own death. See Maurice Blanchot, *The Step Not Beyond*, trans. Lycette Nelson (Albany, NY: SUNY Press, 1992).

3. Jean-Luc Nancy, *The Inoperative Community*, ed. Peter Connor, trans. Peter Connor, Lisa Garbus, Michael Holland, and Simona Sawhney (Minneapolis: University of Minnesota Press, 1991), 6. Original emphasis, translation modified. The French for this quote is the following: '*La communauté, ou l'être-extatique de l'être lui-même*': Jean-Luc Nancy, *La communauté désoeuvrée* (Paris: Christian Bourgois Editeur; Détroits edition, 1990), 23. I wish to preserve the 'ex' in Nancy's neologism *extatique*, which I translate as 'extatic', to indicate that being is outside of itself, which then defines community.

4. Nancy, *The Inoperative Community*, 15. 'Une communauté est la présentation à ses membres de leur vérité mortelle [. . .]. Elle est la présentation de la finitude et de l'excès sans recours qui font l'être fini : sa mort, mais aussi bien sa naissance, seule la communauté me présente ma naissance, et avec elle l'impossibilité pour moi de retraverser celle-ci aussi bien que de franchir ma mort.' Nancy, *La communauté désoeuvrée*, 43.

5. Nancy, *La communauté désoeuvrée*, 98. This phrase is translated as 'the unworking of works'. Nancy, *The Inoperative Community*, 39. I maintain the French to emphasise the link between the artwork and the (inoperative) community.

6. Maurice Blanchot, *L' espace littéraire* (Paris: Gallimard, 1955), 48.

7. Jean-Luc Nancy and Jean Christophe Bailly, *La comparution: Politique à venir, Jean-Luc Nancy* (Paris: Christian Bourgois Éditeur, 1991).

8. Nancy, *The Inoperative Community*, 29, 74. The French is printed in the translation.

9. 'Sharing Voices' comes from Nancy's *Partage des voix*. Jean-Luc Nancy, *Le partage des voix* (Paris: Éditions Galilée, 1982).

10. Ian James, *The Fragmentary Demand: An Introduction to the Philosophy of Jean-Luc Nancy* (Stanford: University Press, 2006), 201.

11. '[. . .] une peinture, dans une danse, et dans l'exercice de la

pensée. . .), il faudra qu'on désigne par « la littérature » cet être lui-même, en lui-même, c'est-à-dire cette qualité ontologique singulière qui le donne en commun [. . .] « la littérature » fait le partage.' Nancy, *La communauté désoeuvrée*, 160.

12. Jean-Luc Nancy, *The Experience of Freedom*, trans. Bridget McDonald (Stanford: Stanford University Press, 1993), 72–3. '« être » (exister), c'est partager. C'est le rapport [. . .] c'est l'existence livrée à l'incommensurabilité de l'être-en-commun.' Jean-Luc Nancy, *L'Experience de la liberté* (Paris: Galilee, 1988), 98.

13. Nancy coins the term 'exscription' to describe a form of inscription that can be traced outside the text. Jean-Luc Nancy, *Corpus*, trans. Richard A. Rand (New York: Fordham University Press, 2008a), 11.

14. Didier Semin, Tamar Garb and Donald Kuspit, *Christian Boltanski* (London: Phaidon Press, 1997).

15. Jean-Luc Nancy, *The discourse of the syncope: Logodaedalus*, trans. Saul Anton, (Stanford: Stanford University Press, 2008).

16. 'La ligne de demarcation'. Maurice Blanchot, *Le pas au-delà* (Paris: Gallimard, 1973), 22. Maurice Blanchot, *The Step Not Beyond*, trans. Lycette Nelson (Albany, NY: SUNY Press, 1992), 54.

17. Walter Benjamin, 'The Work of Art in the Age of Mechanical Reproduction', in *Illuminations* (London: Random House UK Limited, 1999), 211–44.

18. Roland Barthes, *Camera Lucida* (London: Flamingo, 1981).

19. Jean-Luc Nancy, 'L'Art de faire un monde' (The art of making world), in *Cosmograms*, ed. Melik Ohanian and Jean-Christophe Royoux (New York: Lukas & Sternberg, 2005). Although this 2005 text is unpublished, a version of it appeared in the form of an interview for an exhibition titled *Cosmograms*.

20. Jean-Luc Nancy, 'Art Today', trans. Charlotte Mandell, *Journal of Visual Culture* 9, no. 91 (2010): 92.

21. Nancy, 'L'art de faire un monde', 5–6.

22. Barbara Maria Stafford, *Echo Objects: The Cognitive Work of Images* (Chicago: University Press, 2007), 148.

23. Jean-Luc Nancy, *The Sense of the World*, trans. Jeffrey S. Librett (Minneapolis: Minnesota University Press, 1997).

Turning Around the Written Mark, Opening from a Weight of Thought

Robert Luzar

There is an exscription from writing, as Jean-Luc Nancy explains, 'that doesn't happen exactly *in* writing, if writing in fact has an "inside". But along the border, at the limit, the tip, the farthest edge of writing nothing *but* that happens'.[1] An exterior and multiple 'x' of sorts,[2] this indiscernible limit finds the writer, and more broadly the drawer as well, in a state of exposure. It is a state of physical and mental extremity that I want to look at here, investigating how one tries to inscribe throughout this exteriorising limit.

Sense, a term imperative to the writings of Nancy,[3] often indicates a signifying generated in advance of a text, grapheme, or imprint. Nancy dubs the exteriorising operation exscription. With the 'ex-', as in exteriorisation, extension, and exposure, Nancy is thinking of sense as 'outside'. In exscription, sense is exscribed by touching the body. The body is the exterior act, or means, of opening in advance of anything that otherwise is essentially sense. The body is the exterior act, or the act (means) of opening onto . . . and in excess of meaning.

Prevalent in textual inscription, as much as in drawing, is the individual effort to display the effect of such a hermeneutical touch. Exscribing touch prompts a trace of thought, so to speak, giving form not merely to thought, but to one of the most singular of bodily effects – weight. Since thinking resonates with weighing, incurs a heaviness and a downward movement, one should question inscription with regards to drawing, since it is by means of drawing that writing turns back, withdraws to a more exscriptive condition of speculation that emphasises the inscriber. The proposition I consider here is that thought is not an essence one comprehends from within a substantial 'self', nor visually evidences through an inscribed imprint, or graphic trace. Rather, the aim of my investigation is to explore this essentialist notion of thought,

which discards a condition of sense shared by the body, and to move towards thinking as an extremity that is weight 'exscribed in advance of all writing'.[4]

Exscription turns inscription outward. It obstructs and generates a sense that is otherwise grasped within the visible imprint of a trace. There is, moreover, an exposure that happens through weight that echoes a certain notional point. If gravity prompts one to descend and, in this downward passage, to undergo pressure, then the means (of generating thought and sense) can be considered as a logic of 'contact-in-separation'.[5] In this 'contact-in-separation', a topological notion of a point is the benign touch of contact vis-à-vis pressure, whereby one feels oneself punctuated and, thus, one feels oneself separating from within. This would be an extreme ontological condition that is overrun by a figure of the graphic trace.

In normative paradigms of the graphic trace a topology of the line prevails. Ideologically, the line takes course, so to say, along an impulse to directly contact, bridge and conjoin body with a more profound self. Consequently, sense is relegated to full presence, present in substantial positivity. The overrunning of the point I mention is because, in deconstructive terms, 'the point, as a limit, does not exist in act, is not (present)'.[6] It is possible that the point is negated because it punctuates the line. It divides and arrests a continual movement to act – to will, to depict, to reveal the desire to create ideas immediately. The point is not an act, then, because it purportedly does not generate thought. So the line would then imply that it 'removes the limit of the point only by developing its potentiality'.[7]

I wish to consider that a point is ontologically impenetrable, yet constitutive of the body. In this materialist reconfiguration, the line also transforms. This estranges the logic of inscription of (graphic) tracing. In some cases, one even physically withdraws from inscribing. This means that one who exscribes neither draws out sense immanently nor renders visible any hidden, transcendent limit.[8]

To use Nancy's term, sharing [partage] is akin to how a point is as much exteriorised through the literal mark as it is extended by weight. Heaviness incurs a speculative and, in some ways, spacious mode of sharing. In other words, gravity exposes one's body to others, opening physicality around a 'shared-separation'.[9] Right there, in the location one thinks – or tries, if thinking

obstructs itself – and becomes weighty, meaning or sense happens *in extremis*, tracing right through the notional point.

By examining a series of artworks – some of which I have made and, hence, inform my investigations here – I shall look at a notion of the body in relation to speculative thought. As an artist, I am interested in thought as a speculative and material event – rather than a purely cognitive system, wherein theoretical axioms abound. For me, a thought that cannot be reduced to an intellectual concept lends itself to forms of dislocated bodily gesture. Drawing through physical action is predominantly how I explore inscription as a kind of performative mark-making. My interest in Nancean exscription aligns with a reconsideration of current understandings of drawing through bodily performance.

In part, my approach to drawing is akin to the Renaissance concept of *Disegno*: a graphical means of marking a two-dimensional surface to display one's first thoughts [*primi penseri*]. Drawing continues to be regarded today as generating 'the partially comprehended ruminations of the mind: the operations of thought'.[10] As American artist Richard Serra suggests, and in terms that echo Nancy's own, drawing is plural.[11] While drawing, one rethinks and expands the inscribed mark anew. Sense in drawing, Nancy warns, however, 'cannot be exhausted by any sensorality or sensibility but, on the contrary, exhausts and exceeds them in drawing them to the limit of their potential intensity'.[12]

Straightaway, to draw is to invent and exceed any proper form of drawing. Current inventions of drawing often focus more closely upon the process of making – rather than the completion of an object or final work of art. This process of making is now largely explored through live-art performance. For me, the intriguing quality that performative drawing carries is in exposing both the inscriber's physicality, and the marks he or she makes, to a radical kind of trace that is devoid of reference. 'Mark' and 'body' remain distinct, punctuated by a radical trace shared throughout an indiscernible point. Weight extends such a trace. This resonates with exhaustively thinking through a sense that, although arresting in effect, is inexhaustible.

For Nancy, there is an impenetrable pressure that forms in the mutual implication of weighing [*Pesée*] and thinking [*Pensée*]:

> We certainly do experience thought. Sometimes the heaviness, sometimes the gravity of a 'thought' ('idea', 'image', 'judgement', 'volition',

'representation', etc.) affects us with a perceptible pressure or inclina-
tion, a palpable curve – and even, with the impact of a fall (if only the
falling of one's head into one's hands).[13]

Finding one's head in one's hands, as Nancy mentions in reference
to a profounder 'fall', seems to suggest that a state of obstruc-
tion is integral to thought. Topologically, the point exscribes a
conceptual region, or limit, that obstructs effective cognition. Yet,
in bodily receptions to such pressing, a dislocation occurs in the
separating appropriations otherwise made possible by touch.

I approach the relationship between weighing and thinking in
one of my performative works *Approximately Pointing Out A
Figure* (2010–11). This work explores actions of deixis, point-
ing with the index finger and marking each touch with a dot-like
imprint. The dot represents a visual point. Deixis is one of the
foremost gestures I use whilst creating work. 'The point', as I call
it, is similar to what British artist John Latham describes as 'the
least event': a 'dimensionless point' that indicates 'zero extension
and zero action'.[14]

The process in making *Approximately Pointing Out A Figure*
involved sitting and facing a table bearing a sheet of graph paper.
Upon this paper, I drew points by combining and aligning pen and
index finger. Weight was integral to my gesture – the heaviness
of my arm and hand, the pressure in holding the pen between my
finger and thumb, the downward direction of pointing and recur-
sively dotting. Rather than inscribe an isolated figure or abstrac-
tion of lines, I covered every millimetre of the graph paper. Once
completely covered, I photographed the overtly marked (grid)
paper and, using a digital process, inverted the image (from white
to black) while, finally, making a print – a virtual inversion of
the drawing. Exact in scale and detail, the print I made from the
drawing became a representation of an ostensibly celestial abode.
The drawing and print combined to represent more radical quali-
ties than the action ensued. Multiple spots of pressure condense
throughout my head, arm and abdomen; my thoughts seem too
open to form any particular content or figure. This creates an
overall sense of turning down towards the paper and, so to say,
outward.

Unexpectedly, pointing became the effect of weighing into an
endless trajectory. The point is not the mark as such but, more pre-
cisely, a complex event. Inscribed or exscribed, any thought here

accorded less with literally tracing intellectual actions, indexing the aporias of mark-making. Rather I engaged in a certain extreme openness of making (this as that), which echoed diminutions of affect and gestural dislocation – subjects that I will come back to.

Exscribing through weight

Exscription is partly derived from the deconstructive term 'inscription'. To inscribe means to write, sketch or, plainly speaking, make a mark. Foremost, inscription is an intellectual effort towards producing an origin of writing, or archi-writing. Originary writing is opened and deferred by an elusive kind of trace. Jacques Derrida explains that 'the trace is produced as its own erasure. And it belongs to the trace to erase itself, to elude that which might maintain it in presence. The trace is neither perceptible nor imperceptible'.[15] He continues by declaring, 'there is no trace *itself*, no *proper* trace'.[16]

Nancy posits a more post-phenomenological approach to the deconstructive trace.[17] He will go so far as to say that there is indeed a trait, but in its act a trace radically voids affect and sensory reception: 'a nonsensory trait that is not embodied in any sense – neither a pencil stroke [*trait*] nor a stroke of the violin bow'.[18] Here, the French noun, *le trait*, indicates the recognition of that which has been marked, as in how a contour on paper visually suggests connection to a pencil having engaged prior in sketching or cursively writing. There is also 'trace', as in the verb *tracer*. This has two definitions: the act of marking, as with imprinting tracks in snow; and the extension of a direction, a trajectory of tracing out. Tracing, in act, thus opens up the line in advance. Nancy explores trace fully, albeit emphasising the act of tracing out. And what should also be noted is his stronger emphasis on the body as the means – what he will also call ecotechnics – of producing sense vis-à-vis inscription.[19]

In its gestural connotation, tracing is akin to how sense opens the body itself throughout a trajectory implied by its action. While making a drawing, for example, one undergoes an exposure to thought in its excess; and the gesture concurrently becomes weighty in an effort to generate some idea of the action. Thinking can prompt extensive effort, so extensive that one risks losing engagement all together. One tarries with this negational yet formative force, as Hegel would say. The physicality of the gesture, so

to speak, presses into oneself. And in the midst of the pressures induced one undergoes weight. Moreover, one paradoxically negates interior selfhood. This is important to note. The trace cancels out deeper meanings of inner plenitude. In other words, one undergoes the loss of essential being not only in presence, but fundamentally in principle.[20] To this effect, the gesture of pointing into a point, to return to my previous example, exposes physicality and mark to an irreparable separation. I believe the proximity suggested by 'approximately pointing' certainly regards actual distancing (the separation of index finger and paper) as well as the sensory quality of weight. I feel myself tracing outward, a direction that is not so palpable or intensive in figuring contact.

Throughout this trajectory, the ontological bastion of 'self' turns itself outward. One opens up and dislocates any proper selfhood. Presence, conventionally perceived as the innermost kernel making up the self as unified and substantial, is fundamentally absent, traced and ontologically subtracted. Such is the exteriorizing effect of 'the extreme point of all thought'.[21]

Thinking prevails then in this way: from a non-substantial state of finitude, one is infinitely exposed through weight. '[T]he body is the ultimate weight, the extremity of the weight sinking from this fall. The body *is* weight', as Nancy claims.[22] Downward weight presses, and yet seems alight with a sense of (ontological) traversal. Heaviness takes one through the turn of gravitational descent. 'Through' invokes the passage, indicating the surpassing of pure presence. This complex operation (of thinking/weighing) is the trace in ontological subtraction. The trajectory is, to borrow Maurice Blanchot's term, a traceless trace.

To try and approach this complex condition of exscribing thought through weight, I look to a key work by American choreographer Trisha Brown. In *It's A Draw/Live Feed* (2003) Brown uses her entire body to draw a series of actions, many of which appear as stumbling and falling onto a gallery floor that is covered by paper.[23] In each hand she holds charcoal sticks, the black pigment enabling her to mark out repeated actions – standing, twisting, shifting. Always within and throughout the paper, she falls while tracing paths of her movements. Throughout the horizontally laid paper, her markings unfold in a myriad of dark trails, which reflect the slackened control of her arms, legs, and torso. As writer Andre Lepecki claims, Brown's 'falling is more like a splattering: the formless splattering preventing figurability'.[24] Indeed,

within the maelstrom of markings, her falling exposes a multiplicity of disfigured contortions (arching, stretched, twisted, and so forth). These physical postures, progressively, produce an array of consuming marks. Lepecki asserts, however, that these are 'tracings that will not be arrested or bound to the horizontal, a plethora of actions that cannot leave a mark, that have nothing to do with marking'. Brown's actions thus express a 'traceless expenditure'.[25] Of course spectators see Brown momentarily, present and in person. And yet the drawing pervades. The more she draws the further her descending trajectories supplant the spectator's focus upon the outlines of a restless composition. For she moves, up and down, in and out, 'sinusoidally overrun by the multitude of liquid lines . . . the thousand upon thousand of rustlings' that lead into a 'thousand shatterings'.[26] Whichever way, Brown never effectively enacts 'traceless expenditure'. Her movement expends dispersive energy – expressively falling then standing up, each move attentively resisting intentionality. Nevertheless, the visible tracings of her falls prevail; the work on paper becomes a record, a mnemonic trace of the performance. Her gestures therefore sustain a standard model of marking qua inscription that, I believe, aims to embody an expressive, pure presence.

Inscribing a line onto any surface – be it paper, wall, or floor – expresses what some now perceive as a graphic and kinetic continuum.[27] The line is predominantly understood as a special sign in two ways: presenting 'the direct presence of the artist's inner self' and making thought 'transparent to the mind, immediate to experience'.[28] Such is 'drawing as a visual thinking'.[29] Thought seems to be at once anonymously moving and transcendent, continuously becoming other, vital in presence. It is this intensively affective and operative movement that pure inscription engages. The embodying act then resonates with the idea that 'thinking would take place 'within the flow' so to speak, rather than simply retrospectively'.[30] For instance, when Brown traces imprints of her falling movements, she invokes gravity. All the while her gestural markings revert to a graphical operation. Experiential immediacy and transcendent continuity coincide. Each stroke expresses the transience of her physicality, and yet a higher-order continuum remains fluidly operative, which each graphic trace renders visible.

Incarnating touch

So far the mark and bodily gesture have been covered with respect to largely philosophical topologies. Rather than present some imprinted point that is distinct from the line, I am trying to show how physicality, the amalgamation of weighing and thinking, dislocates and reconfigures movement. In order to unpack the ideology of marking movement (the flow of transcendent continua), it would be apt to look closer at related semiotic and phenomenological operations. The following discussion will develop this description of the trace.

Index, a key property of the trace, is how 'the sign is related to its referent, as smoke is to fire, or a track in the snow', writes Michael Newman.[31] The index displays 'an empty linguistic expression that derives its sense from the context in which it is performed, such as "this", "that", "now", and the personal pronouns'.[32] As direct as the index is in referring inscriber to imprint – this to that – the mark still 'becomes the ground of a refusal to separate idea from existence', as Rosalind Krauss states.[33] Drawing out movement accords with this fully indexical operation; in other words, the operation is that of the action of tracing and leaving a trait of the action. It not only deems thought visible but inseparable from a profoundly existential presence. In all its immediacy, indelibly marked as being there, and continuously present, the body also becomes sublime – not merely one's ontic physical being, but drawn towards an immeasurable and encircling ontological principle (Being, Presence).

One could say that the act of inscribing a mark is sustained by an enthusiasm to augment a phenomenological reduction. A graphic trace expresses essence in purity, stripped away of all that is superfluous and unveiling the origination of inscription. Origination is a metaphysical act, reflexively encircling and continually creating presence anew. Here, visibility plays a key role in perceptions of this so-called continuum by doubling inscription: the surface effect, plainly shown by the imprinted mark; and a mnemonic trace, the retroactive effect of perceiving actions long passed. A mark *becomes* a trace of pure inscription 'insofar as it is recognizable as such, is always already re-marked'.[34] In other words, a mark seems inscribed once, the visual effect evidencing bodily effort, an effort that is at once intellectual and physiological. Then there is the conceptual quality. This regards a trace disclosed by means of

the index. It is here that the reduction, posed by expressions of an emphatic re-mark (tracing, *tracé*), becomes questionable in terms of its haptic activity – the act of seeing through touch in an effort to gain proximity to and contact with presence.

Maurice Merleau-Ponty summarises the theory of the haptic when he writes, 'it is not *I* who sees, not *he* who sees, because an anonymous visibility inhabits both of us, a vision in general'.[35] In the act of gestural drawing, it is not only the inscriber's body that is inhabited by touch but also the other – at its most actual being the spectator. The other sees and seeks to touch an anonymous visibility, which intertwines with an alterity (pure presence) transcending the inscriber. The two purportedly incarnate a dimension of what Merleau-Ponty calls flesh: the limit at which self and other conjoin dynamically in a circulating loop. Incarnation is the putative embodied mode by which self and other try to coincide, unifying into a collective body of individual selves. Take, for instance, Merleau-Ponty's claim that visibility 'is a circle of the touched and the touching, the touched takes hold of the touching; there is a circle of the visible . . . there is even an inscription of the touching in the visible, of the seeing in the tangible'.[36] This chiasmus, as he calls the haptic, is conventionally interpreted in terms of crossing an unbridgeable, existential gap.[37] Performative drawing employs inscription towards materialising this circling continuum in some kind of artistic monstrance. However, the act of binding thinking and collective feelings of union, seeing one and simultaneously touching the other, exercises a precariously communal kind of sense.[38] Haptic metaphysics, in its act of incarnating flesh, curtails this fact: 'The opening of self to itself or to the other does not come back to itself, does not form a loop.'[39]

Pressures of dislocation

To consider exscription in its extremity, how the limit of inscription is a trace dislocating extensions of touch and visibility, I now propose two questions: Can the trace be understood as a radically speculative condition of the marking process? Moreover, can an unmarked trace, a traceless trajectory of weight, be the means through which gesture affirms sense in its pressure and dislocation?

To address these questions, I now turn to another work, *Untitled*, which explores constricted actions. *Untitled* centres on the body in its constriction and dislocations of gesture (Figure 10.1).

Figure 10.1 Photograph by Ollie Harrop.

Nominally vacant, 'Untitled' is my way of indicating an action
bereft of task and (expressive) improvisation. *Untitled* is materi-
ally reduced, emphasising the action rather than the drawing. It
focuses closely on bodily postures, such as standing and bending,
that to the eye seem devoid of motion yet, *very* slowly, change in
distance and shape. Over the span of about two hours the prob-
lematic performance unfolds, wherein I move, although too slowly
for spectators to see, while also stopping intermittently.

This contradictory pace can become testing for spectators. Some
spectators become partially disengaged by my slow motion and
stoppage, paralleling my physical arrest or passing. Arguably, the
offsetting of engaged spectatorship is indicative of how the overall
space of the gallery takes up a quality that lowers in tension,
loosens in subjective reception, or mood – the lessening of rela-
tional tension running somewhat counter to Nancean sense.

My actions are comprised of holding still, seemingly unmoving,
and progressively descending while passing a large drawing. The
drawing is located on a wall a few feet from me. The drawing was
made prior to the performance using willow charcoal, which is
highly erasable. Indeed, there are times during the performance
when I touch this lined pattern, smudging and exposing areas of
the wall. The erasure here, though appealing, is hardly Derridean

in trace. The smudges are visual distortions of the larger drawing, which is premade. That I perform without using any drawing device, physically separated from the wall-drawing, is primarily why I hold still. My gesture lacks intentional aim other than to let my weight take effect and, inevitably from fatigue, go downward, leaving spectators with 'not much to see'.[40] It is because of this state of risking, so to say, the loss of sense that I constrict every bodily part (legs, torso, arms, head) and shift into the trajectory of my weight. My gesture passes throughout the passage of this unmarked trace. For me, the pressure of weight echoes a certain event of thought, a broader state of creating that is speculative and, although obstructive, generative indeed. Here, the event is neither metaphysical nor mystical. By calling thinking/weighing speculative, I am teasing out a kind of irreducibility of sense in its extremity – even in obstructing aesthetic and subjective reception. The obstructive quality I note pertains to a paradoxical effect of sensory diminution. In the case of *Untitled*, the overall pressure I feel is predominantly physiological. It is an effect of bodily weight. One might question if I experience elevated states of consciousness. On the contrary, and in its extremity, thinking becomes tenuous under the duress of weighing. At best I focus attentively on, for example, how my muscles and joints hold while undergoing fatigue. This means being attentive to where my feet are or, generally, my proximity to the wall, drawing and audience. In other words, throughout the action I find myself deferring intellectual observation. Critical reflections take course afterwards, deferring ruminations to studio explorations or phases of writing. My focus is then upon my physicality descending into the most proximate location, an area of about two or three feet in circumference. There is no sudden discovery, immediate comprehension or sense of touching upon the unmarked trace – as the range of thoughts here might suggest.

How then does this investigatory action, of physiological attentiveness and deferred rumination, take effect in the writing I make here? To a degree, Nancean exscription highlights what I believe is the limit of creating through forms of obstruction, that is a dislocated bodily gesture. Recall how Nancy says that thinking (*pensée*) occurs through weighing (*pesée*): 'This means at once: something that weighs me down, that pushes me towards the earth, that bends me, or to want to think is heavy.'[41] The 'something' that Nancy mentions regards a notion incurred by thinking reflexively

about thought in its spacing. Writer John Paul Ricco articulates spacing as sense remaining fundamentally unknown, outside of the reflexive circuit of apperception. The body is exemplary in that it extends through actual spaces – shared with other bodies – while, ontologically, 'never returning to, or having re-course back to, itself'.[42] Here the chiasmus comes into play. The reflexivity is that of one trying to, metaphorically speaking, touch back upon a condition that prompts touching. One tries to, if not effectively think and envision then, more obscurely, touch sense at its purest. What is 'touched' exactly? According to Nancy it is 'this sharp point of dense ore that a thought pushes, presses heavily into the head and into the belly, throughout the whole body, with the force of a fall or a tearing'.[43] Weight is indeed gravitational in force; however, Nancy rightly lodges this force in the dislocated body oneself becomes through gestural descent. 'Fall' connotes an ontological 'tearing', a foundational break that radically dislocates Being as such. It is here that Nancean exscription takes shape: weight emphasises a bodily event structured by a more speculative point, a notion that extends physicality through a traceless trajectory and exposure of bodily gesture. Such effects of dislocating pressure must, however, be looked at more carefully when approaching the mark.

Point again

Before concluding I wish to look again at the point and the line in relation to one interpretation of drawing made by Nancy. In *The Pleasure of Drawing*, Nancy explores the trace in various ways, one of which regards 'an irreducible desire of the line'.[44] Here he 'is led by a more adventurous line, maybe more radically than anywhere else in his multiple approaches to art', comments writer Ginette Michaud.[45] The radical quality is prompted by the point, which connotes a notion of origin that exteriorises – or empties out – the line. As Nancy explains:

> For the line is the point itself – this non-point of birth, its self-origin stripped away [*dérobée*] – in the process of dividing space, dividing it by disposing and forming it, informing it by hollowing it out and affecting it, opening new possibilities for other spacings, in other words, for displacements and proximities, envelopments and avoidances, for folds, curves, departures, and returns. The *line* does nothing

other than mobilise and draw forward a point of truth [sic], and so it is in this way that it has – or rather it is – a desire. It is the point where it suddenly appears possible to go from nothing to something, to go from formless attachments and inherences to the form of detachments and distinctions.[46]

The 'point of truth' is that the line strips away its notion of inception, its origin or birth constituted by a 'non-point'. The irreducibility of the point is that there is no point as such, nothing more to see behind the curtain of being, so to speak. Only a sudden opening and spacing happens in which the point is at once limit and generative excess, the line incising and detaching in essence. Though perplexing, the sudden punctuating and multiplying of linear spacings regards the tracing out of weight pressing through bodily gesture. So the line qua non-point is not a continuum, not in the virtual sense of becoming transcendental and immanent, conditions that would otherwise purport hidden presence or substantial selfhood. Nevertheless, the point still remains bound up with a bodily gesture and sensibility of pressing, as when Nancy states:

·The gesture will have preceded the tracing out [tracé], where an entire body will have preceded the gesture and an entire thrust (impulse, pressure) mobilised the body. An entire thrust – an entire thought, a weighing [toute une poussée: toute un pensée, une pésée].[47]

The 'entire thrust' that is weighing, materially and terminologically (poussée, pensée, pésée), circumscribes not only the body to some prior state, desiring and exscribing itself out, but the point as well. The sensibility of the thrust, the pressure in pressing antecedently, renders the non-point equivocal in also becoming somehow sensible in weight. Is the point some palpable inner force? Is it some obscure figuration one feels within or pictures in mind? There are epistemological consequences here as to how the extremity of the punctuating limit (point) is reproduced through sensibilities of thinking via weighing. Forcing cannot render intelligible, or make sense of, such an irreducible point through tracings of intensive touch. If anything, the point is the negation of existential contact. It empties out interiority. In this way, Nancy proposes a radical topology of the mark in its broadest sense, which emphasises the body in a thoroughly concrete and post-phenomenological sense.[48]

Conclusion

I have examined the written mark as a limit of inscription, par-
ticularly in its philosophical condition and within the context of
performative drawing. The limit I examined concerns a certain
turn: the paradigmatic reconfiguration of the mark expressing
continuum and thought in its bodily event. Thinking happens.
It happens by exposing the inscriber to interruptions of sense
and through weight. Using the concept of Nancean exscription, I
thereby proposed the reconfiguration of three inscriptive proper-
ties respectively: the traversal of the line in its indexical priority
and haptic phenomenology; the emphasis on the body as a technic
of gesture; and the trace conditioned by the more speculative
non-point.

My intention has been less that of separating the mark from the
body than of exploring the complex effects incurred by weighing
and thinking through an unmarked trace. Even though the mark
can be deconstructed' as a 'nonsensory trait', wherein the condi-
tions of continuum and presence are deferred to immaterial impos-
sibilities, the trace of bodily gesture carries forth another problem.
The sensibility of touch pertains to problems of subjective qualities
of reception and space. The point is at once the nonsensory trace
and yet it remains equivocally the gestured trace of touch. Here,
sense becomes telling in its mode of touch. Weight is the means by
which sense is generated by touch, although always already press-
ing in touch. Ontologically, pressing indicates how sense exscribes
the loss of substantial interiority. To keep this touch from becom-
ing absolutely vacuous, touching must remain 'the nerve *nerve-
meter* which this thought has to be, if it is going to be anything'.[49]
For Nancy, the point therefore becomes a kind of augmented
nerving, an intensive pressure that sustains the radical spacing that
thought is in its extremity of exteriorising sense.

Indeed, exscription traverses an overt proximity that seems to
involute the inscriber as a space of inward contact. Sense does
trace out a shared space, exposing gesture to temporal interrup-
tion and lessening visceral sensory responses. The temporal regis-
ter of such spacing can be understood as post-phenomenological.
Spacing regards an '*empty time* or the presence of the present as
negativity, that is, insofar as it happens and is, as a result, nonpre-
sent'.[50] Temporal emptying is but a further extremity of the line of
traceless desire. Time is then obstructed by a kind of trace-less dis-

tancing, which Nancean sense extends as spacing. My proposition is that sense lessens the overall spatial quality of the performative drawing event. The immediacy of the event, wherein one is said to experience 'the moment', thus becomes more nuanced in its displacing complexity.

The dislocation of gesture also changes subjective qualities and responses. In other words, the mood invoked by the immediate space, the sense of quietude and stoppage, can leave spectators to either engage or even drift. Waiting is one way of considering how such broader exscription happens. Waiting is indeed an extension of weighing. I had alluded to this when exploring *Untitled*, noting how spectators could be found standing or passing around me. My conclusion does not favour complete disengagement. Rather, there is a more diminutive quality of the space that can lend to widening degrees of engagement. Waiting is without anticipation. It becomes a way of letting the work happen that, in this example, parallels a tempo characterised by slowness and stoppage. In principle, 'waiting' regards radical passivity, a state 'that exposes and holds open the irreducible, irrecuperable, and unconditional disjunction between an experiment and a foundation, an invention and an absolute demand'.[51]

However tenuous such a space might be, its mood offsetting visceral kinds of experience, the event should be considered more carefully. Some, such as Gerard Granel, will say that the space produced through excscription is 'an Opening that is nowhere itself open, or better: without any "itself". Space "itself" means nothing.'[52] Nancy elaborates that this 'Opening' is an 'absolute opening', meaning that thought and space are both 'empty of all content, all figure, all determination'.[53] Spacing space, so to speak, displaces thought in its temporal effect. A trace of thought is therefore the obstruction from which, in spacing, an irrecuperable openness results. And in this openness, thinking sustains a demand to remain generative. A trace of thought is not absolute obstruction. In accordance with philosopher Catherine Malabou, I believe that there is another kind of trace that 'does challenge us to think a new, non-graphic meaning', which regards 'interrupting the tracing of the trace' and, thus, extending 'a power of trans-formation'.[54] This, I believe, is a trace shared and transformed by the body and the mark. Thinking is the demand for inventing new multiplicities that seem 'out of reach of all thought, even a thought of the unthinkable'.[55] Thinking then always already risks its trace

to a 'radical negativity of thought'.[56] It is radical in so far as thought 'separates itself from itself'.[57] And it is indeed contrary to any existential figure enabling contemplations of 'the pure void'. The trace is, alternatively, a notion that transforms and invents thinking anew.

Notes

1. Jean-Luc Nancy, *Corpus*, trans. Richard A. Rand (New York: Fordham University Press, 2008a), 11.
2. Jean-Luc Nancy, *Adoration, The Deconstruction of Christianity II*, trans. John McKeane (New York: Fordham University Press, 2013), 14.
3. Nancean sense (*sens*) can indicate both a sensual and signifying sense.
4. Ibid.
5. Ian James, *The Fragmentary Demand, An Introduction to the Philosophy of Jean-Luc Nancy* (Stanford: Stanford University Press, 2006), 143–51.
6. Jacques Derrida, *Margins of Philosophy*, trans. Alan Bass (Chicago: The University of Chicago Press, 1982), 52.
7. Ibid.
8. Jean-Luc Nancy, *Being Singular Plural*, trans. Robert D. Richardson and Anne E. O'Byrne (Stanford: Stanford University Press, 2000), 169.
9. John P. Ricco, *The Decision Between Us, Art & Ethics in the Time of Scenes* (London: University of Chicago Press, 2014), 73–97.
10. Avis Newman and Catherine deZehger, *The Stage of Drawing: Gesture and Act* (New York: Drawing Centre, 2003), 67.
11. Richard Serra, *Writings, Interviews* (London: The University of Chicago Press, 1994), 51.
12. Jean-Luc Nancy, *The Pleasure in Drawing*, trans. Philip Armstrong (New York: Fordham Press, 2013), 21.
13. Jean-Luc Nancy, *The Gravity of Thought*, trans. Francois Raffoul and Gregory Recco (New Jersey: Humanities Press, 1997), 76.
14. John Latham, *Report of A Surveyor* (London: Tate Gallery Publications, 1984), 7.
15. Derrida, *Margins of Philosophy*, 65.
16. Derrida, *Margins of Philosophy*, 66.
17. James *The Fragmentary Demand*, 202–30.
18. Jean-Luc Nancy, *The Ground of the Image*, trans. Jeff Fort (New

York: Fordham University Press, 2005), 75. See also Jacques Derrida, *Of Grammatology*, trans. Gayatri Spivak (London: The Johns Hopkins University Press, 1998), 74–93. For Derrida the trace is definitely nonsensible, a 'dead letter' as he says; and 'thought has no weight . . . measured against the shape of writing'.

19. Ian James, in Verena Conley and Irving Goh, *Nancy Now* (Cambridge: Polity Press, 2014), 110–26.

20. Nancy, *Adoration*, 32.

21. Nancy, *Adoration*, 15.

22. Nancy, *Corpus*, 7.

23. Available at https://www.youtube.com/watch?v=U7DQVW6qRq8 accessed 10 December 2014.

24. André Lepecki, *Exhausting Dance: Performance and the Politics of Movement* (London: Routledge, 2006), 71.

25. Lepecki, *Exhausting Dance*, 72.

26. Henri Michaux, *Miserable Miracle*, trans. Louise Varèse (New York: New York Review of Books, 2002), 12.

27. For the 'graphic continuum' see Deanna Petheridge, *The Primacy of Drawing, Histories and Theories of Practice* (London: Yale University Press, 2010); and for the 'kinetic continuum' see Carrie Noland, *Agency and Embodiment, Performing Gestures/Producing Cultures* (London: Harvard University Press, 2009).

28. Rosalind Krauss, *The Originality of the Avant-Garde and Other Modernist Myths* (London: MIT Press, 1985), 96.

29. Petheridge, *The Primacy of Drawing*, 3.

30. Patricia Cain, *Drawing, The Enactive Evolution of the Practitioner* (Bristol: Intellect, 2010), 32.

31. Michael Newman, in Newman and deZehger, *The Stage of Drawing*, 93.

32. Michael Newman, in Newman and deZehger, *The Stage of Drawing*, 94.

33. Krauss, *The Originality of the Avant-Garde*, 19.

34. Newman and deZehger, *The Stage of Drawing*, 100.

35. Maurice Merleau-Ponty, *The Visible and the Invisible*, trans. Alphonso Lingis (Evanston: Northwestern University Press, 1968), 142.

36. Merleau-Ponty, *The Visible and the Invisible*, 143.

37. See Jane Blocker, *What the Body Cost – Desire, History, and Performance* (London: University of Minnesota Press, 2004).

38. Philip Armstrong, *Reticulations, Jean-Luc Nancy and the Networks*

of the Political (London: University of Minnesota Press, 2009), 91–115.

39. See Malabou, in Catherine Malabou and Adrian Johnson, *Self and Emotional Life, Philosophy, Psychoanalysis and Neuroscience* (New York: Columbia University Press, 2013), 63–72. For the heterogeneity of touch, particularly the reflexive affect that disrupts touching, see Jacque Derrida, *On Touching – Jean-Luc Nancy*, trans. Catherine Irizzary (Stanford: Stanford University Press, 2005), 285–90.

40. As a short anecdote, I recall how Lithuanian reporters did comment on my performance of *Untitled* with, in general translation, 'one should not expect too much here'. This comment was written front page in the Lithuanian national newpaper, *The Baltic Times*, after I had presented *Untitled* for the exhibition *London International* at the KCCC arts centre in Klaipèda, on 21 May 2011.

41. Nancy, *The Gravity of Thought*, 2.

42. Ricco, *The Decision Between Us*, 73–97.

43. Nancy, *The Gravity of Thought*, 77.

44. Nancy, *The Pleasure in Drawing*, 100.

45. Michaud, in Conley and Goh, *Nancy Now*, 108.

46. Nancy, *The Pleasure in Drawing*, 101.

47. Nancy, *The Pleasure in Drawing*, 102.

48. James, in Conley and Goh, *Nancy Now*, 125.

49. Nancy, *Corpus*, 43.

50. Nancy, *Being Singular Plural*, 168.

51. Armstrong, *Reticulations*, 191.

52. Gerard Granel, in: Jean-Luc Nancy, *Dis-Enclosure, The Deconstruction of Christianity*, trans. Bettina Bergo, Gabriel Malenfant, and Michael B. Smith (New York: Fordham University Press, 2008), 166.

53. Nancy, *Dis-Enclosure*, 148.

54. Catherine Malabou, *Changing Difference: The Feminine and the Question of Philosophy*, trans. Carolyn Shread (Cambridge: Polity Press, 2011), 63.

55. Jean-Luc Nancy, *The Birth to Presence*, trans. Brian Holmes and others (Stanford: Stanford University Press, 1993), 10.

56. Rudolf Gasché, *The Honour of Thinking: Critique, Theory, Philosophy* (Stanford: Stanford University Press, 2007), 12.

57. Gasché, *The Honour of Thinking*, 31.

Uncanny Landscapes of Photography: The *Partage* of Double Exposure after Jean-Luc Nancy

Chris Heppell

Realist accounts have traditionally contrasted the expressive originality of painting and portraiture with the essentially objective, documentary character of photography.[1] Yet photography does not merely reproduce and frame the familiar, whether a beautiful face or a picturesque landscape. It may also estrange and contest those bodies whose indexical traces it presents as deferred.

Photography can challenge assumptions surrounding 'landscape' as an inert backdrop against which cultural work takes place, gesturing instead towards emergent forces of co-composition. This notion is particularly important to my own photographic practice. In this chapter, I will draw my *Time Out of Joint* series of double exposures into dialogue with the thought of Jean-Luc Nancy. If, for Nancy, '[Art] touches on the living integration of the sensuous', and 'isolates the exteriority and exposition of a being in the world',[2] modes of production are themselves always implicated in multiple worlds. The photograph thus implies a doubling of exposure: the co-appearance of multiple traces in the distension of each singular, discrete image.

My intention here is not to produce an authoritative account that would promote a notion of ownership over this work. I will instead discuss how irreconcilable gaps[3] take place 'between the producer and the produced, and thus between the producer and himself',[4] emphasising, with Nancy, my complicity with other material forces that co-compose these hallucinatory bodies of photography 'detached and removed by the film'.[5]

Analogue mediality: the doubling of the ground

My *Time Out of Joint* series was produced using an entirely analogue process.[6] By choosing to use film, a photographer involves

herself in a contemporary questioning of ontological or realist discourses that contend the notion of photography as a medium with a direct or indexical connection to the referent. The use of film allows us to reflect upon the resistant graininess of a chemical medium, while also acknowledging the anachronistic and haunto-logical repercussions of such a gesture in digital times.

Nancy muses upon the materiality of film as an emulsion in the essay 'Lux Lumen Splendour' from *Multiple Arts: The Muses II*. In his fragmentary account, the photograph becomes the place where the suspension of an originary light, *lux*, takes place. The photographic image becomes a suspended passage where *lumen*, 'the secondary or incidental light in the translucency of surfaces or bits of matter' is 'reflect[ed] and refract[ed]'.[7] This luminosity, for Nancy, interrupts itself in the passage between *lumen* and *lux*, so that rather than the 'capturing' of bodies in the framing of an image, a rhythmic play is set into motion between the source of illumination and the resonant bodies that reflect and refract it. Photographic film, considered as 'transparent matter'[8] in Nancy's terms, is like a skin or skein, a liquid materiality, where the lumi-nous doubling of a sensory landscape, or *paysage*, takes place. As Nancy puts it in 'The Image, The Distinct' from *The Ground of the Image*:

> In the image, the ground is distinguished by being double. It is at once the profound depth of a possible shipwreck and the surface of the luminous sky. The image floats, in sum, at the whim of the swells, mirroring the sun, poised over the abyss, soaked by the sea, but also shimmering with the very thing that threatens it and bears it up at the same time.[9]

My practice in the *Time Out of Joint* series seeks to attend to this doubling of the ground through the photographic image, thus making explicit its involvement in the excessive exposure of multi-plicities irreducible to a particular grounding.

The *Time Out of Joint* series

The images that comprise my *Time Out of Joint* series are double exposures, presenting two scenes in the same frame. Using a manual focus 35mm Minolta SLR from the early 1980s, I rewind the film of my first set of 36 exposures into the body of the camera

and proceed to take another 36 exposures over the top. This achieves an effect of layered glassiness. The procedure raises questions about temporality and intentionality, agency and alterity. In the first case, the notion of an individual or 'interior' memory is called into question, since by the time I get to the second shot I have only a vague recollection of what lies underneath. On viewing the developed admixture, I become other to those selves who framed the particular landscapes in a certain way. The use of double exposures emphasises this sense of implicatedness with material others in relation to the missed temporal encounters the photograph presents.

Considering these photographs as indicative of particular corners of the country, my implication with them then oscillates between recognition (and photographic capture) and estrangement (that which escapes capture). For Nancy, landscape is 'The country as a sector cut out of an indistinct expanse, like a portion of space that becomes separated out and placed above the general spacing.'[10] In this work, I seek to present a tension between the arbitrariness of a particular apportioning above 'the general spacing' and the careful framing of my eye each time I focus and depress the shutter. Through the use of double exposures, the implications of an estranging dynamic are brought closer for me, presented extensively as a question posed to my memory. Gaps sustaining memory, production, spectatorship and product are emphasised. The affectivity accompanying these aporias is akin to that Nancy describes in the following passage from *The Ground of the Image*: 'When one is taken out of one's country, one feels estranged, unsettled, uncanny: one no longer knows one's way around, there are no more familiar landmarks, and no more familiar customs.'[11] What Nancy's thought helps me to engage with is that this lack of familiarity experienced when looking at one's 'own' work is in one respect a question that landscape photographs always present to us as discrete, as imaged, as distinct. And holding to this discretion, this doubling of the image as image might foster a less appropriative relation to these refracted bodies. Nancy's thought helps me to engage with the question of whether these images can be said to be 'mine' in the first place.

To restate the above slightly: the journey involved where an alien surface is traversed, which is also a surface in which one is ecologically complicit, explodes the notion of a non-porous sense of interiority that might be dependent on a subjectivity grounded

in the imaginative appropriation of memories. The self who hapti-
cally encounters these images is other to the self who framed and
depressed the camera's shutter. The transition from practitioner to
spectator that I'm attempting to chart here touches upon Nancy's
thinking of sense as 'an elsewhere'. 'Sense is a referring [*renvoi*] or
sending [*envoi*] toward somewhere else, toward others (within or
outside me).'[12] Through my spectatorial traversal of the elsewhere
of these images, the otherness that is both within and outside of me
is mobilised as part of the field of forces that compose the vibra-
tion of a landscape signifying its very withdrawal from appropria-
tion. For Nancy, writing in *The Muses*, a play of forces traverses
the field of the image, disrupting the possibility of intentionality
on the part of an auteur,[13] and interrupting a flux that foregrounds
the abrasiveness of a contested photographic landscape. The
agency-alterity of my camera is related to these extrinsic interrup-
tions of propriety. The otherness of my camera, as an alien opera-
tor, emphasises that all sensory landscapes are co-composed in the
ways Nancy thinks them through the concept of *partage*.[14]

Text and Image: A very paradoxical bond

In the following discussion, I will use two images from the *Time
Out of Joint* series to elucidate concepts from Nancy's thinking
about landscape in the chapters such as 'Uncanny Landscapes'
and 'Nous autres' from *The Ground of the Image*. In so doing,
I wish to suggest how Nancy's practice of writing about images,
my practice of doubling-exposing film, and the process of then
writing about this practice inform one another. I have produced
a description of each image, offering something like an ekphratic
translation of what touches me, a weighing up of sense through
the production of a writing that I hope will pay attention to the
excess of sense presented by each image.

The style I use to write about images and the ways I practice
photography are both extrinsic to, or distinct from each other, and
yet in that very distinction, these two practises resonate or oscillate
with each other in ways that draw inspiration from the thought
of Nancy. In Nancy's thinking of the image in *The Ground of
the Image*, the self that makes and encounters art as a plurality of
sensory distributions oscillates with the self whose writing is an
attesting to or weighing up of sense, a response to the taking place
of each presented image. In broadly subjective terms, then, my

sense of myself as either photographer/operator (image-maker) or spectator/critic (encountering, attesting, responding to) is replaced by the simultaneity of a 'with'. I take pictures and I write about them, and these separate practices touch upon each other. The novelty of this assignment will involve my attempt to preserve the fragility of a writing that touches upon and responds to these images while also assuming an artificial distance from them.

To use Nancy's terms, the image, distinct in its plenitude, is that with which one can only form a 'very paradoxical bond'.[15] I would like to attend to these surfaces in a way that preserves their discretion while also recognising the paradox of their givenness to my touch. Following Nancy, images are to be encountered extrinsically: the 'within' of an image (its content considered separately from its formal framings) should be attended to as:

> ... not anything other than its 'fore': its ontological content is surface, exposition, ex-pression. The surface, here, is not relative to a spectator facing it: it is the site of a concentration in co-incidence.[16]

Text and image, in Nancy's terms, touch without communion. A static representation of a specific place, within the context of landscape photography, never forms. In 'The Image – the distinct', Nancy makes the distinction between image (the distinct) and text (the oscillator) as mutual-agitators, plural modes of sensory production that operate through ekphratic translations of one another: 'Each one, in the end, is the distinct and the oscillator of the other.'[17] In what follows I take a performative rather than synthetic approach as I endeavour to preserve Nancy's 'paradoxical bond'.

The hyphen of double exposure

In the landscape below, a disjunctive play between the seaside and the city takes place in a contested sharing of cultural and natural boundaries. The top floor of a Reykjavik town house with its distinctive corrugated iron cladding appears to emerge from the sea, its lower windows fractured in the sand. Windbreakers and a beach fence complicate the middle third of the composition, with the comb-like fence echoing the vertical channels of red covering. A second series of reflective echoes takes place, this time between the small dunes of sand in the foreground and the shadowy troughs of

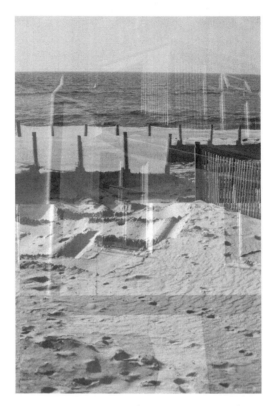

Figure 11.1 *Time Out of Joint* series i). Photograph by
Chris Heppell.

wave-crests behind. Faded rectilinear blocks of colour are visible
on the beach like the shadows of coloured canvas fluttering in the
sea breeze, or the dream of a Mondrian in red and blue. Here, the
primacy of primary colours, the solidity of an Icelandic house of
northern climes, is exposed to the shifting becomings of sand, sea,
and wind. The erosion of the solidity of the house perhaps speaks
of how this land is rented and, for the photographer, contains
echoes of the financial crisis, which hit Iceland in 2008, the year
these traces were embedded together in the film.

When using the 'blind' method of double exposure, the two
scenes presented together are rarely completely synchronised.
Often there are overlaps and breaks in the alignment of the two
layers of exposed negatives. We might say, with Nancy, that these
images operate in the space of an interruption between the coher-
ence of scenes that are exposed together as doubled. The image is

something like a hyphen or pivot presenting itself as the playful contestation, un-working, or 'désoeuvrement', of a landscape.[18] The above image then, might evoke a multiplicity of possible hyphenated aporias for discourses considered as practices of identification. There is an absurdly surrealist sense of juxtaposition that the hyphen of a double exposure indexes.

These images suggest their own possible disjunctive (and necessarily reductive) nominations, such as: Reykjavik-Côte Savage, Iceland-France, City-Beach, and so on. Like the hyphen that, in Nancy's work on the Judeo-Christian tradition, both builds and separates the terms of that appellation, the interruptive double exposure speaks 'also of their com-possibility . . . their construction and their destruction taken together'.[19] In the gap of the hyphen (that is also the space between two irreconcilable co-habitants, two discrete yet touching landscapes), the double exposure exposes a play between the constructions of singular landscapes and the deconstruction that an excess of sense poses to such constructions through its very plurality. This resonant play is akin to that which Nancy speaks of in *The Sense of the World* as the untying of knots of sense in order to ask the questions that sustain the boundaries of the political.[20] It is through an openness to the senselessness of a passage to nothing that 'Locations [might be] delocalised and put to flight by a spacing that precedes them and only later will give rise to new places.'[21] The double exposure exposes the absence of a single regime for dividing up the space of the exposed film. At the limit, perhaps, a movement of '[d]is-enclosure' takes place, the 'dismantling and disassembling of enclosed bowers, enclosures [and] fences. [The] Deconstruction of property – that of man and of the world.'[22] Through this en-actment, the surface muddies our expectations regarding the properly bounded and framed. Rather than landscapes of something, they perform the with of a division that could have been otherwise, a fortuitous encounter between things. The sense that emerges in this admixture is of two discrete spatio-temporal continuums sliding against one another. Within the matrix of the camera's body, an encounter takes place that traverses the fabric of the film.

Eco-technics

I want now to attend to how this encounter might be significant in terms of its potential as a questioning of cultural and natural

boundaries, via the figure of 'eco-technics' after Nancy. The happenstance that a double exposure presents can neither be reduced to the question of an overcoded enframing in terms of an intentional posture on my part as the camera operator (photographic constructivism), nor to the question of a chemical, indexical transfer of a natural object (photographic realism). On the side of the spectator, it is precisely this breaking down of binary modes of reading a landscape – as either a play between foreground and background, or as a mode of capturing or en-framing 'Nature' considered as separate from the cultural – that I believe we can think productively using Nancy's concept. Eco-technics is Nancy's nomination for the originary imbrications[23] of the ecological and the technological, and resounds for me with practices, which seek to unsettle the opposition between natural and cultural realms.[24] The concept of eco-technics presents an opening to an infinity of sense through multiple exposures that are not self-identical with the forces that went into their composition. On the one hand, the human here is always already traversed by non-human forces, complicating the notion of human cultural fabrication or imagination. On the other, remnants of nature as a holistic other to the human should be attended to as they 'withdraw' as a way of making-sense of the human. In my work I seek to move away from the figurative concerns of the explicitly political, as these might be understood in anthropocentric terms (as a concern for the dynamics of strictly human struggles for recognition and political representation). I hope that the distributed fields of sensory forces that double exposures present might, in a modest way, be part of a larger expansion of the grounds by which we establish what is of concern to the human in a landscape.

'Nous autres'

In this image, on the plane of an overlaid portrait composition, the refracted shadows of a city tree emerge through relation with the opacity of a bright shop window. In the background, a street scene (un)grounds the clusters of structure on the surface: branches, twigs, and leaves. A strong upright pillar of concrete at the far right of the image provides a counterweight to the office building on the left. Lamp posts and road markings echo and interpenetrate the other elements in a mesh of artificiality. The distinctions between natural and cultural elements are called into

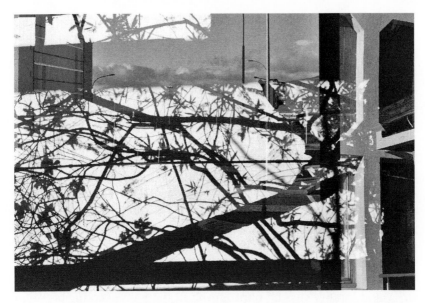

Figure 11.2 *Time Out of Joint* series ii). Photograph by
Chris Heppell.

question through this play. The mediated artificiality of light is
made doubly prominent by the glazed illumination of an arcade
window. A semiotic marker is provided, in the form of half a street
sign, but an interruption cuts it in half, so the iconic or mimetic
grounding this marker might provide to a spectator is limited to
the common Icelandic suffix of a 'gate', the legible 'gata'.

In the following paragraphs, I will continue to develop the ques-
tion of eco-technics in relation to the above landscape photograph.
As Nancy develops it in *The Ground of the Image*, imagination is
the arrival of the givenness of an image, an image that, in a chias-
matic schema, gives itself with 'a proposition that could be called
profoundly graphic or pictorial: there is a thing only through the
design of the thing, and this design gives the thing the contour of
a look turned toward our vision'.[25] The image harbours a certain
potentiality in his account, as 'an antecedence . . . to itself' – a
singularity dragging plurality behind it.[26] It is always already
ecological (in that it is invested with a concern for others through
a multiplicity of different gazes). I chose the above image (Figure
11.2) to act out this play of imagination because it presents itself
as a contestable surface (as artificial rather than natural, as struc-
tured through the interplay of elements hard to define as *either*

cultural or natural). It is both singular, discretely framed, and plural. Considered as an untotalisable collective, the images that form the *Time Out of Joint* series present the passage of *partage* in Nancy's sense: one shares only that which is divided in the very movement of sharing.

In 'Nous Autres', an essay written for the catalogue of the photography exhibition NOsOtros: Identidad y Alteridad (the PhotoSpana festival in 2003), Nancy develops a thinking of the photograph, which operates by way of a hesitation. The image and its subject are suspended together in something like a mesh of interconnectivity, preserving the moment where continuity was interrupted through the emergence of a discrete formal tableau: '[like the snap of a camera shutter] by pressing down, the finger says *I*; it suspends the hesitations between the multiple subjects intersecting and mixing . . . in a suspense that dramatically immobilises a possibility caught in the process of becoming a necessity, or even a fatality'.[27] The photograph in Nancy's account becomes a site where the suspension of a becoming can be traced as the oscillation between the legible (the necessary) and the illegible (the indistinct, the possible).

For Nancy, the necessity/fatality of an image as self-positing resides in the exposure of its finitude as incommensurable with that which it presents (we might say, with its referentiality). This question of the referentiality of a discrete image becomes the 'wholly-other of a singular subject', a subject that, in its (non-holistic) plenitude, resists all identifications. The image here is nothing other than itself and this nothingness speaks to the surplus of something like an eco-technics whereby the 'I' is distributed through different productive assemblages that contest the boundaries between nature and culture. Such outward-facing boundaries are indicated, in Nancy's account, by 'a fold of skin, a pouting face, a plume of smoke'.[28] The photograph then should be considered as an event, a coincidence, or a, a 'common incidence'[29] of disparate material forces[30]. There is a discomforting proximity at stake in this co-incidence that I would like to suggest we can expand and think of as an ethical claim made on us as spectators. The ecological proximity of other (non-human) species abrasively encroaches upon our anthropocentric conceptual grounds. Traversing the space of a singular image[31], strange residents contest these sensory landscapes.

Nancy's term for the co-appearances that emerge in the surface

of the photographic image is *nous autres*, a nomination which I think has a powerful resonance when suggesting the genealogical and ecological perversity of photographic images (perverse in relation to, or in excess of, processes of species identification). In a key passage, Nancy deploys the term as the name for the instantaneous co-production that takes place during the photographic event (the event here considered as something like the index of an interruption of durational flow). 'Each one affirms its alterity while both together make the request for an identity distinct from every other, in whose distinction they are absorbed into.'[32]

Nancy's concept of singular-plurality[33] presents the relationality of encounters between entities that are simultaneously discrete and relational. Encounters between strange neighbours form the basis of an ethical framework. Listening to the echoes and referrals that comprise sensory communications between bodies, without an external means of qualification or justification, is how something like an ethos takes place.[34] Value is located in the antinomy, discordance and contrast between human and non-human forces of co-division. Ultimately what is shared is an incommensurable exposure to the suffering of the other: compassion emerges through being-with-others in a shared landscape.

For Nancy, estrangement is extrinsic and occurs in the production of *partage* between forces of co-division. It is the sensory composition of a landscape with which a fractalised subjectivity is implicated that is uncanny. The landscape, for Nancy, is presence, it is not a backdrop, as the following passage from 'Uncanny Landscape' attests:

> 'A landscape contains no presence: it is itself the entire presence. But that is also why it is not a view of nature distinguished from culture but is presented together with culture in a given relationship (of work or rest, of opposition or transformation, etc.)'[35]

Rather than inert sites ready to receive subjective projections, Nancy's uncanny landscapes surge forth towards an implicated spectator. This is not a return (as in the Freudian uncanny experience of déjà vu, as a revisiting of the mother's body, for example), but is rather the involvement in a passage 'which essentially estranges and unsettles'.[36]

Nancy thinks of photography as an extrinsically strange and ecologically attuned medium. It is because the 'illumination, a

dividing up and sharing out of shadow, frame, grain, and depth of field' cannot be undone entirely, 'only somewhat loosened, through a few interpretative sketches', that 'thought remains here fundamentally a thought of its own strangeness'.[37] Photography here speaks of the abrasive encroachments to our human sovereignty via co-habitations with other radically-other species, forces traversing and dividing the image.[38] The double exposure amplifies the echo of the ecological relation: relation is both distinction from and opening towards the other. We touch each other through our separation: we are exposed to that which we cannot sublimate, and this is the real that we share.

The temporal aspect of this specifically photographic co-exposure of a separation is highlighted by Nancy in a significant passage from the essay *Nous Autres*. Evoking Roland Barthes's reflections on photography in *Camera Lucida*, Nancy writes that 'In a photograph there is always something hallucinatory, something that has lost its way or is out of place.' As distinct from 'painting – or cinema [that] works to present, to bring us into proximity with a modality of presence, photography, which at first seems bound to operate in the same direction, is given over to an irrepressible removal of its own presence'.[39] As the hallucinatory evocation of real bodies, the landscape photograph can foreground the absenting of that which it presents as removed. Since the experience of the indexical referent is deferred through refracted light, the temporality the photograph presents is that of a missed encounter. The photograph thus presents the mediation of a shared exposure through its spatio-temporal dissonance as surface.

The wager such a thought of photography presents to us goes something like this. If we can attend to the play between reality and hallucination, or absence and presence, which the photograph manifests through the passage of its division, then this might foster a less appropriative relation to the bodies whose traces it presents as deferred. In other words, by attending to a withdrawal of sense that is an evidence always in excess of the semiotic, a landscape photograph can solicit an ethical mode of spectatorial engagement.

The multiplicity of Nancy's philosophical undertaking – his varied writings about sense and the birth to presence of sensory communities, the plurality of modes of producing art, and photography as an extrinsically estranging mode of encounter – suggest to me a significant ecological truth regarding complicity and the impossibility of maintaining a distanced critical focus on, and

therefore an appropriation of, a landscape image.[40] As a practitioner, it is in confronting images that could be most familiar to me, closest to home, that I find that I can no longer recall the moment in which I framed and depressed the shutter. It is where I no longer have an idea of what was at stake for me in a particular framing that my implicatedness grows most insistent. As the one who framed a view and depressed a shutter, my otherness in relation to those others that are suspended is emphasised: 'I fix an other in a suspended hesitation . . . I, the one who takes the photograph, completely other in each case, other than all the rest, other than everything that does not say "I" and other than everything that says it from the position of another.'[41]

I feel uncannily exposed with the alterity of these constellations of disparate forces; exposed to the *partage* of a sensory landscape. I am already implicated, and this implication cannot be reduced phenomenologically.[42] What is shared is the echoing and referring, the dispatching and deferral, of sense, between and within each (double) exposure. The presence of these landscapes is essentially elsewhere: my openness towards them is an openness to an absence. The subject of these landscapes, if we can still speak of one, is quite simply the presenting of 'a world that is itself "subject": subject of the relations of which it is the general connectedness'.[43]

Conclusion

Thinking double exposures as the simultaneous division and sharing of landscapes [*partage*] goes some way to present the unworking of landscape through its exposure to the implication of the ecological and the technological in 'eco-technics'. Yet for me, speaking as a photographer for a moment, there is a tension here that involves the question of intentionality. While recognising myself as involved in the traversal of unsettling sensory landscapes in which I am always implicated, and in positioning myself as far removed from the strong subject of a projective phenomenology, I also cannot excise this question completely from my practice. While the camera introduces alterity at the level of the production, I still consciously choose to frame a scene in a particular way, and, in this sense, I struggle with the thought that I am not, on some level, participating in an intensive practice that might promote a particular stance or view, style, or a mode of seeing that does

not always 'withdraw from the injunction of sense'.[44] If Nancy's thinking of photography is nuanced and delicate in terms of how it pays attention to the emergent encounters that are at stake in the division of a sensory landscape, at the macro level perhaps, between the photographer as implicated in the landscape, and between the spectator as implicated in the landscape image, it also seems to pose questions regarding precisely how the pre-existing hierarchy of power abets the forceful division of a landscape.

While seeking to preserve the fragile play between the mimetic and methexic in each image whose production I'm implicated in, I also find myself condemned to meaning, as Merleau-Ponty might say, and desirous of an explication that, while holding to the emergent indistinguishable in each image, translates it into a more critical paradigm. Perhaps there is something like an irony involved here in my recognition of an ecological complicity as co-composer of these images. The ways in which I let these forces be (by using faulty machine, by emphasising the fortuitous structure of composition, through the assistance of a photo-lab, etc) is, to an extent, the conscious decision of an intending individual, and I do not wish to lose sight of this.

Notes

1. See André Bazin, 'Ontology of the Photographic Image', trans. Hugh Gray, *Film Quarterly* 13, no. 4 (Summer 1960) 4–9.
2. Jean-Luc Nancy, *The Muses*, trans. Peggy Kamuf (Stanford: Stanford University Press, 1996), 18.
3. In doing so, I am suggesting that a movement or play between text and image should not be foreclosed, since, as for Nancy: 'What Image shows, Text demonstrates. It withdraws it in justifying it. What Text exposes, Image posits and deposits. What Image configures, Text disfigures.' Nancy, *The Ground of the Image*, 77–8.
4. Nancy, *Muses*, 25–6.
5. Nancy, *The Ground of the Image*, 107.
6. Prior, that is, to the scanning of negatives for reproduction and dissemination in digital form.
7. Jean-Luc Nancy, *Multiple Arts: The Muses II*, trans. Simon Sparks (Stanford: Stanford University Press, 2006), 171.
8. Nancy, *Multiple Arts*, 173.
9. Nancy, *The Ground of the Image*, 13.
10. Nancy, *The Ground of the Image*, 52.

11. Ibid., 54.

12. Jean-Luc Nancy, *Adoration*, trans. John McKeane (New York: Fordham University Press, 2013), 8.

13. Nancy, *Muses*, 33.

14. Nancy, *The Ground of the Image*, 51–62.

15. Nancy, *The Ground of the Image*, 1.

16. Ibid., 9.

17. Ibid., 75.

18. I make passing reference to Nancy's use of this appellation in *The Inoperative Community*, after Blanchot and Bataille.

19. Jean-Luc Nancy, *Dis-Enclosure, The Deconstruction of Christianity*, trans. Bettina Bergo, Gabriel Malenfant, and Michael B. Smith (New York: Fordham University Press, 2008), 48.

20. Jean-Luc Nancy, *The Sense of the World*, trans. Jeffrey S. Librett (Minneapolis: Minnesota University Press, 1997), 103.

21. Nancy, *Dis-Enclosure*, 160.

22. Nancy, *Dis-Enclosure*, 161.

23. In using the term 'originary' I am not suggesting a chronological or a priori oneness, but rather the infinite play of sense where the natural and technical co-appear and resound with one another. For Nancy, the question of origin involves tracing the post-metaphysical ungroundedness of a sensory oscillation without a meta-position to justify it as origin.

24. Nancy, *The Sense of the World*, 102. Nancy, *Dis-Enclosure*, 40.

25. Nancy, *The Ground of the Image*, 89.

26. 'The image always promises more than the image, and it always keeps its promise by opening its imagination onto its own unimaginable.' Nancy, *The Ground of the Image*, 97.

27. Nancy, *The Ground of the Image*, 101.

28. Ibid.

29. Ibid., 104.

30. Nancy, *The Ground of the Image*, 104.

31. 'We others who are now embedded in the strangeness of our illuminated capture.' Nancy, *The Ground of the Image*, 105.

32. Nancy, *The Ground of the Image*, 104.

33. 'Masked Imagination', in: Nancy, *The Ground of the Image*, 84.

34. 'To keep, to protect sense from being filled, as well as from being emptied – that is *ethos*.' Nancy, *Dis-Enclosure*, 122.

35. Nancy, *The Ground of the Image*, 58.

36. Ibid., 62.

37. Ibid., 106.

38. As Nancy himself puts it in *Adoration*, one is exposed *with* these others, since '*I am the world* and the world is me, just as it is you and us, the wolf and the lamb, nitrogen, iron, optical fibres, black holes, lichen, fantastical imagery, thought, and the thrust of "things" themselves.' Nancy, *Adoration*, 69.

39. Nancy, *The Ground of the Image*, 106.

40. 'Vision is not the relation of a seeing subject to the forms of visible objects, it is . . . in the moment of awakening before the distinction of forms and distances – the clarification of a presence.' Nancy, *Adoration*, 46.

41. Nancy, *The Ground of the Image*, 101.

42. 'Not a "being placed within" something that would contain it, but a belonging, or better, an inherence, or still better, a mutual intrication or enveloping, such that "I" am not "in" the world, but rather that *I am the world* and the world is me.' Nancy, *Adoration*, 69.

43. Nancy, *Adoration*, 69.

44. Nancy, *Dis-Enclosure*, 126.

Contributors

Peter Banki is Research Associate in Philosophy at the University of Western Sydney. His research interests include the German Enlightenment and Romanticism, Post-structuralism (especially Derrida and Blanchot), and Guilt and Forgiveness in post-1945 German Literature. His forthcoming book, *Holocaust Forgiveness: A Literary Philosophical Investigation* (New York: Fordham University Press, 2016), addresses the difficulties posed by the Holocaust for a thinking of forgiveness inherited from the Abrahamic (i.e. monotheistic) tradition. He is also practising sex educator and founder and director of the Sydney Festival of Really Good Sex. His website is www.peterbanki.com

Lorna Collins is an artist, critic and arts educator. She completed her PhD in French philosophy as a foundation scholar at Jesus College, University of Cambridge, UK. She is the author of *Making Sense: Art Practice and Transformative Therapeutics*, and co-editor of *Deleuze and the Schizoanalysis of Visual Art*, both published by Bloomsbury. Her provocative practice as an artist (in paint, film, installation and performance) drives the motor of all her philosophical enquiries. http://lornacollins.com

Martin Crowley is Reader in Modern French Thought and Culture at the University of Cambridge. He is the author of: *L'Homme sans: Politiques de la finitude* (Lignes, 2009; with an afterword by Jean-Luc Nancy); *The New Pornographies: Explicit Sex in Recent French Fiction and Film* (co-authored with Victoria Best; Manchester University Press, 2007); *Robert Antelme: L'humanité irréductible* (Lignes/Éditions Léo Scheer, 2004); *Robert Antelme: Humanity, Community, Testimony* (Legenda, 2003), and *Duras, Writing, and the Ethical, Making the Broken Whole* (Oxford

University Press, 2000); and the editor of *Contact! The Art of Touch/L'Art du toucher* (*L'Esprit Créateur*, Fall 2007), and *Dying Words: The Last Moments of Writers and Philosophers* (Rodopi, 2000).

Carrie Giunta is a freelance writer and visiting research fellow at Central Saint Martins (UAL). Her PhD in Philosophy from the University of Dundee (2013) was funded by a Royal Society of Edinburgh Research Network Award for the Arts and Humanities. Giunta's writing has been published in *Radical Philosophy*, *teleSUR English* and the *Times Literary Supplement*. She is a contributor to *The Directory of World Cinema* for Intellect Books. Her recent publications include a chapter entitled 'Community in Fragments: Reading Relation in the Fragments of Heraclitus' in the edited collection, *Global Community? Transnational and Transdisciplinary Exchanges*, for Rowman & Littlefield.

Chris Heppell is an academic and photographer whose work has most recently featured in *Frieze* magazine and on the cover of Mark Fisher's *Ghosts of My Life: Writings on Depression, Hauntology and Lost Futures* (Zero Books, 2014). His research in the areas of Visual Culture and Modern Thought considers contemporary landscape photography, film, and installation art in relation to ecologically informed aesthetic theories.

Adrienne Janus lectures in English Literature in a World Context, and Film and Visual Culture at The University of Aberdeen. She received her PhD in Comparative Literature from Stanford University and has held post-doctoral positions at Stanford and at Queens University, Belfast. Her recent publications include 'Listening: Jean-Luc Nancy and the anti-ocular turn in continental philosophy' in *Comparative Literature* (2011), 'Soundings: The Secret of Water and the Resonance of the Image' in *The Senses and Society*, a special issue on Jean-Luc Nancy, ed. Michael Syrotinski (2013), and 'Gravity Light' in *Unrelated Incidents: John Wood and Paul Harrison* (exhibition catalogue), Gallery West, The Hague (2012). Her current research explores non-hermeneutic modes of presenting and encountering art, music and literature.

Robert Luzar is an artist, writer and educator based in England. He is Lecturer in Fine Art at Bath Spa University. At Central Saint

Martins (UAL), he completed his doctoral research on notions of thought and event, or multiplicity, as explored in current performance-based drawing practices and Continental philosophy. A native of Slovenia, he exhibits globally in live-art events and galleries, previous examples of which include: Torrance Art Museum (USA), Talbot Rice Gallery (UK), Red Head Gallery (CA), and Künstlerhaus Dortmund (DE). His articles on art and critical theory have appeared in journals and magazines such as *Mnemoscape*, *Desearch*, and *Artfractures Quarterly*.

Phillip Warnell is an artist, film-maker and academic based in London. His recent films, *Ming of Harlem: Twenty One Storeys in the Air* and *Outlandish: Strange Foreign Bodies*, each involved collaborations with Jean-Luc Nancy. *Ming of Harlem* received its world premiere at the FID Marseille Film Festival, winning the Grand Jury Prix Georges de Beauregard (2014). His films are screened, exhibited and distributed internationally, most recently at Tate Modern (2015), VIFF Vancouver (2015), KW Institute of Contemporary Art Berlin (2015), BAFICI Buenos Aires (2015), IndieLisboa (2015), Fotogalerie Vienna (2015), Extra-City Antwerp (2014) and New York Film Festival (2014). His writings on cinema and human-animal relations are widely published and include 'The Beast with Two Backs' in Boro, L'ile D'Amour, Berghahn Books, on Walerian Borowczyk (2015). Warnell is an Associate Professor and Director of Studies in Experimental Film at Kingston University, London. www.phillipwarnell.com

Christopher Watkin lectures in French Studies at Monash University in Melbourne, Australia. His recent publications include *Phenomenology or Deconstruction?* (Edinburgh University Press, 2009), *Difficult Atheism* (Edinburgh University Press, 2011) and *From Plato to Postmodernism* (Bristol Classical Press, 2012). He serves as general editor for the *Crosscurrents* monograph series with Edinburgh University Press. His current research explores issues around the notion of equality in contemporary French thought.

Bibliography of Nancy's work on the visual

Exhibitions, films, videos

Burger, Rodolphe, Isabelle Décarie, Louise Déry, Jean-Luc Nancy, Georges Leroux and Ginette Michaud. *TROP: Jean-Luc Nancy with François Martin and Rodolphe Burger*. Montréal: Galerie de l'UQAM, 21 October–26 November 2005. Exhibition.

Denis, Claire. *L'Intrus*. Film. Directed by Claire Denis. 2004. France: Ognon Pictures, 2004.

Denis, Claire. *Vers Nancy*. Film. Directed by Claire Denis, in *Ten Minutes Older: The Cello*. Claire Denis et al. UK: Blue Dolphin, 2002.

Grün, Marc. *Le corps du philosophe*. Film. Directed by Marc Grün. Paris: Ministère de la Culture et de la Communication, 2003.

Kim, Soun-Gui. *Art, or Listen to the Silence: Soun-Gui Kim, Jacques Derrida, Jean-Luc Nancy, John Cage*. Film. Published by Slought, with Artsonje Center and Institut français de Corée du Sud. Philadelphia: Slought, 2014.

Nancy, Jean-Luc. *The Other Portrait*. Italy: Mart Rovereto, 5 October 2013–12 January 2014. Exhibition. http://www.mart.trento.it/theotherportrait

–. *Le plaisir au dessin: Carte blanche à Jean-Luc Nancy*. 12 October 2007–14 January 2008 Lyon: Museum of Fine Arts in Lyon. Exhibition. http://www.mba-lyon.fr/mba/sections/fr/expositions-musee/plaisir-dessin4478/l_exposition

–. 'The Technique of the Present'. Lecture given at the Nouveau Musée during the exposition of On Kawara's works *Whole and Parts – 1964–1995*, Nouveau Musée/Institut d'art contemporain, Villeurbanne, France, January 1997. Accessed 14 August 2015: http://www.egs.edu/faculty/jean-luc-nancy/articles/the-technique-of-the-present

Rabaté, Jean-Michel, Aaron Levy, eds. *Presentation and Disappearance / Présentation et Disparition. Dialogue between Soun-Gui Kim and*

Jean-Luc Nancy, trans. Fiona Moreno and Tchoi Mi-Kyung, in collaboration with Soun-Gui Kim. Video-conference. Published by Slought, with the Artsonje Center and the Institut français of South Korea. 2002.
http://www.filmsdocumentaires.com/films/582-jean-luc-nancy
Warnell, Phillip. *Outlandish: Strange Foreign Bodies*. Film. Directed by Phillip Warnell. 2009. London: The Wellcome Trust, 2009.
Warnell, Phillip. *Ming of Harlem: Twenty-One Stories*. Directed by Phillip Warnell, UK: Big Other Films, 2014.

Works by Nancy

Broyer, Anne-Lise and Jean-Luc Nancy. *Le ciel gris s'élevant paraissait*. Brussels: Filigranes Éditions, 2007. Exhibition catalogue.
Ferrari, Federico and Jean-Luc Nancy. *Being Nude: The Skin of Images*. Trans. Anne O'Byrne, and Carlie Anglemire. New York: Fordham University Press, 2014.
−. *La fin des fins*. Nantes: Editions Cécile Defaut, 2015.
−. *Iconography*. Rome: Sossella Editore, 2006.
−. *Nus sommes*. Brussels: Gevaert Editeur, 2002. 2nd edn. Paris: Klincksieck, 2006.
−. *The skin of the images*. Torino: Bollati Basic Books, 2003.
Fritscher, Susanna and Jean-Luc Nancy. *Mmmmmmm*. Paris: Editions Au Figuré, 2000.
Hantaï, Simon and Jean-Luc Nancy. *Jamais le mot créateur (Correspondance 2000–2008)*, Paris: Galilée, 2013.
Monnier, Mathilde and Jean-Luc Nancy. *Allitérations: Conversations sur la danse*. Paris: Galilée, 2005.
Monnier, Mathilde and Jean-Luc Nancy. *Dehors la danse*. Lyon: Rroz, 2001.
Nancy, Jean-Luc. 'Addressee: Avital'. *Reading Ronnell*, trans. Saul Anton, ed. Diane Davis, 9–20. University of Illinois Press, 2009.
−. *Anemones Traces, lithographs Moninot Bernard*. Paris: Maeght Publisher, 2008.
−. *A plus d'un titre – Jacques Derrida. Sur un portrait de Valerio Adami*. Paris: Galilée, 2007.
−. 'L'art de faire un monde' ('The Art of Making a World'). *Cosmograms*, ed. Melik Ohanian and Jean-Christophe Royoux. New York: Lukas & Sternberg, 2005.
−. 'Les arts se font les uns contre les autres'. *Art, regard, écoute –*

La perception à l'œuvre, 157–66. Paris: Presses Universitaires de Vincennes, 2000.

–. *L'Autre portrait*, Galilée, 2014.

–. 'Chagall renlève le masque' *Chagall devant le miroir*. Ed. Maurice Fréchuret, Jean-Luc Nancy, Françoise Coblence et al. Nice, Musée Chagall, 2013. Exhibition catalogue.

–. *Corpus II – Writings on sexuality*. Trans. Anne O'Byrne. New York, Fordham Press, 2013.

–. *The evidence of film*. Brussels: Yves Gevaert, 2001.

–. *The Ground of the Image*. Trans. J. Fort. New York: Fordham University Press, 2005.

–. *L'il y a du rapport sexuel*. Paris: Galilée, 2001.

–. *Lux, Lumen, Splendor. Ultimes Limbes*. Annabel Guerrero, Strasbourg: Galerie Alternance, 1993. Exhibition catalogue.

–. *Multiple Arts: The Muses II*. Trans. Simon Sparks. Stanford: Stanford University Press, 2006.

–. *The Muses*. Trans. Peggy Kamuf. Stanford: Stanford University Press, 1996.

–. 'Oh the Animals of Language'. *Ming of Harlem: Twenty-One Stories*. Directed by Phillip Warnell, UK: Big Other Films, 2014. http://supercommunity.e-flux.com/texts/oh-the-animals-of-language

–. *La particion de las artes*, Trans. Cristina Rodriguez. Valencia: Pretextos, 2013.

–. *Le Philosophe Boiteux*. Dijon: Les presses du reel, 2014.

–. 'The Pleasure in Drawing'. Trans. Philip Armstrong. New York: Fordham University Press, 2013. (Le Plaisir au dessin, Paris, Galilée, 2009.)

–. Preface to (and photos) *Veilleuses. Autour de trois images de Jacques Derrida*, by Ginette Michaud. Québec: Nota Bene, 2009.

–. *Le portrait (dans le décor). Les Cahiers-Philosophie de l'art*. Paris: Institut d'art contemporain, 1999.

–. *Le regard du portrait*. Paris: Galilée, 2000.

–. *Visitation (de la peinture chrétienne)*. Paris: Galilée, 2001.

–. 'Vaille que vaille'. *Stock Exchange*, Soun-gui Kim. Domart-en-Ponthieu: Maison du Livre d'Artiste Contemporain, 1999.

Articles by Nancy

Nancy, Jean-Luc. 'L'areligion'. Vacarme 14 (2001). http://www.vacarme.org/article81.html

–. 'L'art, fragment'. *Lignes* 18 (1993): 151–73.

–. 'Art Today'. *Journal of Visual Culture* 9, no. 91 (2010): 91–9.

–. 'A Certain Silence'. *The Oxford Literary Review* 27, no. 1 (2007): 7–16.

–. 'Le danseur de la danse'. *Cahier critique de poésie* 24 (2012).

–. 'Exscription'. *Yale French Studies* 78 (1990): 47–65.

–. 'Icon of Fury: Claire Denis'. *Trouble Every Day. Film-Philosophy* 12, no. 1 (2008): 1–9.

–. 'Image et violence'. *Le Portique* 6, (2000). http://leportique.revues. org/451

Choulet, Philippe and Jean-Luc Nancy. 'D'une mimesis sans modèle'. *L'Animal* 19–20 (2008): 109.

Secondary works

Special journal issues

'Claire Denis and Jean-Luc Nancy', ed. Douglas Morrey, special issue, *Film-Philosophy* 12, no. 1 (2008).

'Contact! The Art of Touch/L'Art du toucher', special issue, ed. Martin Crowley, *L'Esprit Créateur* 47, no. 3 (2007).

'Encounters with Jean-Luc Nancy', special issue, *MonoKL* 10 (2011).

'Exposures – Critical Essays on Jean-Luc Nancy', ed. Ian James and Patrick ffrench, special issue, *The Oxford Literary Review* 27, no. 1 (2007).

'Jean-Luc Nancy and the Sense of the Visual', ed. Louis Kaplan and John Paul Ricco, special issue, *Journal of Visual Culture* 9, no. 1 (2010).

'On the Work of Jean-Luc Nancy', ed. Peggy Kamuf, special issue, *Paragraph* 16, no. 2 (1993).

Books on Nancy's work

Armstrong, Philip. *Reticulations: Jean-Luc Nancy and the Networks of the Political.* London: University of Minnesota Press, 2009.

Collins, Lorna. *Making Sense: Art Practice and Transformative Therapeutics.* London: Bloomsbury, 2014.

Collins, Lorna and Elisabeth Rush eds. *Making Sense: for an effective aesthetics.* Oxford and New York: Peter Lang, 2011.

Collins, Lorna and Bandy Lee, eds. *Making sense: merging theory and practice.* Oxford: Peter Lang, 2013.

Conley, Verena and Irving Goh. *Nancy Now.* Cambridge: Polity, 2014.

Crowley, Martin. *L'Homme sans: Politiques de la finitude.* Paris: Lignes, 2009. (afterword by Jean-Luc Nancy).

Crowley, Martin and Victoria Best. *The New Pornographies: Explicit Sex in Recent French Fiction and Film*. Manchester: Manchester University Press, 2007.

Heikkilä, Martta. *At the Limits of Presentation: Coming to Presence and its Aesthetic Relevance in Jean-Luc Nancy's Philosophy*. Frankfurt am Main, Germany: Peter Lang, 2008.

James, Ian. *The New French Philosophy*. Cambridge and Malden, MA: Polity, 2012.

James, Ian. 'Seeing and Touching: Jean-Luc Nancy and the Ground of the Image'. *Modern French Visual Theory: A Critical Reader*, ed. Nigel Saint and Andy Stafford, 201–18. Manchester: Manchester University Press, 2013.

Janus, Adrienne. 'Gravity Light'. *Unrelated Incidents: John Wood and Paul Harrison*. The Hague: Gallery West, 2012. Exhibition catalogue.

McMahon, Laura. *Cinema and Contact: The Withdrawal of Touch in Nancy, Bresson, Duras and Denis*. London: Legenda, 2012.

Michaud, Ginette. *Cosa volante: le désir des arts dans la pensée de Jean-Luc Nancy: avec trois entretiens de Jean-Luc Nancy*. Paris: Hermann, 2013.

Morrey, Douglas. 'Listening and Touching, Looking and Thinking: The Dialogue in Philosophy and Film between Jean-Luc Nancy and Claire Denis'. *European Film Theory*, ed. Temenuga Trifonova, 122–34. London: Routledge, 2009.

Ricco, John Paul. *The Decision Between Us: Art and Ethics in the Time of Scenes*. Chicago: University of Chicago Press, 2014.

Rugo, Daniele. *Jean-Luc Nancy and the Thinking of Otherness: Philosophy and Powers of Existence*. London: Bloomsbury, 2013.

Warnell, Phillip and Jean-Luc Nancy. *Outlandish: Strange Foreign Bodies*. London: Phillip Warnell, 2010.

Watkin, Christopher. *Difficult atheism: post-theological thinking in Alain Badiou, Jean-Luc Nancy and Quentin Meillassoux*. Edinburgh: Edinburgh University Press, 2011.

Watkin, Christopher. *Phenomenology Or Deconstruction?: The Question of Ontology in Maurice Merleau-Ponty, Paul Ricoeur, and Jean-Luc Nancy*. Edinburgh: Edinburgh University Press, 2009.

Articles on Nancy's work

Armstrong, Philip. 'From Appearance to Exposure'. 'Jean-Luc Nancy and the Sense of the Visual', ed. Louis Kaplan and John Paul Ricco. Special issue, *Journal of Visual Culture* 9:1 (2010) 11–27.

Armstrong, Philip. 'The Murky Point of Modern Thought: Some Contexts for Nancy's Writings on Space', in 'Encounters with Jean-Luc Nancy', special issue, *MonoKL* 10 (2011): 324–42.

Ferrari, Federico. 'De l'iconographie: Jean-Luc Nancy et la question de l'image'. *Etudes Françaises* 51, no. 2 (2015).

Hayes, Julie Candler. 'The Body of the Letter: Epistolary Acts of Simon Hantaï, Jean-Luc Nancy, and Jacques Derrida'. *Postmodern Culture* 13, no. 3 (2003).

James, Ian. 'Art – Technics'. *The Oxford Literary Review* 27, no. 1 (2007): 83–102.

James, Ian. 'The Evidence of the Image'. *L'Esprit Créateur* 47 (2007): 68–79.

James, Ian. 'The Persistence of the Subject: Jean-Luc Nancy'. *Paragraph* 25 (2002): 125–44.

Janus, Adrienne. 'Listening: Jean-Luc Nancy and the "Anti-Ocular" turn in Continental Philosophy and Critical Theory'. *Comparative Literature* 63 (2011): 182–202.

–. 'Soundings: The Secret of Water and the Resonance of the Image'. *The Senses and Society*, special issue 'Jean-Luc Nancy', ed. Michael Syrotinski (2013).

McMahon, Laura. 'Deconstructing Community and Christianity: "A-religion" in Nancy's reading of *Beau travail*'. *Film-Philosophy* 12, no. 1 (2008): 63–78.

McMahon, Laura. 'Jean-Luc Nancy and the Spacing of the World'. *Contemporary French and Francophone Studies* 15 (2011).

McMahon, Laura. 'Post-deconstructive realism? Nancy's cinema of contact'. *New Review of Film and Television Studies* 8 (2010) 79–93.

Surprenant, Céline. 'Occidentaux de 1963'. *The Oxford Literary Review* 27, no. 1 (2007) 17–34.

Websites of practising artists in this volume

http://www.peterbanki.com
http://www.harrisonandwood.com
http://www.lornacollins.com
http://www.phillipwarnell.com
http://www.robertluzar.com

Index